The Big Book of
DRAWING & PAINTING

Drawing · Oil · Pastel · Watercolor

The Big Book of
DRAWING & PAINTING

Drawing · Oil · Pastel · Watercolor

HDi

HARPER
DESIGN
international

Concept: **Arco Editorial, S.A.**

English text: **Harry Paul**

Graphic design and layout: **Ignasi Gràcia i Blanco**

Illustrations: **Vicenç Badalona Ballestar**

Photography: © **Enric Berenguer**

Copyright 2003 © by HDI, an imprint
of HarperCollins Publishers and Loft Publications

First published in 2003 by Harper Design International,
an imprint of HarperCollins Publishers
10 East 53rd Street, New York, NY 10022-5299

Distributed throughout the world
by HarperCollins International
10 East 53rd Street, New York, NY 10022-5299
Fax: 212-207-7654

Paperback ISBN: 0-06-055726-5
D.L.: B-3.299/2003

Printed by:
Industrias Gráficas Ferre Olsina. Barcelona. Spain

PASTEL

WATERCOLOR

INDISPENSABLE MATERIALS

To begin drawing you only need cheap and simple tools such as a notebook and a pencil, or a stick of graphite, or charcoal; everything else is supplementary. The basic materials for drawing can be found in fine art shops or stationers.

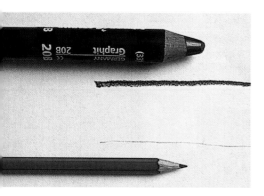

A graphite pencil and a small notebook are enough to launch yourself into the world of drawing.

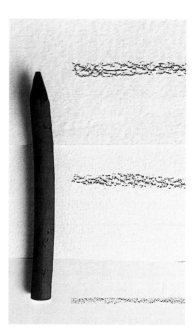

Charcoal is the oldest, simplest and most malleable drawing media that exists. It dates from the first artistic expressions of the human race. As the name indicates, it consists of carbonized wood and, therefore, allows a strong black line to be drawn. When a mark is made on paper with charcoal it is very unstable; it only has to be touched or rubbed with the fingers for it to turn into carbon dust. It is precisely this delicateness that makes it such a suitable medium with which to learn to drawn, for marks can be easily corrected.

▼ *One of the most popular and widely used media for drawing is the pencil. It is made of a lead that can be of several materials (carbon, plastic, sanguine, graphite, etc.) wrapped in soft grainless cedarwood which is easy to sharpen without splintering. The quality of the pencil depends on the two principal components. The lead has to be sufficiently compact so that it does not break. However, try to avoid dropping the pencil, as this may damage the lead. The wood must have the right degree of softness and dryness so that it does not flake when sharpened.*

Pure graphite is a lead so thick that it does not need a wood covering. Most sketchers are heavy users of graphite sticks for they permit a great deal of versatility in the stroke. As they are not covered by a wooden sheath, drawing with graphite is not limited to the point; a wide variety of strokes is possible.

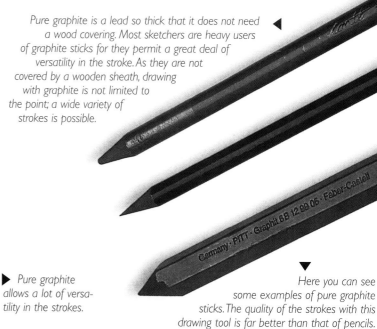

▶ *Pure graphite allows a lot of versatility in the strokes.*

▼ *Here you can see some examples of pure graphite sticks. The quality of the strokes with this drawing tool is far better than that of pencils.*

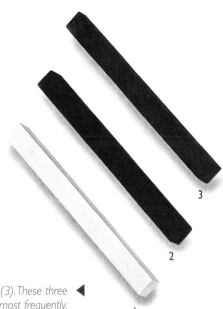

You do not always have to draw with the gray and black tones that we have seen so far. Among the different drawing materials, we should not overlook chalks and sanguine crayons. Chalk is manufactured from calcium carbonate prepared artificially and mixed with glue and pigments. It is sold in little sticks that offer a rich variety of strokes. Sanguine crayons are made from mineral pigments also held together with glue. These drawing media allow a wide range of effects and chromatic variations. When combined, they can produce very interesting results for the artist.

▼ *Here is an example of how you can work in white chalk on colored paper.*

A bar of white chalk (1), sanguine (2) and sepia (3). These three bars are the ones that the majority of artists use most frequently. With three colors you can develop ranges of all types. ◀

PAPER

Paper is the principal drawing medium, which is why we must pay special attention to it. There is a great variety of paper on which we can draw. The grain or texture of paper has an important effect on the mark, or trace, that the different drawing media leave. The thicker the grain of the paper, the stronger the mark will be. Besides the grain, paper is also defined according to its weight–the heavier it is per square foot, the thicker and more resistant will be.

ERASERS

Cleaning materials are fundamental whatever the drawing technique employed. While drawing, paper becomes quite dirty, and every type of medium must be rubbed out or corrected with an appropriate material. Erasers allow lines, stains and smudges to be eliminated and the paper to be left clean. There are other types of implements besides erasers to modify or correct strokes.

Each eraser is suitable for a particular type of drawing medium.◀ *Plastic erasers (1, 2, 3, 4), latex erasers (5, 6), putty erasers are especially suitable for charcoal and sanguine (7, 8, 9, 10), very soft crumbly erasers are suitable for pencil marks on delicate or satin paper (11, 12, 13, 14), and a hard eraser is good for ink (15).*

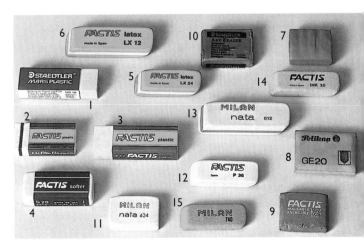

THE COMPOSITION OF OIL AND THE PALETTE

Oil paints are made of pigment and oil, which is why only turpentine can be used to dilute the colors. Unlike other pictorial media, oil colors do not dry by means of evaporation, since there is no water in their composition; instead, they harden through the oxidization of the oil. The most significant characteristics of oil paint are its slow drying process and the way in which it can be superimposed in opaque or transparent layers. There is an extensive range of techniques for oil painting, many of which will be explained later in this volume.

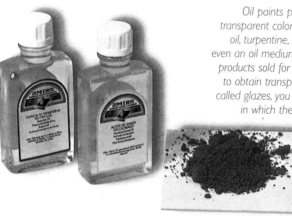

Oil paints permit highly luminous transparent colors obtained by linseed oil, turpentine, and Dutch varnish, or even an oil medium or one of the many products sold for this purpose. In order to obtain transparent layers, normally called glazes, you will need a container in which the color can be diluted.

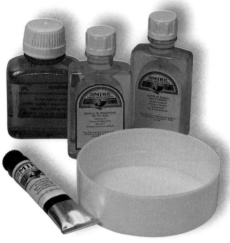

▼ *Oil paint is made up of linseed oil, pigment, and may contain a little turpentine. With these three components it is possible to paint any subject. The brushes used to apply oil paint must be cleaned with turpentine and then rinsed with running water.*

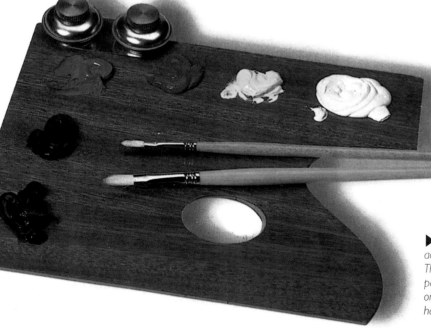

SOUND ADVICE

Dippers are indispensable accessories for painting in oils. These metal containers are used to hold linseed oil and turpentine.

▶ *The colors are placed on the palette according to shade, as shown in this example. They should be placed around the edge of the palette, leaving enough space between each one to avoid smearing. The paints on this palette have been arranged in a specific order.*

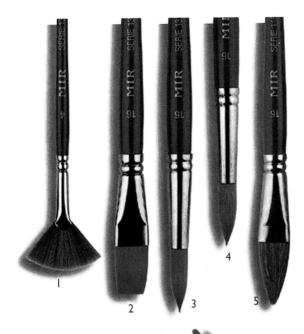

BRUSHES AND PALETTE KNIVES

Brushes are indispensable tools for painting in oils. Virtually an extension of our hands, brushes are used to apply paint to the canvas, to mix colors, and to execute all manner of brush-strokes. Unlike brushes, the palette knife is used to apply the paint in the form of dense impastos; painters also use this implement to drag paint across the canvas. These two tools help the artist execute highly individual and effective brush-strokes.

▶ There is a wide range of oil paint brushes to choose from. Here is a selection of the various types of brushes available on the market: fan brush (1), flat brush (2), round-tipped brushes (3-4), and filbert brush (5).

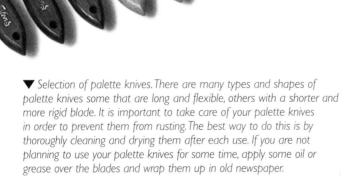

▼ Selection of palette knives. There are many types and shapes of palette knives some that are long and flexible, others with a shorter and more rigid blade. It is important to take care of your palette knives in order to prevent them from rusting. The best way to do this is by thoroughly cleaning and drying them after each use. If you are not planning to use your palette knives for some time, apply some oil or grease over the blades and wrap them up in old newspaper.

▶ This rubber-tipped brush falls somewhere between the palette knife and the brush.

▼ Wide brushes are straight and flat. These are considered the most useful of all paintbrushes. Despite their somewhat rough appearance, they can be employed in a variety of ways. A brush-stroke made with a wide brush facilitates color blending and roughing out, the technique of filling in the canvas.

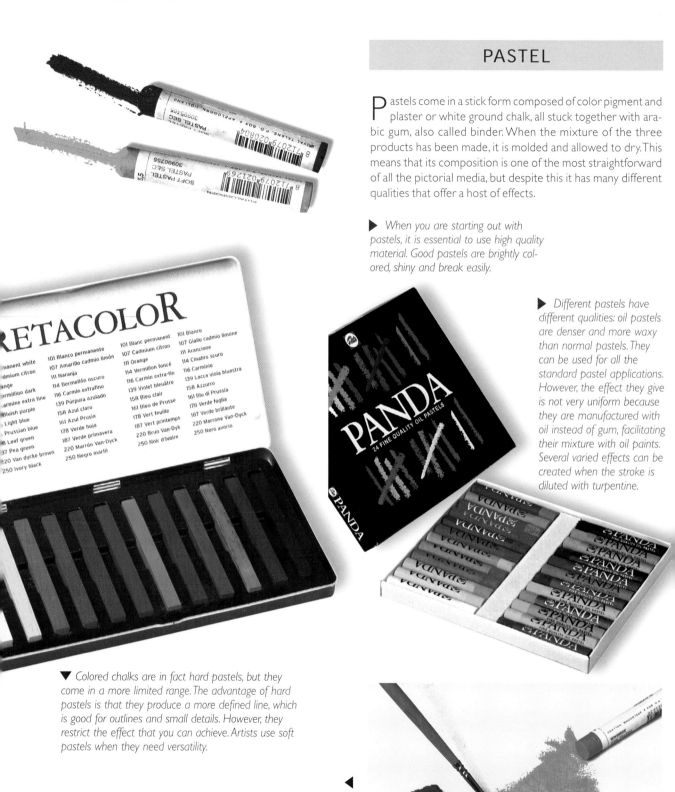

PASTEL

Pastels come in a stick form composed of color pigment and plaster or white ground chalk, all stuck together with arabic gum, also called binder. When the mixture of the three products has been made, it is molded and allowed to dry. This means that its composition is one of the most straightforward of all the pictorial media, but despite this it has many different qualities that offer a host of effects.

▶ *When you are starting out with pastels, it is essential to use high quality material. Good pastels are brightly colored, shiny and break easily.*

▶ *Different pastels have different qualities: oil pastels are denser and more waxy than normal pastels. They can be used for all the standard pastel applications. However, the effect they give is not very uniform because they are manufactured with oil instead of gum, facilitating their mixture with oil paints. Several varied effects can be created when the stroke is diluted with turpentine.*

▶ *Colored chalks are in fact hard pastels, but they come in a more limited range. The advantage of hard pastels is that they produce a more defined line, which is good for outlines and small details. However, they restrict the effect that you can achieve. Artists use soft pastels when they need versatility.*

◀ *This is how pastels are mixed with linseed oil or oil paints.*

THE SUPPORT: PAPER

Pastel is an opaque and dry medium, the properties of which allow it to be painted on a wide range of supports, but without doubt, it is paper which brings out the best this medium. Any type of paper can be used with pastels, although those specially designed for pastels enhance the beauty of the colors, offering the artist the surface needed for a particular style.

▼ *Colored papers. These are the most commonly used papers for pastels. The most renowned manufacturers have a wide variety of papers in all colors and tones. To start with, buy some earth or tobacco colored papers before moving onto bolder, more daring ones. The color of the paper plays a key role in the way the picture develops since it forms part of the color range used.*

▼

Watercolor paper. Watercolor paper, available in many different varieties, is also suitable for pastel painting because it is absorbent. Medium-to-heavy grained papers give the best results.

▼ *A pad of drawing paper. A useful material to do color tests and sketches.*

◄

Handmade paper. Its texture is irregular so any work done on it will incorporate its surface characteristics. In theory, this is not the most suitable paper for a beginner, although it is not a bad idea to try it out from time to time. In this picture you can see unusual and irregular paper shapes.

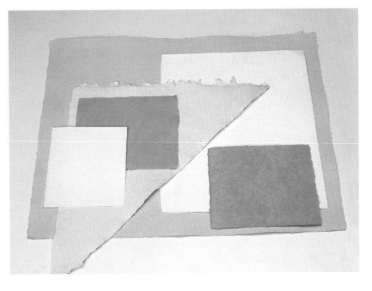

Materials - WATERCOLOR

WATERCOLOR PAINTS

Watercolor paints come in a wide variety of sizes and qualities. The cheapest types are so-called school paints. If you really want to learn how to paint with watercolors, these paints should be automatically excluded, since they will not produce good results. Medium quality paints, are recommended for the beginner regardless of whether you buy tubes or pans. These paints are manufactured by well-known brands and allow all manner of painting styles.

Tubes of watercolor paints.
This option is recommended once beginners have acquired experience and know how to use the colors of their paintboxes. Tubes of paint are sold in a variety of sizes, depending on the manufacturer.

Paintboxes with moist colors in pans. This choice of watercolor is a question of taste. Dry colors require more work to paint with than moist paints. Moist colors are more convenient because they are ready to paint with.

Paintbox containing tubes of watercolor paint. Paintboxes normally contain a complete range of colors, although they may be minimal. The lid of the box can be used as a palette. This paintbox has a medium range, highly recommended for the beginner.

14

PAPER

Whereas other pictorial media can be painted on all manner of supports, watercolor can only be applied on paper. Furthermore, watercolor cannot be painted on any type of paper. This medium requires a paper with special characteristics. The right weight of paper, and thus its density, is fundamental. Another essential feature to bear in mind is the degree of absorption of the paper, which depends on how it has been sized. The grain of the paper determines its smoothness; fine-grain paper is smooth, while coarse-grain paper has a rougher surface. The most commonly used paper in watercolor is medium-grain.

Among the most widely used watercolor pads are the type which come that glued on all four sides so that there is no danger of it wrinkling when it is painted on. The sheets must be separated with a knife.

▼ *Watercolor drawing pads. This is one of the most convenient types of paper. As a general rule, the cover of the pad indicates its characteristics. We recommend you use semi-rough paper for painting in watercolor (the heavier type). There is a wide variety of formats and sizes of pads on the market; the smaller type are ideal for traveling with and painting sketches; the larger sizes are used for full-size watercolor paintings.*

◀
*Handmade paper.
Handmade paper is normally of the highest quality, and therefore it is usually reserved for very special work.*

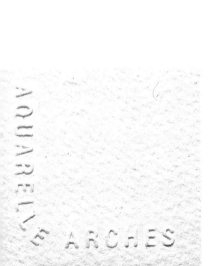

▼ *Brand-name paper.
Manufacturers who specialize in drawing and watercolor paper normally produce papers of various qualities and thicknesses. These sheets usually have a watermark or a stamp in relief on each sheet. This type of paper is sold in units, although the manufacturers also produce pads or blocks of paper.*

Charcoal

CHARCOAL STROKES

Charcoal is a very versatile drawing medium. Depending on how you hold the stick, you can draw with the width of the stick, with the tip, or flat between your fingers. Each way of holding the stick allows a different type of stroke to be made, which, when added to other drawing techniques, can produce a great variety of options and results.

▶ *The charcoal stick has to be broken with the fingers to the necessary length. Light pressure is sufficient to break the stick to the required length. The stick must be neither too long nor too short: two or three inches is about right. This size enables you to make all types of strokes on the paper.*

Charcoal is one of the most highly recommended media for an initiation into the world of drawing. A charcoal stick can vary in thickness and any of its surfaces can be used for drawing. It leaves a mark so unstable that it can be rubbed off just by touching it with the fingers or with a cloth. It is important to pay attention to the basics of this technique, as the most insignificant details, such as rubbing or the way the stroke is made, will be indispensable to the understanding of more advanced processes.

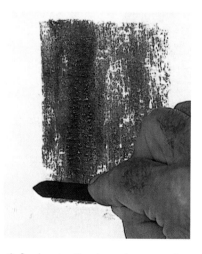

▲ *When it is held like a pencil, a charcoal stick is enclosed in the palm of the hand. This form of drawing will become very familiar to all enthusiasts. However, learning to master the stroke is complicated because, in contrast to a pencil, the upper part of the charcoal is hidden by the hand. The movement of the stroke is entirely controlled by the fingers.*

▲ *To make a stroke like this, hold the charcoal as shown in the picture. This way of drawing enables you to create precise lines and firm strokes since the entire length of the charcoal is in contact with the paper.*

▲ *By dragging the charcoal transversely, as shown in this photo, you can make strokes as wide as the stick is long. It is thus possible to cover a wide area with a charcoal very quickly.*

CHARCOAL LINES

The different faces of a charcoal stick allow you to use a variety of strokes to mark and outline all types of forms. To draw, you only need charcoal and paper. With these simple tools it is possible to create all kinds of works, but first you have to learn the ins and outs of this drawing process and the basics principles of drawing.

▶ *If you hold the charcoal stick near the point, as if it were a pencil, it is possible to do rapid strokes guided by the movement of the hand. Here, it is a question of tracing various lines in order to compare the effects of different pressures. Be careful not to smudge the lines with your drawing hand.*

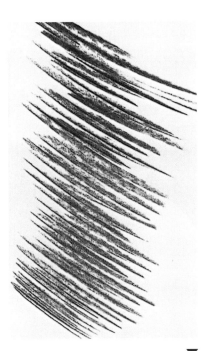

▼

When a charcoal stick is held horizontally, using its length to make the stroke, the result is very firm. The charcoal stick is its own guide as it is dragged over the paper. This process does not allow for fine details. However, it is useful for outlines and adjustments, the first steps of any drawing or picture.

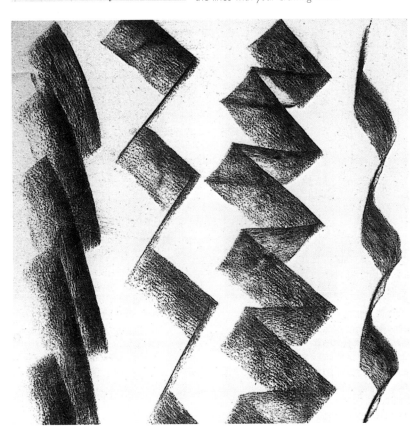

▶ *With the charcoal held horizontally, lines as wide as the stick can be drawn. As can be seen here, this style offers a rich variety of combinations in the same stroke. It is only necessary to make a flat stroke into a transverse one.*

CORRECTIONS AND HOW TO USE THE ERASER

If you have tried the exercises on the last page, you will notice that the charcoal is not fixed on the paper and that your fingers are stained. Because of this quality, it is possible to make all manner of corrections to the work in progress. Corrections can be made in various ways: with the putty eraser or with the hand or fingers. Before starting to draw even the simplest subjects, you must practice correcting and smearing the charcoal on the paper.

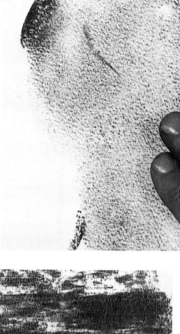

▶ *Make a stroke with the stick flat. Gently go over this line with tiny circular movements of the hand using the fingertips. The charcoal spreads out and stains the paper. This process is called stumping the stroke.*

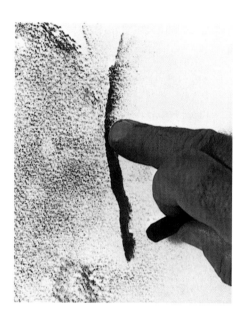

▼ *Stumping the stroke can be done on top of all sorts of lines. All that has to be done is make a stroke with the point of the charcoal, and then run a finger along one side of the stroke so that it merges into the background. If you press too hard, the charcoal may combine with this skin's natural oils to produce an irreversible stain. If the pressure is faint, the merging will be very gentle.*

The hardest erasers can damage the surface of the paper, and, of course, the eraser will get dirty. When another type of eraser is used, it is a good idea to clean it whenever it becomes grimy. Of course, before you use a washed eraser it has to be completely dry.

▼ *A putty eraser can be kneaded with the fingers to give it the shape desired. Depending on the shape of the eraser, different types of corrections and rubbings out can be made. This exercise is very straightforward: it consists of shading all the paper with the charcoal stick flat. Using the eraser, several white spaces are opened up by rubbing softly on the surface darkened by the charcoal. When the eraser becomes grubby, the soiled part is pushed inwards, so that a new surface can be used to continue erasing or to open up other white spaces.*

Drawing requires a suitable type of paper, otherwise it is possible that the charcoal will slip on the surface and spoil the line. The paper must have a surface that lightly rubs the charcoal. This is why paper with a smooth finish is not suitable.

COMBINING LINES

Once the rudiments of charcoal drawing have been learned, they have to be put into practice. All the shapes and forms of nature can be reduced to very straightforward elements so that they can be better represented on the paper.

By combining the different ways of making strokes with charcoal explained so far, seemingly complicated forms can be drawn. Pay close attention to this exercise and you will see that it is not too difficult to start drawing.

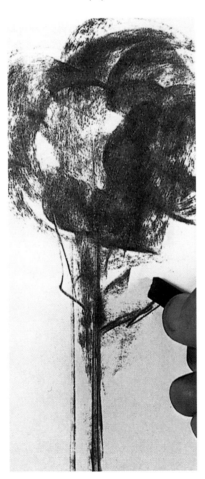

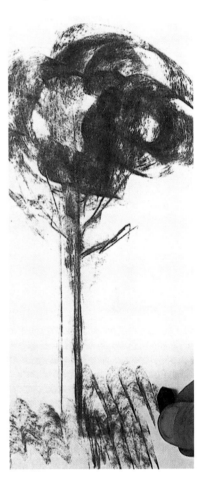

▼ 1. *To produce straight lines without the stroke trembling or wobbling, the charcoal stick is held flat between the fingers and a stroke is made with its entire length. First, a very faint line is drawn without applying too much pressure. The body of the charcoal stick is the guide for the line and prevents it from deviating. Next to this line, another one is drawn, but this time pressing harder will give a darker tone.*

▼ 2. *Starting from these two lines, different strokes are made with the stick held transversely so that its whole surface is in contact with the paper. This allows you to produce very thick lines and curves. You can vary the thickness by changing the angle at which the charcoal moves.*

▼ 3. *The harder the charcoal stick is pressed down on the paper, the darker and more intense the stroke will be. On the left side of the paper, use a strong pressure. In the lower area, draw new strokes alternating flat with vertical. With the stick flat between the fingers, draw fine vertical zigzag lines.*

Step-by-Step
A Tree

The aim of this exercise is to familiarize yourself with charcoal, the possibilities that it offers for different strokes, and its practical application. The exercise should not present any problems. A tree has been chosen because it is a form that is simple to analyze and because landscape elements allow much more freedom of representation than other, more sharply delineated objects. The proportions, of your drawing may differ from those in the example, but the end product will certainly be a tree. In the early exercises, the beginner is not expected to obtain the same result as in the photo; it is only a point of reference.

MATERIALS
Paper (1), charcoal (2).

1. *The shape of the tree may be fitted into a rectangular outline. Within this shape, the outline of the top of the tree is drawn with the point of the charcoal. This enables much looser and freer strokes to be made. This exercise does not require very precise forms. However, the tree trunk does call for greater exactitude, and therefore, in this area the charcoal must be used flat and lengthwise, thus creating a firm stroke line.*

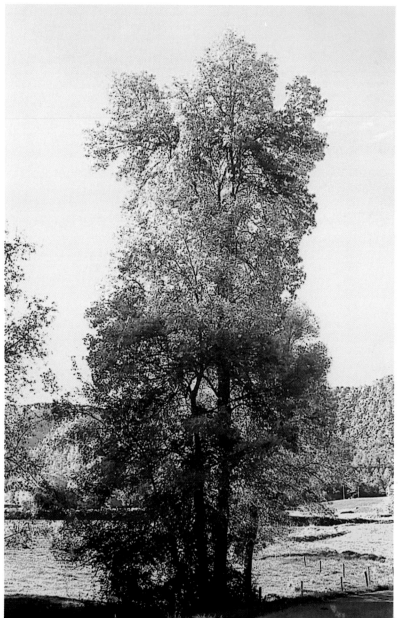

2. *This exercise can be completed in a very short period of time, as it requires only a few strokes, the right type of stroke in each area of the drawing. Start drawing the left of the tree with the charcoal stick held flat and transverse, so that dragging the stick stains all the paper along its width. The stick will have to be broken, enabling you to shade only where necessary. These first strokes should not be too close together and, therefore, will produce a soft gray. As can be seen in this close up, the background of the paper shows through the strokes.*

Sometimes the charcoal stick may contain areas that are not the typical color of this medium, but show a brown seam that could scratch the paper. When this happens, the wisest course of action is to change the charcoal, or rub it with sandpaper until the black reappears.

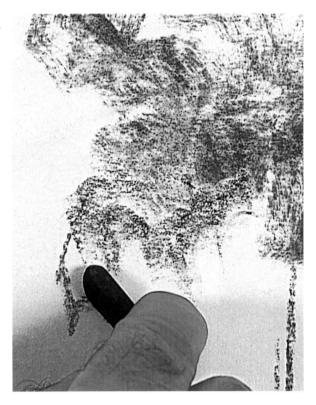

3. *The right-hand side of the tree is drawn with a flat and transverse stroke, going over the drawing made previously with the point of the charcoal. First, draw with a soft stroke, avoiding a strong mark. Afterwards, on the profile of the tree, increase the pressure so as to produce a slightly darker gray. Notice that not all of the treetop is stained; some parts are left white. They are the lightest areas.*

4. *When the right-hand side of the tree has been entirely stained, softly spread part of the gray charcoal color toward the white area of the paper. Just touching the charcoal lightly with the hand is enough to erase or lighten the shade, however dark it may be. When your fingers have touched the charcoal, it is advisable to clean them with a cloth to eliminate any excess, and thus avoid staining white zones of the paper.*

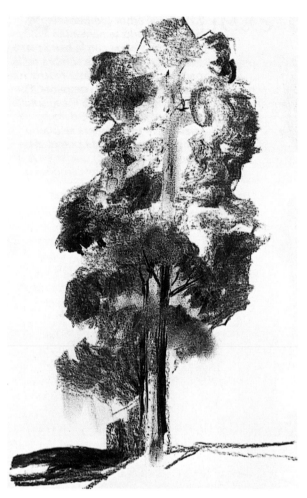

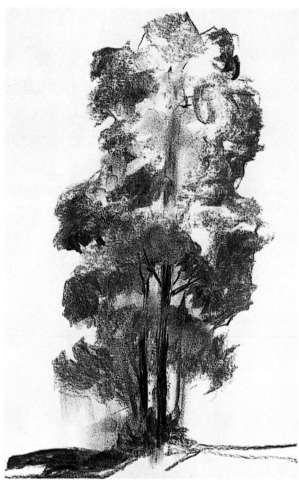

5. *Continue progressively darkening the treetop. Use charcoal pieces of different sizes use so that it is possible to obtain flat and transverse strokes of various widths. The areas that represent denser shadows require a heavier stroke. To make the intense shadow on the ground, use the point of the charcoal in the same way as when the right-hand side of the tree trunk is emphasized. Use a finger stained with charcoal to draw a vertical line in the middle of the tree.*

6. *The tree trunk is drawn with several strokes of the point of the charcoal, holding the charcoal stick as if it were a pencil. In this way it is possible to emphasize the dark zones with fine lines that leave sufficient space so that the background appears clearer. The charcoal point is used to start drawing some of the tree branches. Once again the charcoal is held flat and soft dark strokes are made for the foliage on the right-hand side.*

> If any area needs to be erased, a cotton cloth may be used, rubbing it gently over the drawing without pressing too much. However, to restore the paper to its original white, it is best to use an eraser to clean the area.

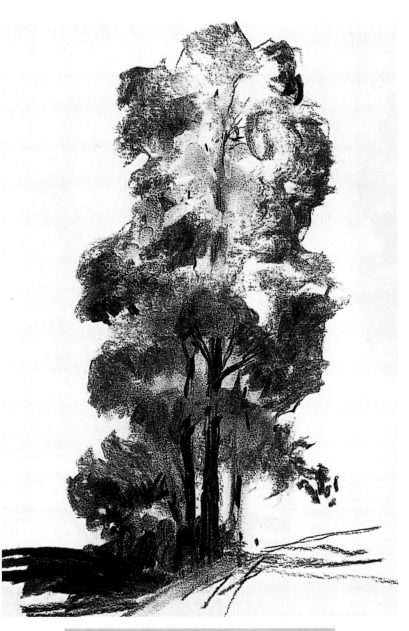

7. *Once all the elements of the tree are in place, the contrast at the top is intensified with the stick held flat and transverse. The lower shadowy part is emphasized much more strongly with firm strokes with the point. Finally, some very clean and separate lines are drawn on the right-hand side of the picture. These are the final details of this first exercise, which has enabled you to practice charcoal strokes.*

Since at this early stage you have little experience with the different strokes, it is advisable to practice them on a separate piece of paper before starting an exercise.

SUMMARY

On the top of the tree, a flat transversal stroke is used.

The tree outline has been done with the charcoal point, thus giving a clean and individual stroke.

To outline the trunk, the stick has been used flat and lengthwise. In this way the lines are straight and firm.

The shadow on the ground has been made with the point of the charcoal.

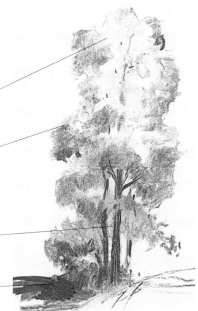

Composition and Planes in the Layout

COMPOSITION

Composition consists of creating a balance between the different elements of the picture. Composing is part of the layout, for it is in this first process that every part of the drawing is structured. When composing individual elements, the different proportions of every part of the model must be kept in mind. When composing a group of objects you must also observe their relative proportions.

In the previous topic we saw how objects can be represented schematically with simple lines, and how to create more complex forms on the basis of such outlines. The placing of objects within a group must be carefully studied in order to produce an aesthetic balance. This balanced placement of objects within the picture is known as composition. Good composition needs a fair amount of practice, although it is not the most complicated aspect of drawing. In addition to the placement of the objects, composition also involves separating out the different planes of the model; these levels are established during the layout process.

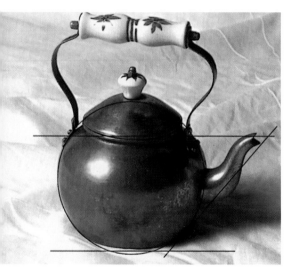

▶ 1. The composition of a drawing begins with the individual elements. Here the exercise is to draw a teapot, paying close attention to the proportions of the different parts.

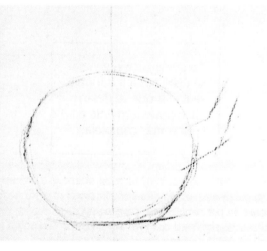

▶ 2. When drawing the body of the teapot, many beginners fit it into a circle. However, if you look closely, you see that its form is not circular, but a little flattened. The next stage of constructing the teapot is fitting the spout—it must be almost in the middle. The opening must be higher than the body of the teapot.

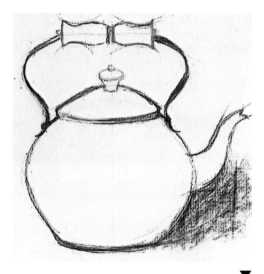

▼

3. Just as the distance between the spout and the bottom of the lid must be studied, the same must be done with the upper part of the handle and the base, allowing the lid and its knob to be fitted in and the right amount of space to be left blank. For this exercise, you can try out sketches and measurements on a separate sheet of paper.

▶ *This model can be fitted into an almost triangular form, the vertices of which are perfectly established by the elements in the corners. A triangular type of composition is very frequent and allows complicated themes to be resolved quite easily. As can be seen in this image, it is not advisable to lay out a still life or model with exact symmetry. A little bit of asymmetry always gives the picture an edge, making the composition more interesting.*

PLACING THE ELEMENTS

To situate the elements correctly, you must first learn to see the separate parts as if they were one. The layout process is a great help in developing this skill. This page contains three simple exercises, each composed of a variety of objects. Each image includes an outline of the overall shape of the composition. Try copying these outlines. If you compare the three, you will see that they all have two points in common: they are all asymmetrical, and none of them is perfectly centered on the paper.

▶ *When elements of a similar height are combined, as in this case, the composition is no longer triangular, but takes on a more complicated polygonal form. The scheme of the composition becomes harder work, and at the same time the number of reference points increases as they are the different vertices of the composition. When the proportions are transferred to the paper, it is important to bear in mind both the distances between the outer limits of the objects, and also the distance between these points and the edge of the picture.*

▶ *As can be seen in this example, any composition, however complex it may seem, can be schematized in lines that permit a rapid comprehension of the general form.*

1. A layout is the representation of a theme with straightforward lines that leave the model perfectly marked off. In the process, it is necessary first to observe the model carefully and then try to structure its form. Good observation is one of the principal foundations of drawing.

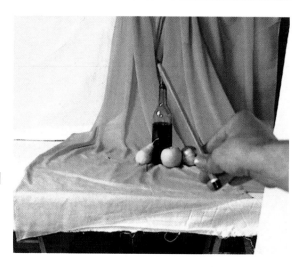

THE DIFFERENT PLANES AND PROPORTIONS

In the last section we looked at some compositions and their basic schemes. The composition of the objects in a picture is not limited to the layout of the external forms; this is only the start of the structure of the drawing. It is useful to remind ourselves of the first point of this topic, where the composition was structured within a concrete object. This same system must be used for the group of elements as a whole. We will now look at how to calculate the proportions of each one of the objects and planes of the composition.

2. The space can be divided up in several ways. It can be done using the real model, rearranging the forms of the simple elements. Once the model has been arranged, you can draw the framing, the composition and the layout, thus enabling you to pick out the composition lines. To appreciate this effect one eye must be closed.

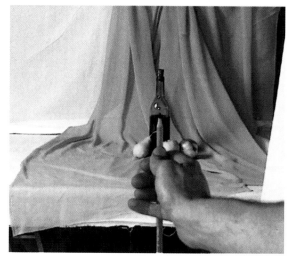

3. If you stretch out an arm and take the pencil or charcoal stick as a reference, it is possible to place the proportions on the paper with considerable precision. In this way the proportions between the different objects can be compared. This is how the distance between the base of the bottle and the top of the wine is established. In fact, the wine level is exactly halfway between the cork and the bottom.

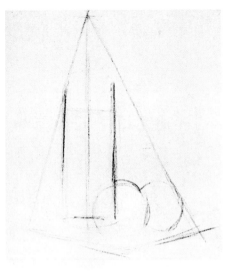

▶ I. *In this example, the scheme of the composition has a clearly defined triangular form. The base is not completely flat because the apple in the middle produces a new vertex that increases the dynamism of the overall form. The height of the bottle marks the vertex of the triangular form. This first stage is carried out with a flat lengthways stroke to enable the straight lines to be drawn as precisely as possible.*

LINES AND STROKES IN THE COMPOSITION

Once the model has been studied and you have been able to evaluate the structure of its composition and how the different planes are distributed, you must lay down the structure before you actually start doing the drawing itself. In the construction process, the general form has to be considered first, then the elements and the proportions. This page contains an exercise based on the model of the previous page. All you have to do is create a schematic for the composition.

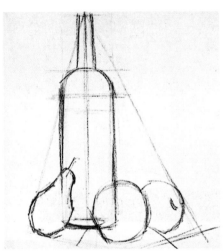

▶ 2. *Starting from the initial layout, you can establish the forms of all the objects. This time the drawing is made with the point of the charcoal to help you master the short stroke. Follow this method to outline the fruit. Once the scheme is set up, the lines that have been used for the layout and to compose the still life are no longer useful. Rub them out. Whenever forms or planes are superimposed on top of one another, they must be drawn as if they were transparent. In this way you can observe where every line starts and finishes.*

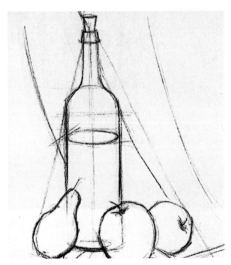

> The composition scheme of a model is a step that is quickly rendered superfluous as the drawing progresses. Therefore, it must be done with soft strokes, without pressing, so that it can easily be rubbed out when its function has been fulfilled.

▶ 3. *Once all the objects have been fitted into the layout, the lines have to be made bolder and the now unwanted guiding lines must be erased. All that remains to be done is to define the form of the curves and the interior lines of the bottle.*

Step-by-Step
Fruit and a Bottle

Throughout this topic you have studied different aspects of composition and layout. The composition of the elements that make up the model and the form of each one of them are more easily understood as they become more structured. This experiment goes further than the previous exercise on this topic. Although the elements are similar, the structure of each of them is studied in more detail, as is the superimposition of the planes that they occupy.

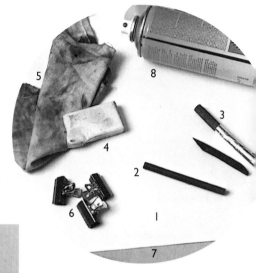

MATERIALS

Drawing paper (1), charcoal (2), pressed charcoal stick (3), putty eraser (4), cloth (5), clips (6), board (7), and charcoal fixative (8).

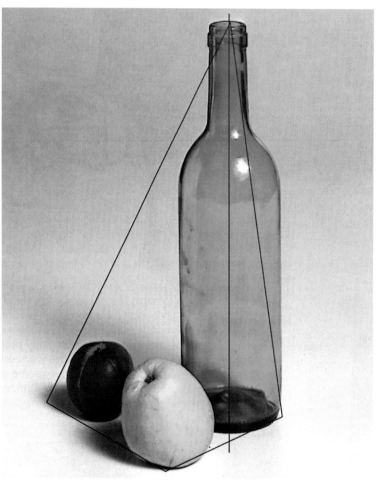

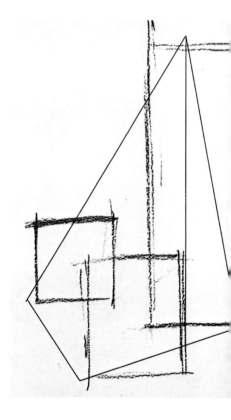

1. *The basic composition of this still-life is triangular. The bottle, slightly displaced to the right, marks the height that will serve as a reference for all the elements. Once the triangular composition has been absorbed, it is advisable to outline each of the forms separately, bearing in mind their placement and the distance between them. The base of the apple on the left is slightly higher than the bottom of the bottle. The apple on the right is interposed between the plane of the bottle and the plane of the apple in the background.*

28

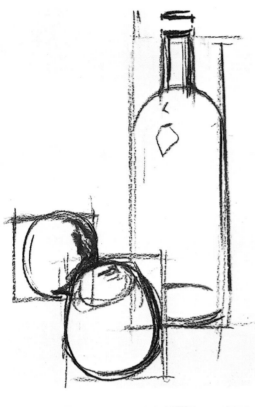

2. *The scheme of square forms used here gives a good approximation of what will be the definitive forms of the drawing. The apples are easy to do, starting from the squares that frame them. To draw the bottle, the semi-circular shape of the base of the bottle neck is outlined and then the entire neck is drawn.*

3. *Once each of the elements of the still life has been outlined, the dark areas and the details are drawn in. In the area close to the apple in the background, draw with the point of the charcoal. An energetic stroke gives a very deep black. Use a finger to rub softly until the form of the apple is filled in. Once again, the shadow is shaded. Use an eraser to create the shiny part of the apple.*

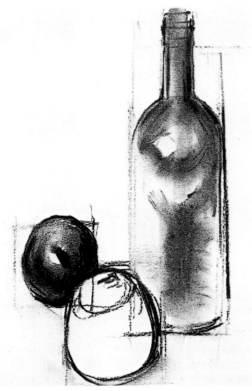

4. The outline of the bottle is made bolder, this time with much more definitive lines that make the neck longer and give it shape. A few strokes with the point of the charcoal are sufficient to darken the outline of the bottle. Smudge the inside of the bottle with charcoal-stained fingers, leaving clear the areas that appear brighter. In the midst of the dark area, an eraser can create a highlight.

5. *The staining of the apple in the foreground is completed with the fingers still covered in charcoal. This time the tone should not be too dark in order to achieve a contrast with the apple on the left. In this exercise the eraser is extremely useful as it enables areas that have been accidentally smudged to be cleaned up. Also, it can create highlights on a surface stained with charcoal.*

The composition aims at achieving a harmony between the forms and the space that they occupy. The elements must be placed in such a way that they are not too centered, too close together, or too far apart.

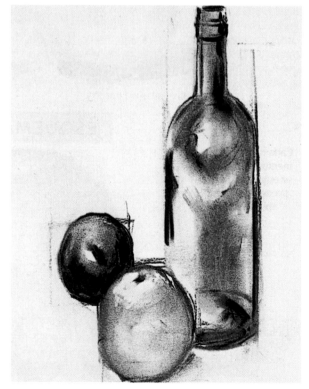

6. *If you do not want the drawing at this point to be spoiled by any accident, a fixative spray can be used to set it. Before doing this, you have to be completely sure that all accessory lines have been rubbed out, for once fixed, they cannot be changed. Once the drawing has been fixed, the strongest contrasts can be brought out on top of the previous work, on both the neck and the base of the bottle.*

The framing of the composition is of great assistance in settling the distribution of the elements of the model on the paper.

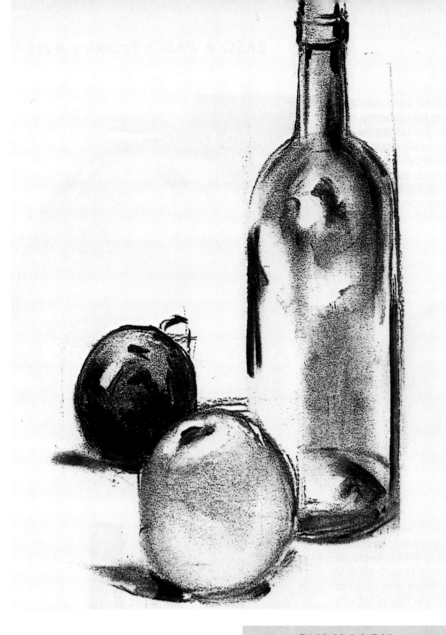

7. *On top of the apple in the foreground, some very dense dark patches are drawn so that it is perfectly separated from the plane of the first apple. These last very dense strokes are done with pressed carbon, which produces darker blacks than charcoal. Some dark spots can be made on the bottle by gently stumping with your fingers. Stain your fingers with carbon to do contrasts on the apple in the foreground and open up some shiny highlights. After drawing and stumping the shadows on the table, you will have completed this exercise.*

If you wish to prevent your charcoal drawings from becoming smudged or losing definition, you should spray the finished work with a fixative. This will preserve the charcoal and the drawing.

SUMMARY

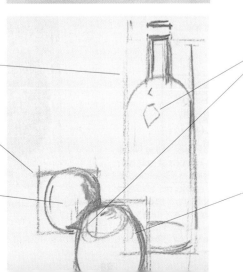

Each one of the elements of the still life is structured within **a rectangular frame**.

An eraser allows you to create selected shiny areas or highlights.

The base of the apple on the left is slightly above the bottom of the bottle.

The strokes are superimposed on top of each other while the composition planes are being constructed.

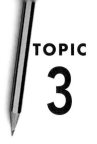

3 Drawing with Sanguine

SANGUINE: ANOTHER VISION OF DRAWING

A sanguine stroke will complement any other dry media. We are going to try a simple exercise to practice integrating sanguine and charcoal together.

Sanguine opens the door to endless tone possibilities, and its use is similar to charcoal. However, the results that can be achieved make it appear to be a different medium. A drawing in sanguine can be one of the most beautiful possible. The warmth of the sanguine stroke cannot be compared with any other drawing medium. Furthermore, both the mark of sanguine and its gradations combine perfectly with other drawing media such as charcoal.

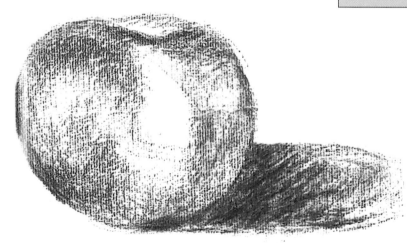

▶ 1. *The shape of this fruit is basically a circle, slightly deformed in its upper and lower zones. When the definitive line is started, with a fine but steady stroke, draw the little dip on the upper part. After outlining the nectarine, make the dark stains with the charcoal stick held flat between the fingers. In the left-hand area, the charcoal stick is not pressed very hard—it is only the start of the first tone. On the right, in contrast, the pressure is much harder. With a piece of sanguine the same size as the charcoal, flat between the fingers, stain the left-hand side. As you can see in this example, charcoal and sanguine are two media that can blend perfectly.*

2. The paper can be gently shaken in the zones where the contrast is too strong. Stump the darkest charcoal shadow with a fingertip. Finally, make the form more definitive using the sanguine stick and leaving the highlights white. The sanguine is used to intensify the reddish zone with softly insistent strokes.

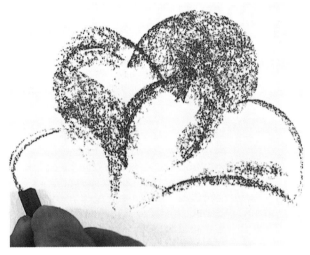

THE POTENTIAL OF THE STICK

Just like the individual elements, the overall effect of all the forms together has to be constructed observing the proportions between each of the parts of the objects. You will do three exercises for which the general form of the composition has been schematized. First, draw this outline on the paper.

▶ 1. *Break the sanguine stick. If it is new, break it roughly in the middle so that you have two pieces. Take the stick flat between the fingers and start to draw transverse to the stroke. As can be observed, the contact with the paper is different than with charcoal. Sanguine covers the paper with greater density and is slightly more sandy. overall*

▼

2. The stroke of the sanguine point is more precise than can be achieved with charcoal. Draw the lines that outline the leaves and the petals on the left. The stroke has to be made in one movement, without any breaks. If you use the tip of the sanguine stick you can achieve an effect quite similar to that of a pencil stroke.

▶ *3. Depending on the pressure of the sanguine stick on the paper, you can completely cover a zone and even close the pores of the paper. On the left side of the drawing, the background is covered with strong pressure by holding the stick flat. Sanguine can also be applied with a paintbrush. With a thick bristle brush, smudge all of the right-hand side of the drawing to produce a special effect.*

Topic 3: Drawing with Sanguine

COLORED PAPER AND SANGUINE

Sanguine has a warm and opaque appearance. It offers the same stumping possibilities as charcoal. This characteristic can be combined with colored paper to achieve a very strong integration of the drawing media. The tones of the paper can be perfectly combined with those of sanguine. In this exercise you are going to use sanguine and charcoal again, but this time on colored paper. Although the process is as straightforward as in the last exercise, the difference in the finish and the texture is evident.

◀

1. *This simple exercise consists of drawing a fruit with two tones: charcoal and sanguine. The initial outline is done in charcoal. The stick is used flat to do the shadows. The shadow stroke is easily done with the charcoal stick flat. Afterwards, drag a finger over the outline to blend the stroke into the paper.*

▼ 2. *Draw on top of the charcoal with the sanguine stick. The highlights of the fruit are left blank, so that the color of the paper remains visible. Use a fingertip to stroke the sanguine on top of the charcoal until the two tones are blended together. If the highlight has become covered, open it up again with the eraser.*

▼ 3. *The background is completely drawn over with a dense, closed black stroke. Now the fruit and the table on which it rests take on a considerable luminosity and volume. Darkening the background completely with charcoal makes the fruit stand out perfectly and gives it a more realistic volume.*

SANGUINE POWDER AND THE BRUSH

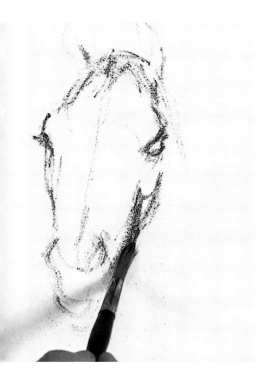

▶ **1.** *Sanguine can be laid down in a number of ways without losing the character it bestows on the drawing. In its manufacturing process, gum arabic is dissolved in water to make the paste that, when dry, becomes sanguine. If a stick is scratched or pressed strongly, it will crumble into powder. This exercise consists of working with sanguine powder and a brush. To ensure that the powder sticks to the paper it is necessary to dip the brush in water.*

One good method for getting very fine sanguine powder is to rub the sanguine stick gently with fine-grained sandpaper. The resulting powder can be piled up on paper and then picked up with a brush.

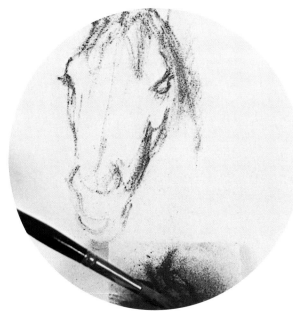

▼ **2.** *Use a bristle brush which you have moistened slightly so that the sanguine powder will stick to it. You can now start your drawing; begin by roughly sketching the horse's head, using very fine lines. The point of moistening the brush is neither to dilute the powder nor to wet the paper, but to ensure that the brush will pick up the sanguine. This means that any corrections can be made by simply wiping the drawing with a cloth.*

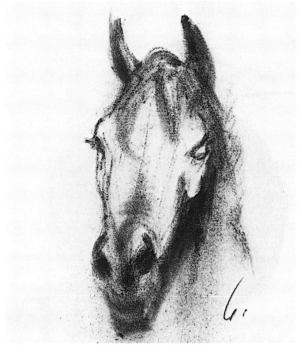

▼ *3. The lines that contrast the darkest areas are finished off. These strokes can be made with a somewhat wetter brush so that the sanguine is more dense on the paper. In any case, when the work is finished it is advisable to use a spray fixative to preserve the drawing.*

Step-by-Step
Layout with Sanguine

Sanguine is a drawing medium with a very varied potential. It allows the artist to make all types of strokes and stands out sufficiently even when the paper is colored. The range of possibilities that sanguine offers make it a particularly suitable medium for the following exercise, in which you are going to try figure drawing. As always, you must first sketch the layout, producing simple geometric forms which will then gradually take the shape of the model.

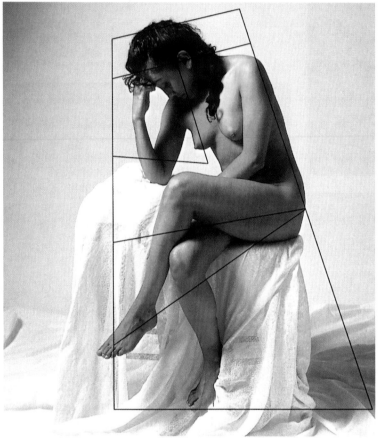

MATERIALS
Colored paper (1), sanguine (2).

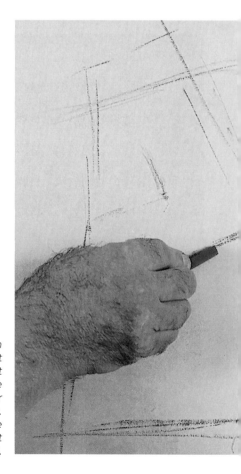

1. Before starting to draw, you should try to visualize the general shape in the simplest possible geometrical terms. What sort of outline would best enclose this figure? A straight line down from the arm appears to meet the foot; a straight horizontal line gives us the base of the figure; and the right side is closed off with a sloping line, giving us an almost triangular shape. These first lines are made with the edge of the sanguine stick. Once the external outline has been laid down, the internal forms are sketched in the same way; first the space between the arm and the right breast is schematized, and then the sloping line of the leg.

2. *After drawing the slope of the leg, do the same with the line that places the arm. In the upper part of this triangular layout, sketch in the shape of the head. As is evident, it too has a geometric shape. Having marked out the gap between the body and the arm, it is now easy to place the breasts and fit in the arm, which in turn will support the head. Now, using the point of the sanguine, outline where the thigh begins.*

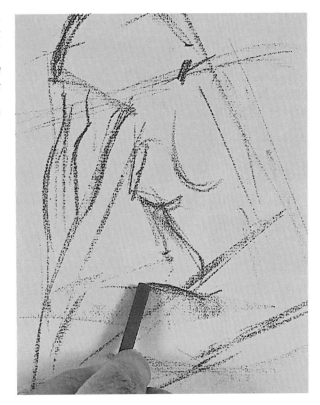

The lines that are put down on the paper are exclusively for construction purposes. Before making any other stroke, it is well worth going over the whole exercise and trying to match every line you have drawn with those of the photograph.

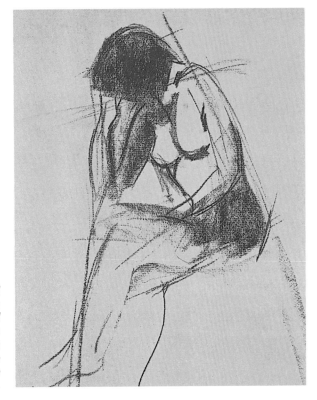

3. *The outline of the shape of the left arm is finished off, using as guides the inclined line that ends up at the thigh and the one which schematizes the right-hand side. The line that connects the beginning of the thigh with the arm marks the extension of the leg. Use a clean stroke to situate the leg that is resting on the floor. Use a bit of sanguine flat between the fingers to lay down the major shadowed areas.*

STEP-BY-STEP: Layout with Sanguine

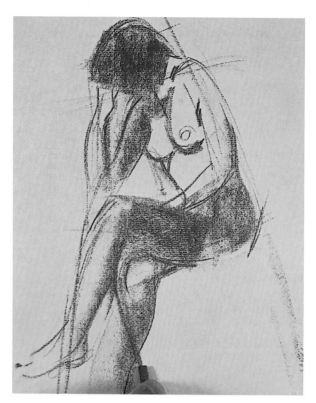

4. *The dark areas that have been drawn in the last step separate the different planes in the drawing, as well as give more body to the figure. With the stick flat, give more contrast to these dark zones, leaving the lighter zones unmarked. Observe how the legs are resolved; the knees are left as highlights. With the sanguine stick held lengthways, finish off the leg touching the floor.*

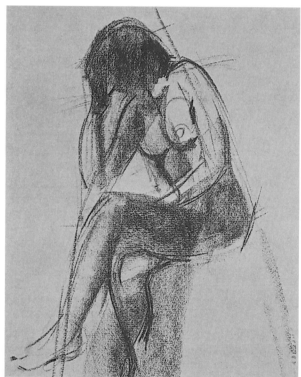

5. *The figure slowly takes shape. Any corrections necessary should be made as you go along rather than left until the end. It does not matter if different lines are superimposed on each other as long as this improves the general scheme and avoids confusion. By now the principal lines are defined. With the stick flat, some soft contrasts are drawn on the torso and the shadow beneath the body.*

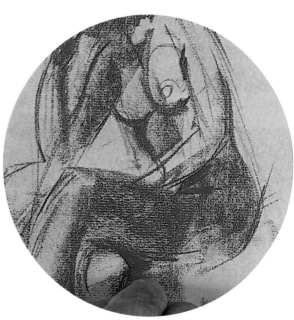

6. *This is how the point of the stick is used to create the dark zone on the crossed leg. When you do the densest dark bits, the medium and light tones become even brighter due to the contrast established.*

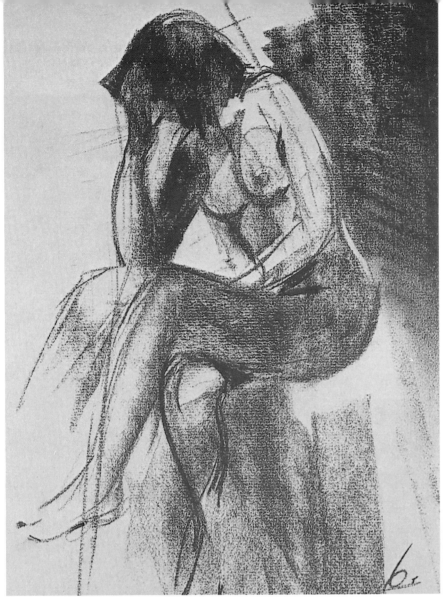

7. *The scheme of the figure is now completely finished. You can now make the lines that outline the arms and legs bolder with a much freer stroke. Use the point of the sanguine to intensify the dark zones and contrast the background strongly. This rounds off this figure sketch. As you have seen, the details have not been worked on. Throughout this process, the central idea has been schematization and construction starting from simple forms.*

As with any drawing medium, when using sanguine the basic work scheme must concentrate on the drawing as a whole. The details and nuances are left for a later stage in the process.

SUMMARY

The initial scheme fits the figure into an almost triangular form. This is made with the sanguine stick flat, in long strokes.

The maximum contrasts of the shadows of the figure are drawn with the point of the stick to achieve a better outline.

The first lines are always the most schematic. The lines of the leg, of the arm, and the gap between the arm and the torso allow the form of the figure to stand out more.

The shadows are marked with the sanguine stick flat. Different pressures give varying intensities to the different zones.

The Way They Painted
Leonardo da Vinci
(Vinci, Tuscany 1452–Le Clos-Luce, Amboise 1519)

A Kneeling Figure

Leonardo da Vinci is without doubt one of the most prodigious historical figures. He possessed all the qualities of an artist and excelled in everything: as a poet, scientist, musician, anatomist… No single label can define more than a part of what he was. As an artist he was outstanding in everything he did, but his drawing technique in particular marks him as one of the greatest of the Renaissance realists.

MATERIALS

Sanguine stick (1), sanguine crayon (2), black conté crayon (3), white chalk crayon (4), sepia chalk crayon (5), colored paper (6), fixative spray (7), and sticky tape (8).

This chapter presents a study of clothing. This type of exercise is undertaken by an artist to produce a three-dimensional aspect to the image on the paper through the study of light, the shadows, and the white highlights that allow the drawing to appear as if it were the real thing. Leonardo used these studies as the basis for later works in oil. Before starting to lay out the drawing it is important to study the model. This first analysis must be meticulous and thorough because it is the basis for placing the folds, the creases, and the structure that is formed by the light and the shadow.

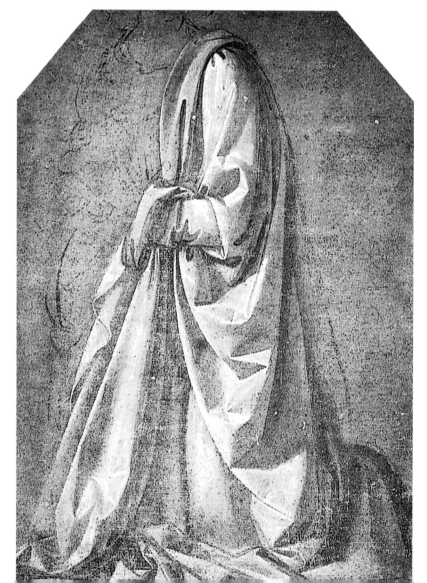

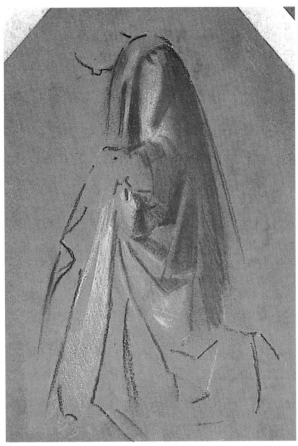

1. *Use the sticky tape to frame the space that the drawing will occupy. Once framed, cover the entire background in sanguine so that the brown tone of the paper is slightly altered. Moreover, there is another advantage: On top of the sanguine-stained base the other media will show up better and the tones will blend well. On this background, use the white chalk crayon to draw the general form of the cloth and then the principal lines of the folds. Go over the drawing with the conté crayon, making the darker lines more solid and shading the first dark areas in the upper portion.*

2. *The right side of the drawing is darkened with a soft stroke with the black conté crayon. Only the shadows of the folds are dark; the parts that must be somewhat more luminous are left alone. Not all the dark portions have the same tone. The sepia crayon is used to lay down the shadow areas in the folds where the arm is. Once the dark parts have been drawn, you can start to make the brighter contrasts. When the first white strokes are added, the cloth appears to take on a very realistic volume. In the upper fold the white is blended with the fingers, dragging part of the gray that surrounds it. Make an effort to give each stroke the same direction as the plane of its fold.*

You must bear in mind the value produced
when two simultaneous contrasts are yuxtaposed.
That is to say, when a very dark tone is next to
a lighter one, the medium tones tend to disappear
due to the strength of the other ones.

STEP-BY-STEP: *A Kneeling Figure*, by Leonardo da Vinci

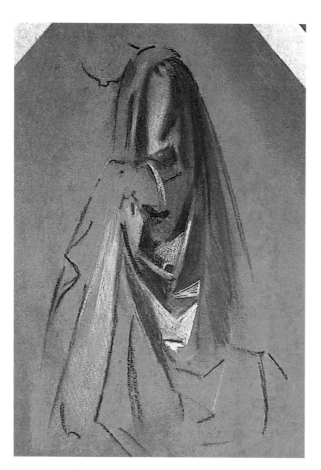

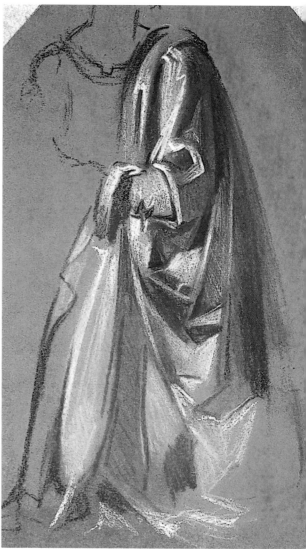

3. *The whites are drawn gradually, augmenting the intensity as the need for brightness increases. In the center of the clothing the presence of the whites becomes more accentuated. They do not necessarily have to be touching a dark shadow zone. The shadow bulge sometimes coincides with the background paper tone seen in the detail below.*

4. *The contrasts are increased gradually. They go from the subtle tones in the background right through to bright, direct highlights. In the upper part of the clothing, you can start to accentuate the sharp contrasts between the black tone of the conté crayon and the luminous white of the chalk. When you are drawing an area with a strong dark tone, the whites of the highlight must be balanced so that the dark part does not dominate. At the moment the medium tones are not very important. This structure of this drawing allows a precise study of the light, thanks to the way the dark contrasts have already been incorporated.*

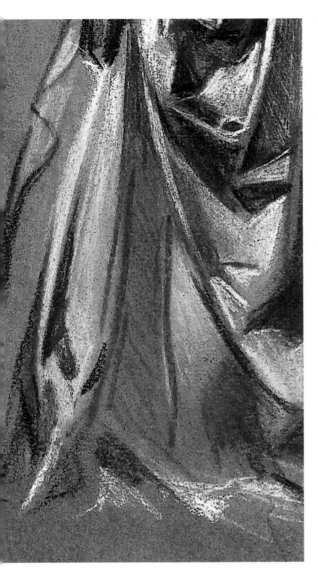

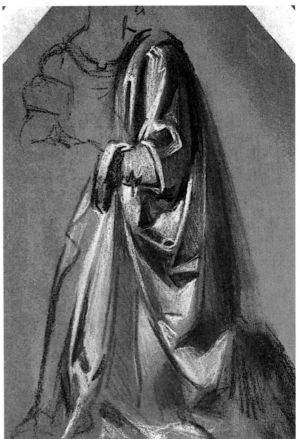

6. *Once again the contrasts on the right are increased and the drawing of the cloth is finished. This large dark area is produced with a soft stroke, avoiding the most luminous areas and blending into the background. The dark tone in the corner of the fold on the lower right side is laid down with more contrast in order to give it greater depth. The kneeling figure itself is sketched with a few lines.*

5. *When the whites in the lower part are too bright, it is necessary to tone them down with a cloth, softly flicking until the white comes off in the area of the central fold. This will be one of the most often repeated actions while working on this drawing: mute or intensify the tones depending on the overall effect that you want to produce. Use black conté crayon to produce the medium tones of the vertical fold. The stroke will be soft so that the paper is not marked. After the shadow has been drawn in, gently stump it with the sanguine of the background.*

Pressing down on the paper with the different media can completely block up the pores, making it impossible to gradate the tones correctly or to erase any mistakes. The shading must always progress gradually, enabling many tonal values to contribute to the richness of the drawing.

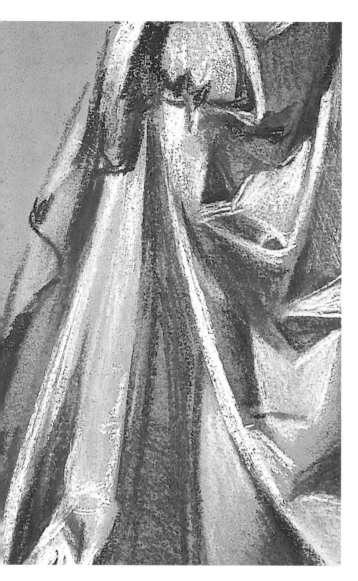

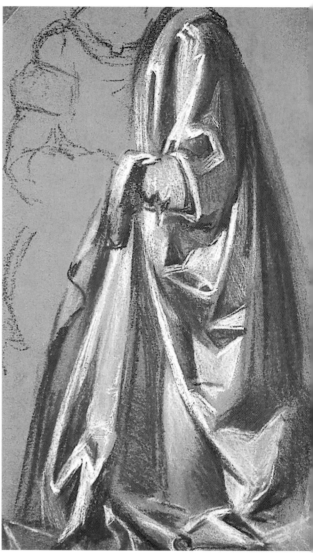

7. *In this close-up you can see how a few firm, clean strokes perfectly render the long fine creases on the left side of the fabric.*

8. *The medium tones of the shadows that must not be gray are gone over with the sepia chalk crayon. This tone integrates completely the hard contrasts produced by the conté crayon with the background paper hue. The shadows on the right of the drawing are softly blended into the background; their presence fades away.*

White chalk responds differently when it is used on top of a sanguine background, or when, as in this example, it is used on a black background.

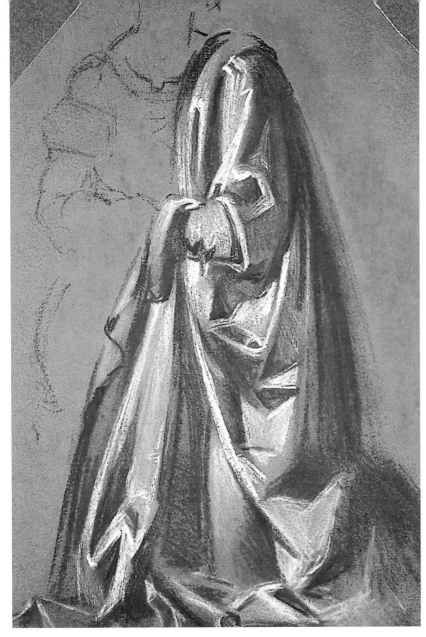

9. *The white highlights are drawn on top of zones that have been previously stumped. This creates different position planes of the fabric with respect to the light. Finally, some of the densest shadows are drawn with very defined strokes. All that remains to be done is to take away some of the presence from the outline of the kneeling figure. The drawing is sprayed at a distance of about 12 inches in order to fix it without the tones sticking together. This is the final touch to this study of clothing, an intense, but interesting, work for which we have applied a method not very different from that used by Da Vinci himself.*

SUMMARY

The study of the creases is begun in the upper shadow zone.

The background is covered with the sanguine stick which produces a tone that only varies within certain limits.

The half shadows are outlined in **sepia crayon**.

The lines are gone over in **black conté crayon**.

The white highlights give the right light to the creases and folds.

The Way They Painted
Michelangelo
(Caprese, Tuscany 1475–Rome 1564)

Studies for Sibila Libia

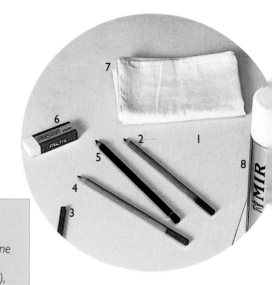

Like Leonardo da Vinci, Michelangelo was a principal figure in the Renaissance. Without him, our modern concepts of art would have been very different. Drawing is a basic way of studying and approaching an understanding of the world, as is evidenced throughout his artistic career. There is no limit to the magnificence of his work; in a true Renaissance spirit, he explored both the arts and the sciences, in all of which he excelled. The culmination of his great work was the Sistine Chapel, which he completed in a period of four years.

MATERIALS

Cream-colored paper (1), sanguine crayon (2), sanguine stick (3), sepia crayon (4), carbon pencil (5), eraser (6), cloth (7) and fixative spray (8).

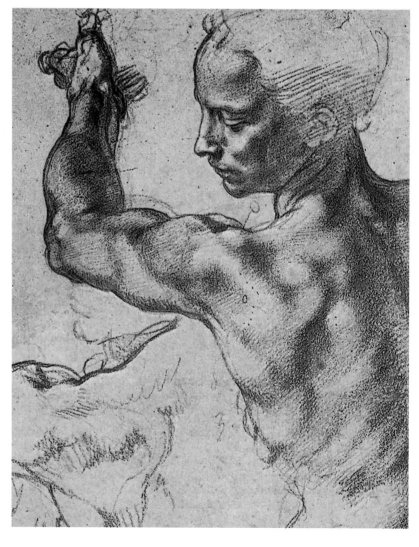

Drawing the anatomy was one of the fundamental interests of all the Renaissance artists. Studying the body and defying the visual laws are challenges that only great artists like Michelangelo have overcome. The foreshortening of the body consists of the presentation of a difficult pose, in which it can be seen how part of the drawing defies the paper plane and becomes a three dimensional volume. If you observe the arm of this figure, you can easily see this effect. It is a complex study that requires dedication and analysis of the model, but it is, without a doubt, one of the best exercises that can be realized.

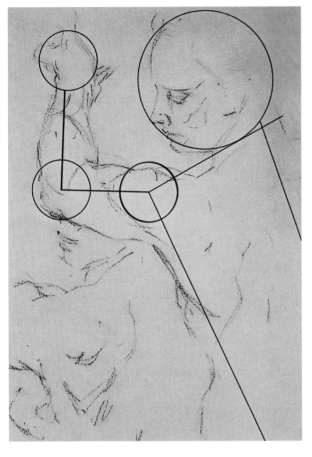

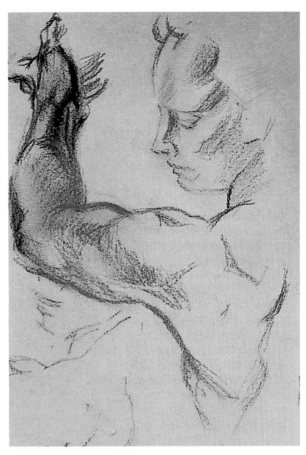

1. *The layout is the most important stage of any drawing. This is even more true for an exercise like this one, in which the main concern is the anatomy. The initial scheme can be analyzed in terms of simple, elementary forms. This is always a useful technique for sketching even the most complex poses. Here, the head is fitted into a circle. The line of the spinal column extends out from the neck; it definitively determines the form of the back. The joints of the shoulder and the elbow can be schematized starting from circles. On top of this scheme the entire outline of the figure can be constructed. Observe the pose of the arm: the forearm is further away. The foreshortening effect means that it appears smaller.*

2. *Once the initial outline has been laid down the principal lines of the anatomy can be reinforced. Start with the external lines in such a way that the structure of the figure becomes clearer. The shoulder blade is also solidified. The face is done with soft lines, the first objective of which is to mark out the principal dark areas. The aim is not so much to place the shadows as to outline the most illuminated zones.*

> You should never start drawing without having first done the layout. This is especially indispensable when you are working on human anatomy. The first step is always building up a coherent whole on the basis of simple geometrical shapes.

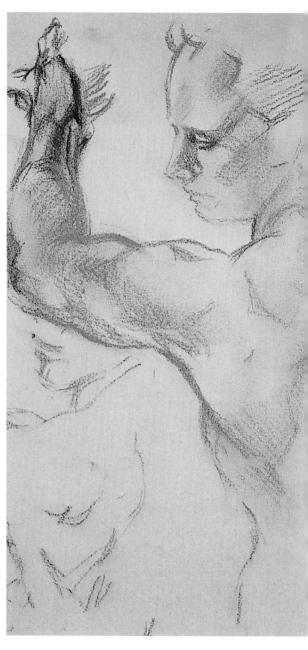

3. *The dark parts of the face are softened by stumping with the fingertips. The tone is integrated into the color of the paper. You should now concentrate on developing the arm. In fact, the arm will be the center of attention of this study. The musculature of the shoulder is modeled as if it were spherical, slightly tapering because it is tensed. The shoulder muscle is between the biceps and the triceps. This area is finished off by darkening the hollow between the muscles, while the parts with the greatest volume are left more luminous. The first contrasts are accentuated in the face, giving rise to the half-closed eye and the form of the nose.*

4. *Draw each area of the forearm in turn. The side section that runs to the wrist tendons is grayed. The muscle is rounded and given its characteristic form. The wrist tendon is drawn much darker. You must pay special attention to this zone because it gives real profundity to the foreshortening by defining an important separation between the lighted planes of the figure. The luminosity reappears in the work done on the hand, the fingers of which are barely outlined.*

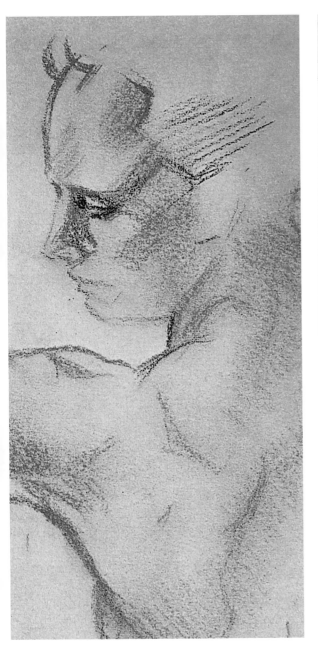

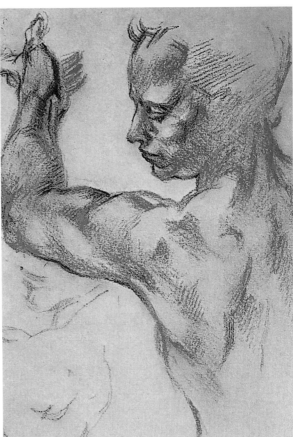

6. *Once the features of the face have been drawn, the shadows that define the different muscle groups of the back are realized. The spinal column is placed with a soft line representing its shadow. The same sanguine tone is used to draw the shadows of the shoulder and the shoulder blade. The darkest areas of the arm are reinforced with the sienna crayon, softening its tone so that it blends in with the sanguine tone and with the paper color which is now one of the most prominent hues.*

5. *The evolution of the face can be clearly observed. At this stage you should concentrate on the lights as defined by the shadows. The forehead is darkened with sanguine, leaving a highlight on the eyebrow. Another bright line is left on the nasal septum. The darkest parts of the face are worked with the sepia crayon, without pressing too hard. Soft strokes will allow you to match the tone perfectly. Deeper shadows are put in around the mouth, on the cheek and on the right side of the eyebrow.*

Complementary contrasts make shadows next to more luminous tones appear much denser. The same effect occurs with the luminous tones: if they are set next to shadows they seem more brilliant.

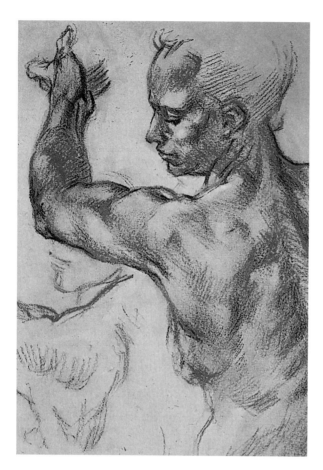

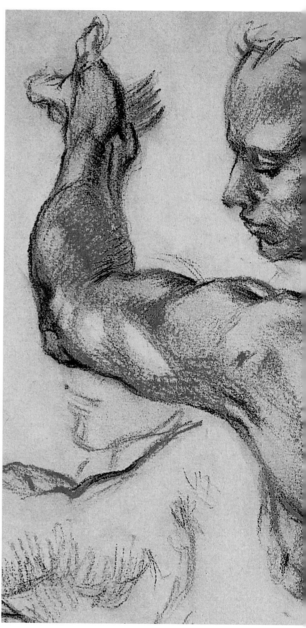

7. When the principal muscle groups are accurately placed, you can go on to put in the rib forms that start from the spinal column and thus finish the anatomical work of the back. Before drawing them, schematize their curved shapes. Starting from this scheme, it is much easier to place the shadows which define the form. First, draw soft strokes in sanguine. Once the principal mass is in place, you can use the sepia crayon. The carbon pencil is used for the dark reliefs in the most intense shadow zones. The function of the carbon pencil in this drawing is to round off the tone scale of the sepia crayon.

8. In this close-up you can see how the hand is dealt with. The dark tones are alternated with more luminous tones. As can be seen, the fingers are not drawn completely; instead, they are hardly outlined. In this area the stroke is particularly important, as by only varying the pressure can you make different aspects stand out.

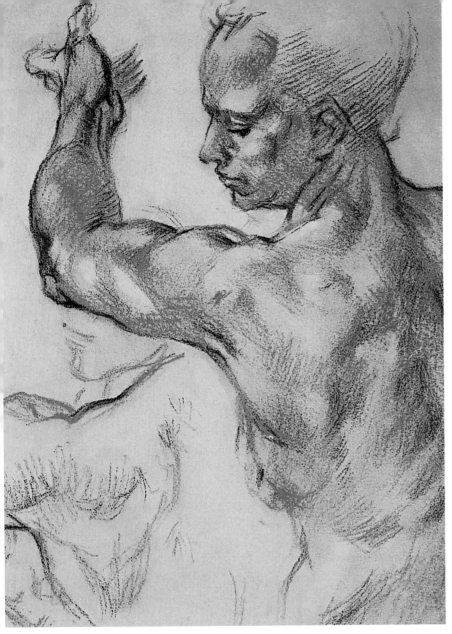

9. *The eraser is used to open up the most prominent highlights on the musculature; during the earlier work, thin gray layers have been created. The work with the eraser has to be very accurate, since too much highlighting will lessen the effect more than necessary. To finish off this study of Michelangelo's drawing, all that remains is to fix it. Spray it lightly once from a distance of about 12 inches.*

SUMMARY

The outline sketch plays a crucial role. It is best to base it on very simple geometric forms.

The shoulder musculature is a slightly elongated spherical shape.

The hand is only defined in its nearest plane. The fingers are merely sketched.

The shadows of the face outline the principal highlights and contrast strongly with them.

Starting from **the drawing of the spinal column,** the ribs are added. They are defined primarily by their shadows.

The Way They Painted

Georges Seurat
(Paris 1859–1891)

A Sunday Afternoon on the Island of La Grande Jatte

MATERIALS

Paper (1), graphite pencil (2), eraser (3), and a cloth (4).

Georges Seurat, together with Signac, created neo-impressionism. He developed the pointillist technique, as well as an extensive treatise on the theory of color. Seurat's work was a decisive influence on masters like Pissarro and Van Gogh; they worked according to his theories. He had many imitators, although none could match his mastery. He died young, at age thirty-two, however, his pictorial legacy made a great impact on later generations of artists.

It can be claimed that the pointillist technique was born from this piece. Pointillism consists of using tiny dots of different colors which combine at the retina to make up the hues perceived by the viewer. In preparation for this canvas, Seurat carried out many experimental sketches in which he examined the physical effects of light on each of the elements which would make up the composition.

This exercise is based on one of the preliminary notes for Seurat's most famous work. He was not aiming for great realism; his principal concerns were the composition and the light.

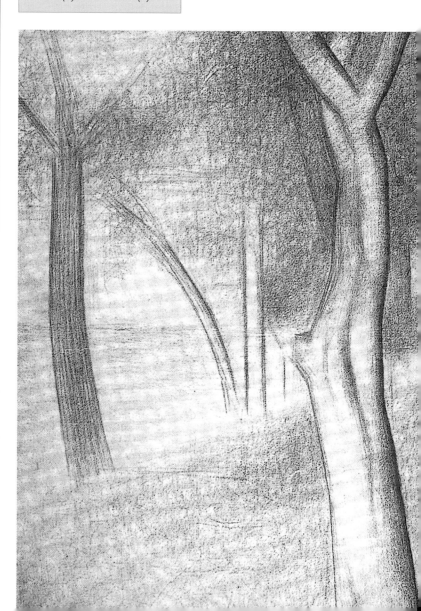

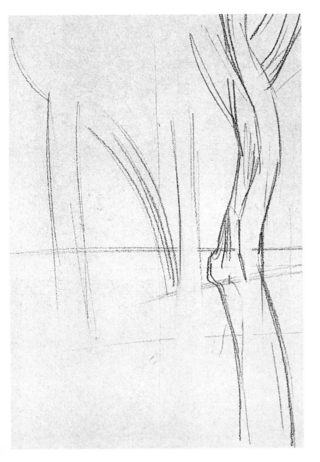

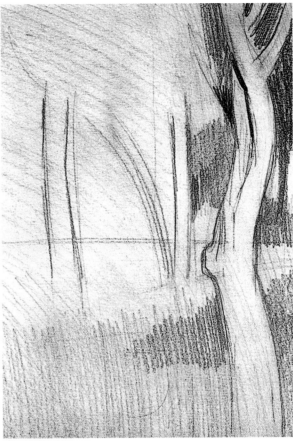

1. *To begin with, the principal sections of the drawing have to be defined on the basis of the horizon line. The first stage of the drawing is crucial for the rest of the composition because everything is going to be balanced around the horizon; it will be the equilibrium point. Once the horizon lines have been marked, the trees are drawn in. They are laid down at first in a very schematic way. When their placement is correct the drawing is reinforced with a much firmer stroke.*

2. *In this drawing the shadows must always be added progressively. Never forget the way Seurat built up his original study. When the tree trunks are perfectly laid down, then start on the first shadows. First comes the grass, with a long, soft vertical stroke. In this area a triangular shadow is created by increasing the intensity of the lines. There is a strong shadow in the upper part. It contrasts with the much brighter shape of the tree.*

When setting out a piece of work, instead of focusing on the details and the nuances, you must consider the overall effect of the elements and the light and shadow zones that come together. This will shape the way the work starts out and will help to decide the forms, establish the volumes and resolve the details.

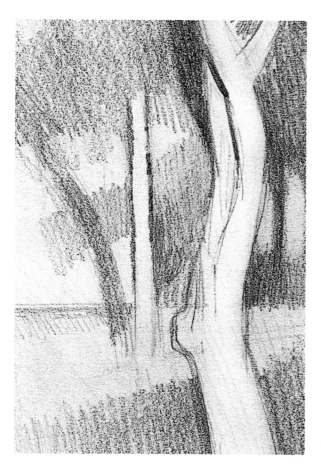

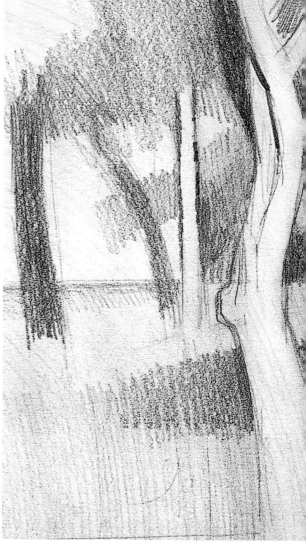

3. In this close-up you can see one of Seurat's fundamental interests: his constant reference to the effects produced among the contrasts in the drawing. Seurat studied in depth each one of the phases of his drawings. To this end he did many studies and sketches which he used for visual experiments, like the interplay between complementary and simultaneous contrasts. Observe the way this section evolves throughout the drawing process. The darker the tone around the tree is, the brighter it will appear.

4. The shadows made with the graphite pencil can be very deep grays, depending, of course, on the grade of pencil that is used and its pressure on the paper. In the early stages of the drawing we do not want the dark areas to be too intense. What is much more important is that the gray areas are laid down progressively. The trunk on the right is drawn in a dark tone, but without blocking the pores of the paper. The lines have to follow the shape of the trunk exactly.

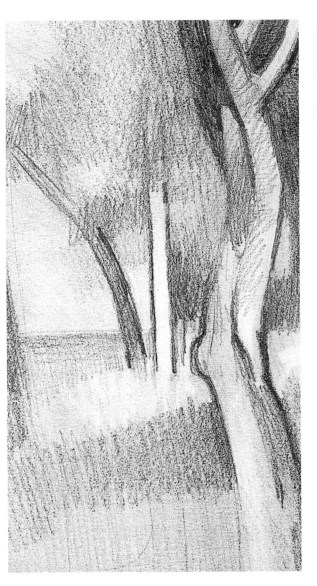

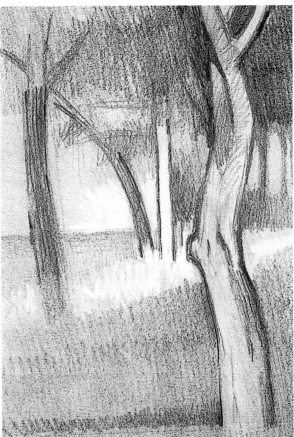

6. *The pencil stroke becomes more intense in the upper area. The result is a quite intense medium tone. Now all the intermediate section, and the tree in the middle, are the brightest parts. Before continuing, lightly smudge over the drawing with your fingers. As you are using a soft pencil you can achieve a very soft stumping. Avoid pressing down too hard so that the lines do not fade away. The tree on the left is drawn more firmly to suggest the texture of the bark.*

5. *The outlines of the trees are gone over with a soft but firm stroke. This can be repeated as often as necessary, until the desired tone is achieved. Not all the trees are outlined equally firmly; the one in the foreground is the most established. On this tree the first contrasts are realized, starting the stroke from the upper part. As this area is darkened, the contrast with the background decreases. This means that it is necessary to add more background to re-establish the contrast between it and the tree. The eraser is used to open up a lighter area on the grass.*

You should always use the appropriate materials for any drawing. For example, hard pencils do not allow stumping and the marks are difficult to erase.

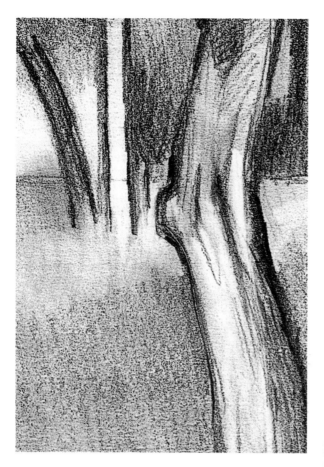

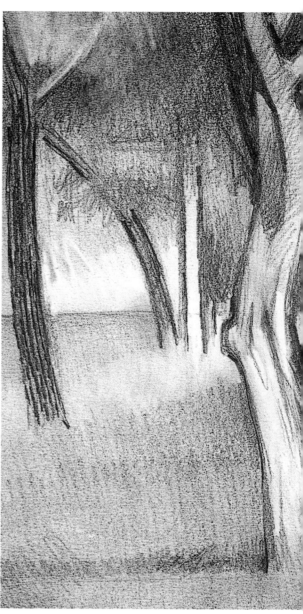

7. In this close-up you can appreciate how the bark texture of the foreground tree has been produced. The contrast is essential to achieve the required effects of light and shade in this area. The bark is drawn with dark strokes, not pressing too hard. They are then gently spread with the fingers, and then immediately next to each stroke a highlight is opened up with the eraser.

Using sandpaper on the point of your pencil will keep it sharp without constantly using to the sharpener.

8. In the tree on the left the contrasts are now made much more obvious: The strokes are darker and more linear. The contrasts must be applied to the whole picture. The upper area is darkened noticeably and then stumped with the fingertips. Also the texture of the foreground tree is begun. The shadow that this tree casts on the ground is drawn softly and firmly: the stroke should be steady.

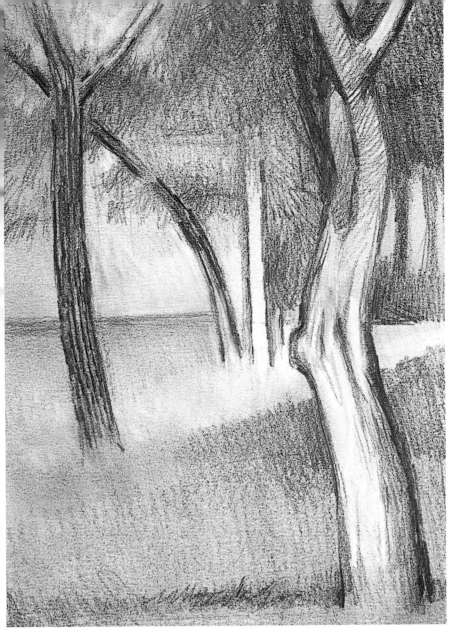

9. *The contrast in the foreground tree is augmented. The highest branch is outlined strongly until a rather intense black is obtained, but without completely obscuring the white of the paper. The right-hand side of this tree is also darkened. The highlights on the bark are made more luminous with the eraser. To add the final touches, continue perfecting the contrasts in all the areas of the picture: on the grass, on the background trees, and, very softly, on the left in the foreground.*

SUMMARY

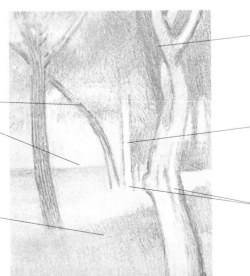

The composition scheme begins by separating the principal areas of the picture, which is then started with the horizon line and the trees.

When **the grays of the grass** have been diffused, the contrasts are again readjusted until a balanced interplay is achieved.

The first shadow outlines the shape of the tree in the foreground.

The tree in the middle is an interesting study of simultaneous contrasts.

The brightest whites are achieved with the aid of an eraser.

Mixing Color

TESTING COLORS

The palette should not be filled with excess paint. You should place only the colors you are going to use on it and in the necessary quantities. With only three colors it is possible to obtain all the colors of the rainbow and by extension all the colors existing in nature. Once you have enough experience in color mixing you will easily be able to obtain any color.

In this chapter we are going to outline the fundamentals of the medium. It is not difficult to start painting in oils, but the beginner does need some basic knowledge on how to mix colors. Before any artist begins to paint, he must arrange the colors correctly on the palette. Before going on to more complicated matters, it is essential to fully understand the rudimentary aspects of this art form. Here we will demonstrate how easy it is to blend oil colors.

▶ To begin, you will need the three primary colors: blue, reddish carmine and yellow. It is important to place these colors far enough apart so that they can be mixed conveniently. Remember that the better the quality of the paints, the better the results obtained. The palette you use must also be of good quality and have a varnished surface so that the paint does not penetrate the pores of the wood.

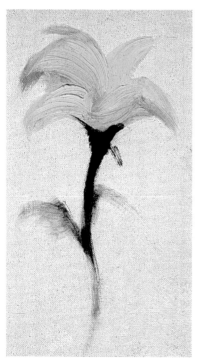

▶ 1. In order to learn about the possibilities of the oil medium, you should begin painting simple motifs such as a flower. Dip your brush in the yellow and paint several strokes in the shape of a fan. This is easy, isn't it? If you combine blue and yellow you get green. Now apply a new stroke of this color to paint the stem; if there is little paint on the brush, the marks of the hog's hair brushes will be left on the paper.

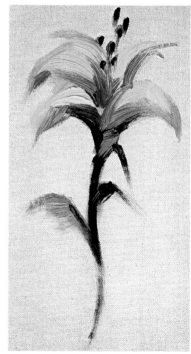

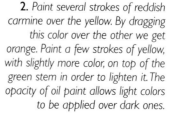

2. Paint several strokes of reddish carmine over the yellow. By dragging this color over the other we get orange. Paint a few strokes of yellow, with slightly more color, on top of the green stem in order to lighten it. The opacity of oil paint allows light colors to be applied over dark ones.

Having tried our hand at the first exercise, we will now attempt to work with more colors, since many tones are difficult to obtain with only the three basic colors. When inexperienced amateurs take up oil painting, they often arrange their colors randomly. This is a mistake; the order in which artists arrange their colors will make the task of mixing and applying either easier or more difficult.

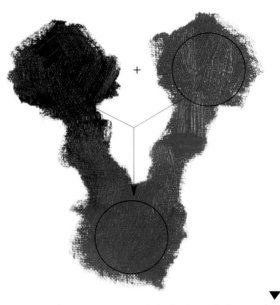

▼ This is a classic arrangement of colors on the palette: white should always be first, and in abundance; the other colors in ascending tonal and chromatic order—yellow, red and carmine; then the earth colors, such as ochre and burnt umber; last, green, dark blue and black.

▼

A common error made by beginners is the way they make luminous color. White is used to gray tones and to obtain highlights. Try the following simple exercise: lighten carmine by adding red and then darken it with white. In the first case, the result is a lighter but intense tone; in the second, a pinkish pastel tone.

▲

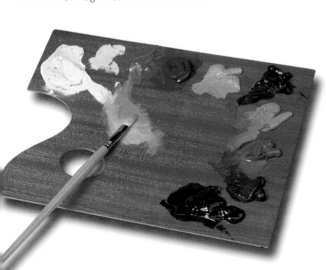

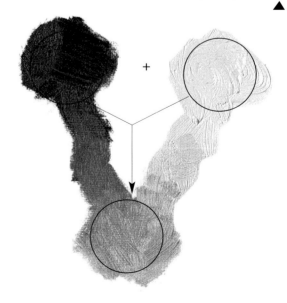

▼ The best procedure for obtaining correct color combinations is to drag a tiny amount of the first color to the center of the palette. Then drag the second color over it and mix the two until you obtain a homogenous color. Then you can add other colors to this mix to achieve the desired tones.

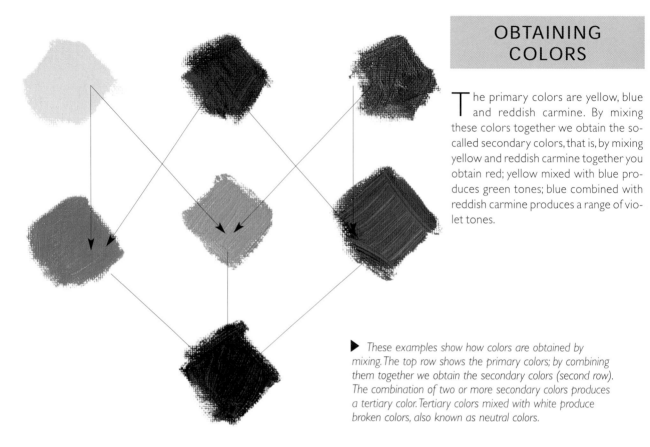

The primary colors are yellow, blue and reddish carmine. By mixing these colors together we obtain the so-called secondary colors, that is, by mixing yellow and reddish carmine together you obtain red; yellow mixed with blue produces green tones; blue combined with reddish carmine produces a range of violet tones.

▶ *These examples show how colors are obtained by mixing. The top row shows the primary colors; by combining them together we obtain the secondary colors (second row). The combination of two or more secondary colors produces a tertiary color. Tertiary colors mixed with white produce broken colors, also known as neutral colors.*

◀ *There is no precise color for painting an orange or a tree. Unintentionally, we tend to relate a color to a specific object. For instance, when we think of an orange, the first color that comes to mind is orange, but this is not altogether true. The color of any object is made up of many other colors; furthermore, the light that envelops an object makes a color tend toward one tone. The orange's skin may very well be orange, but only under certain conditions. For instance, placed next to a blue object, its shaded area will no longer be orange but will take on bluish and even violet tones.*

HARMONIC RANGES

Colors can be organized according to their range and tone. They are divided into three basic ranges: cool, warm and neutral. The colors belonging to the warm range are those that appear to give off heat, in other words, red, pink, carmine, orange and their mixtures. Other colors considered warm are earth colors, such as brown or ochre. The cool range of colors includes green, blue and violet. The colors corresponding to the neutral range comprise gray, or "dirty", tones that are the result of mixtures made on the palette.

▶ *Warm range colors are formed with reddish carmine and yellow, but by combining them with earth tones, an extremely wide range of tones can be produced. Therefore, the warm range of colors extends to yellow, orange, red carmine and the so-called earth colors: ochre, sienna, and burnt umber. Cool colors like green have been combined with red to make them warm.*

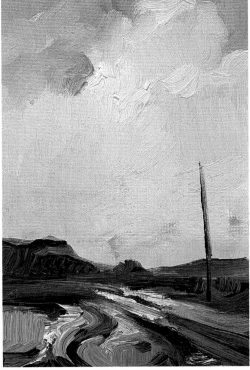

Neutral colors, also known as broken colors, comprise dirty undefined colors. When a dirty color is added to clean or pure colors, the result is a dirty blend but, when this range is used exclusively with neutral colors, a pictorial range of stunning beauty is achieved. A neutral color is obtained by mixing two secondary colors together and then adding white.

▶ *The basic colors comprising the cool range are greenish-yellow and blue; but if we combine them together, we can obtain a very wide chromatic scale. By combining different amounts of red, a range of violet tones is produced. Therefore, the cool range of colors comprises tones of green, greenish yellow and violet.*

Step-by-Step
Landscape with Basic Colors

With only three colors and white, we can obtain most of the colors existing in nature. To demonstrate this, we have chosen this cliff as our model. It is important to pay close attention to each step and not become discouraged. In the initial roughing out, the brush-strokes may appear awkward; but this is normal. If you carefully follow the instructions explained in each step, this exercise will be easy. Pay special attention to the color mixes produced on the palette.

MATERIALS

Palette, oil paints: white, blue, carmine and yellow (2), hog´s hair brush, (3) canvas-covered cardboard (4) and dippers: one filled with turpentine and the other with linseed oil (5).

1. First, dip the brush in turpentine and wring out excess liquid to prevent dripping. Then, using a little blue, begin to draw the brush over the canvas-covered cardboard. Paint the outline of the cliffs first. If you make a mistake, the oil medium allows you to make as many corrections as necessary. Paint the hollows in the clouds last.

2. *Blend a little blue and white together on the palette. The mix should contain more white than blue. A touch of blue is enough to give the white a cerulean tone. Always start in the uppermost part of the sky, where the white of the clouds is clearer. As the shapes of the clouds are defined, add a touch of reddish carmine to the mix; the tone obtained is akin to violet. Paint the darkest areas of the clouds with this tone.*

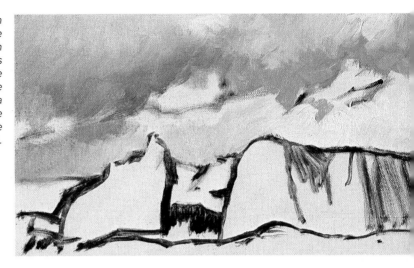

3. *By combining blue with white, we obtain a cerulean tone that is much darker and more luminous than the color of the clouds. This new mix does not include reddish carmine. Use this blend to paint the blue of the sky. Then, with an almost pure white, paint the tops of the lowest clouds. For the cliffs, start with a mixture of reddish carmine and yellow to obtain an orange tone, and then add a hint of blue to "break" the mix.*

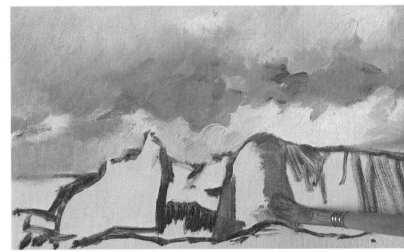

4. *Paint the right-hand side of the cliff with various colors obtained from mixes made on the palette: blue mixed with yellow produces green; blue mixed with reddish carmine produces a violet color with a tendency toward one color or the other, depending on the proportions used. By blending a touch of yellow and reddish carmine you can obtain red, but if the amount of yellow is increased, it turns orange. A touch of violet added to the green produces the broken color on the right-hand side of the cliff. To apply lighter tones to the left-hand side, first a yellowish green tone was created, to which orange was added . Finally, white was added to lighten the tone slightly.*

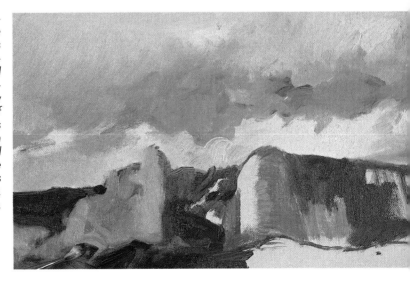

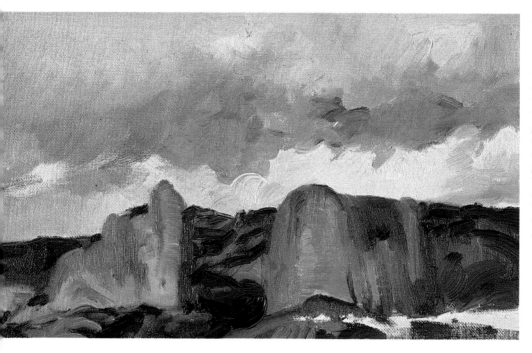

5. *In the previous step, we mixed broken colors together. The contrasts of the craggy cliff face should be painted with darker broken tones than the ones previously applied to each area. The brightest area of the cliff is painted with a pinkish tone obtained with reddish carmine and white to which a touch of yellow has been added.*

As the painting advances, the layers are applied more densely without adding any turpentine to the mix.

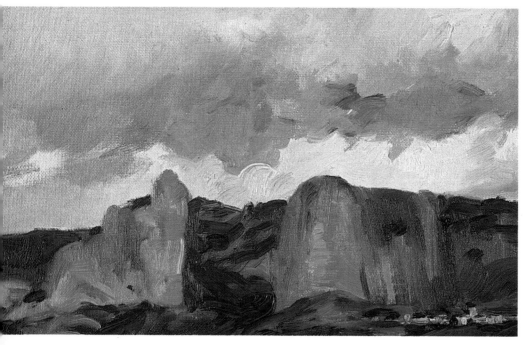

6. *The range of greens of the lower area is slightly broken. The first green has been obtained from green and yellow and blue, the result of a homogenous mix made on the palette; with reddish carmine and some white the color has been turned into an earth color. The tone varies in some areas, and is even mixed with blue. The houses situated below the cliff are painted with several small patches of white, dragging some of the underlying color with it so as to obtain slightly dirtier colors.*

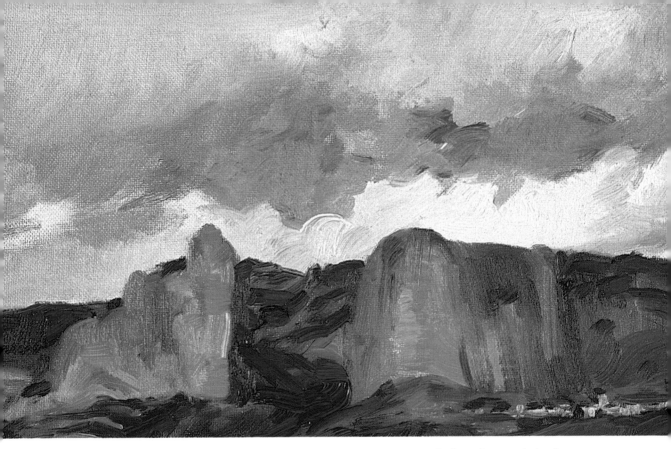

7. *All that remains now is to slightly increase the contrasts of the cliff with the darker tones. These same dark tones are used around the little houses, so as to make them stand out even further. This simple landscape shows you how easy it is to paint a picture based on mixes obtained from primary colors.*

SUMMARY

The whitest aspect of the clouds is comprised mainly of a large proportion of white and a small touch of blue.

The lightest tones on the right were grayed with white.

The greenish tones in the lower part were painted with blue, yellow and a touch of reddish carmine.

The orange tone of the cliff was painted with reddish carmine, yellow and a dash of blue.

The preliminary outline was painted in blue.

The village was painted with tiny touches of white.

The Brush-stroke

BRUSHES AND THEIR IMPRESSION

The impression or mark that paint leaves on a surface depends on the instrument used to apply it. In this chapter we will first deal with the effects of different kinds of brush-strokes and then move on to their practical use. As we have seen in the first section of this book, there are many kinds of brushes, each with its own characteristics and uses.

Oil paint is sticky to the touch, but it is also soft enough to mold with a brush. The paint saturates the brush and permits the tip to interact with the canvas in a variety of ways. A brush-stroke can create lines, smudges and a number of effects that, when viewed together, allow for numerous textures.

▶ I. *After dipping the brush in oil paint, place the tip on the canvas and spread the color over it. The length of the line depends on how much paint the tip can hold. For this reason, there are different kinds of brushes for different types of effects. This picture shows a line painted with a small, flat brush. Flat brushes leave a line with an even, regular edge.*

2. *In order to produce a smooth gradation between two colors, the two original colors must be kept perfectly clean and free of any other color before their edges make contact. This permits us to add several tones on top of the colors.*

▶ 3. *The two colors are blended by passing the brush several times over the two freshly painted colors. Use long strokes that merge part of each color onto the other. After several horizontal strokes, without adding more paint, the two colors will blend together in a soft, progressive gradation.*

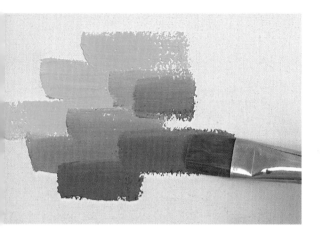

▼ 1. *This is a simple exercise that consists of practicing brush-strokes and changing from one color to another by adding a second color to the first on the palette. Paint a yellow line with a flat brush. Then add a bit of red to the yellow paint on the palette and mix them. With the resulting orange paint, apply another stroke on top of the first. Avoid using repeated strokes, which would start to pick up the color underneath. In this exercise, the brush-strokes should end straight. The procedure creates an accumulation of small strokes with decreasing amounts of yellow until they finally are completely red.*

THE USE OF BRUSHES

Some areas of a painting may require brush-strokes that allow the colors to blend, whereas others need brush-strokes that are superimposed on one another, leaving small clearly distinguished lines. These different types of lines can be painted easily if the correct type of brush is used. Some brushes allow you to rough out the surface with patches of color, and others with small dabs. Still other kinds of brushes are ideal for creating large, uniform surfaces. As we will see in this section, there are brushes for every type of line, and after all, lines are the main technique in painting.

> The brush-stroke can vary according to the thickness of the paint, the drag of the brush, and the condition of the underlying layers of paint. By taking these various factors into account, we can blend the different colors or apply them one on top of the other.

3. *Brush-strokes can produce an infinite variety of appearances depending on how the brush is applied over the colors. The line can be soft and barely show the grooves from the bristles, or the brush can be used to daub on blotches of color, as in this illustration. Here the strokes are small and pasty, and they are superimposed on top of one another.*

▲

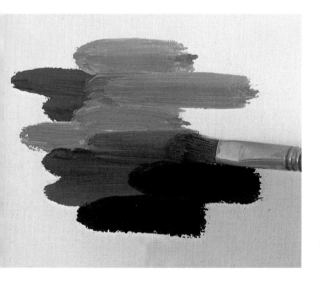

▼ 2. *These brush-strokes, painted with a filbert brush, end differently than the previous ones. This technique uses cool tones. First, paint strokes with blue paint that has been lightened by adding white on the palette. Paint dark blue over this without mixing the colors. From this point on, add new tones without mixing them with the previous ones. Compare the results of this exercise and the previous one.*

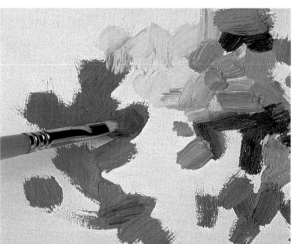

Topic 2: The Brush-stroke

STROKES AND PATCHES

Each brush has its own characteristics, which are expressed when the brush is applied to the canvas or on top of other colors. In this exercise we will use different techniques for blending colors, as well as a number of strokes, to create different parts of a painting. This simple exercise will highlight the uses of each type of brush in terms of its impression and how it is used to blend colors.

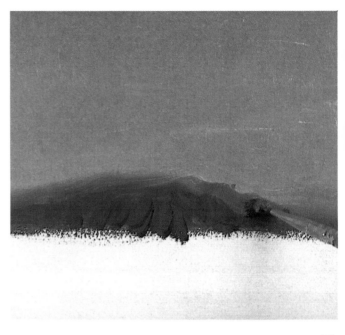

1. *The largest areas should be painted first. Before painting them, consider what the next color will be, so that the two tones can be blended or superimposed. When painting the larger area, keep in mind where the next color will begin.*

▲

▼

2. *Just as we blended the patches in the first part of the chapter to form a gradation, this exercise calls for a blend at the boundary between the two areas. To do this, use a medium-sized brush instead of the large one. This will allow a discrete blended area where one color mixes with the other.*

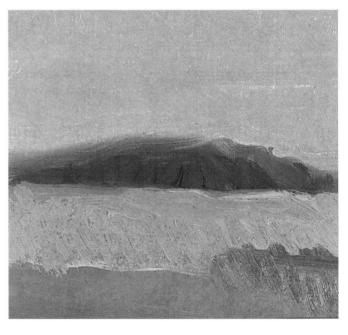

◀

3. *The foreground also has two colors, but there is no gradation between them. Not all parts of a painting require the same treatment; some require gradations, while others require the colors to be superimposed.*

▶ **1.** *Since the preliminary sketch reveals that the sky occupies a large part of the landscape in this composition, it should be painted with a large brush. With just a few brush-strokes we can cover this area of the canvas, including the contour of the sky above the mountains. Use long, uniform brush-strokes, and avoid leaving lumps of paint on the canvas.*

APPLYING IMPASTOS AND BLENDING

A brush-stroke can produce many different effects, depending on how it is applied across the surface and the amount of paint used. If we use thick brush-strokes on a freshly painted surface, the stroke will move some of the underlying color along the new line. If, on the other hand, the brush-strokes are precise and do not drag on the wet paint, there will only be a minimum of blending between the two tones.

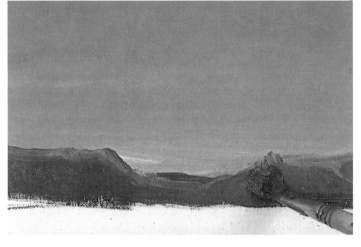

▶ **2.** *Any medium-sized brush is suited to this part of the painting. A flat brush or a filbert brush will work equally well. First, dip the clean brush into a bit of white paint and use long horizontal strokes on the blue background. Paint the mountains in the background with burnt sienna. Blend part of the blue paint from the sky into your stroke when painting the top edge of the mountains; this will add texture to the painting.*

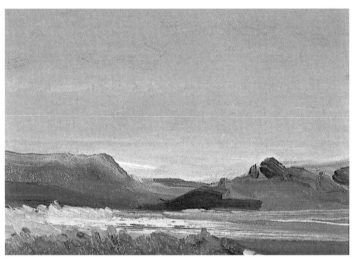

▶ **3.** *Use a small brush to paint the distant parts of the landscape. Combine green, yellow, and brown, and paint with long brush-strokes. By superimposing and dragging the brush-strokes, the tones and colors will blend. Paint the foreground in bright green, applying the paint with a medium-sized brush and using long strokes. This area shouldn't be covered with a thick coat of paint, but rather covered with color as quickly as possible. Add texture to the grass by using short, vertical brush-strokes.*

Step-by-Step
Fruit

Here is a simple exercise in terms of both drawing and composition. The shapes in this still life are all extremely simple and based on circles. The exercise allows you to practice with several types of brush-strokes and color. In contrast with the previous exercise, we will deal with the shapes and take a close look at the brush-strokes involved in a step-by-step analysis. In order to simplify this exercise, we will use a very limited palette of colors.

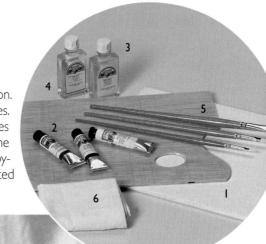

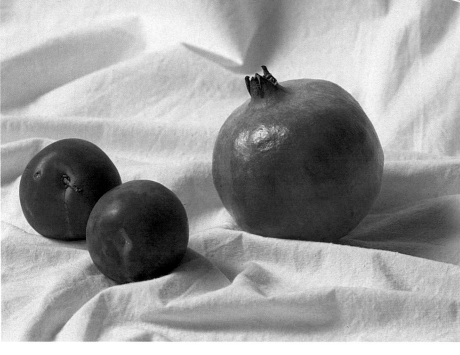

MATERIALS

Canvas-covered cardboard (1), oil paints (2), linseed oil (3), turpentine (4), paintbrushes (5), and a rag (6).

1. *Since the preliminary sketch of this still life is extremely simple, it can be drawn directly with oil paint instead of pencil. A more complex composition would require a preliminary sketch of the main contours using any type of drawing medium. Sketch the outlines with heavily diluted paint. Add the three pieces of fruit using quick, approximate strokes. There is no need to erase any mistakes: the lines can simply be covered over again.*

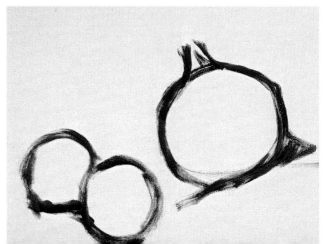

2. *Once the fruit has been sketched, we can start with the first colors. The first step is to color in the background. A neutral color is a mixture of the dirty colors on the palette. If the palette is still clean, it can be made by mixing green, umber and white. Paint the area corresponding to the shadow of the pomegranate and upper part of the plum. The most illuminated part of the pomegranate should be shaded with violet carmine, leaving the area of the reflection white.*

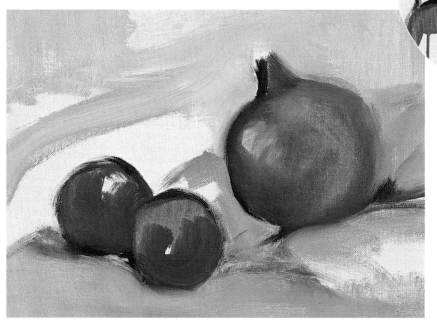

3. *The plums are painted with the same violet carmine that we used for the pomegranate. The gray area of the plum separates the two pieces of fruit. Run the brush over the pomegranate several times so that the colors blend. This will also give the fruit its spherical shape. Start painting the tablecloth with more white and violet carmine, green and blue, without letting the colors mix completely on the palette.*

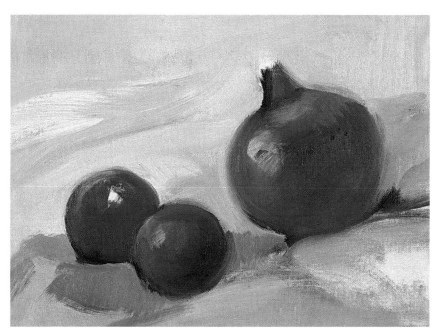

4. *Use curved strokes to bring out the spherical shape of the pomegranate. When the brush passes over the gray area the color will lighten slightly, as it removes some of the underlying colors. Now is the time to start separating the illuminated areas with touches of dark violet mixed with cobalt blue. Use this same color mixed with a bit of ultramarine blue to paint the foreground. These brushstrokes will also pick up some of the underlying color.*

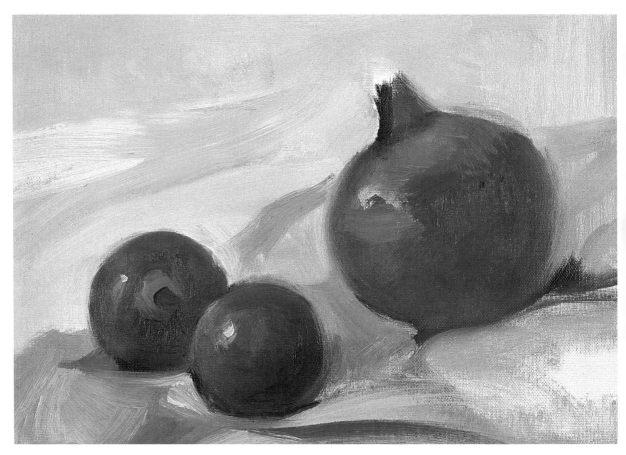

5. *Resolute brush-strokes of carmine should be applied to the plum on the left. The colors on the right side of the painting tend to be cooler and bluish, whereas on the right they are much warmer. The highlight should be the main reference for positioning the darker tones. The bluish tones on the brighter side should be slightly lightened with white. Paint the more illuminated parts of the pomegranate with violet carmine lightened with white. Bluish lines mark the folds on the tablecloth.*

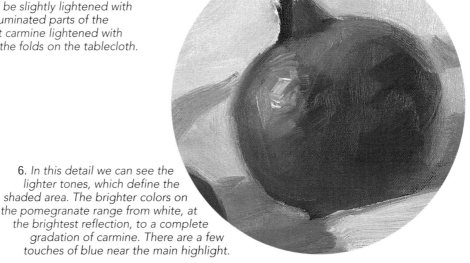

6. *In this detail we can see the lighter tones, which define the shaded area. The brighter colors on the pomegranate range from white, at the brightest reflection, to a complete gradation of carmine. There are a few touches of blue near the main highlight.*

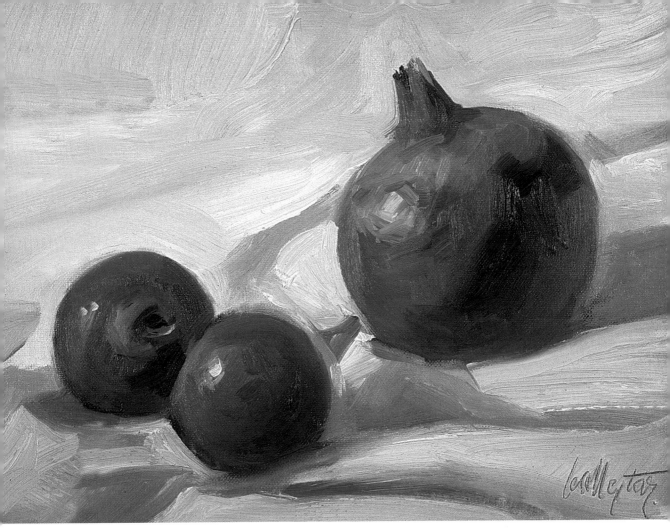

7. *On the pomegranate, the highlights can be enriched with tones of orange that contrast with the red and pure carmine. In order to do this without changing the color to pink, we use Naples yellow instead of* white. *The dark parts of the plums completely define their spherical shape. This puts the finishing touch on this exercise, which involves a great variety of both direct and blending brushwork.*

SUMMARY

The preliminary sketch was painted directly with a paintbrush and oils. The brush-strokes should be free and very diluted.

A very diluted grayish color was used to paint the plum on the left and the pomegranate. Some tones blend in this area.

The areas of reflection on the plums and the pomegranate were left unpainted so that they could serve as a reference point. The reflections are later painted with bright dabs of color.

The dark area of the plum was painted with dark violet and cobalt blue. Repeated brush-strokes were used to make the tones blend with each other.

Blocking in
and Planes of Objects

BLOCKING IN AND COMPOSITION: OIL PAINTS AND CHARCOAL

The blocking-in technique consists of simplifying the complex forms of a model. The first step is to look carefully at the shape of a model and try to find the simplest lines that could define it. In these exercises we will see how different motifs can be developed by blocking in their essential lines, and how objects can be understood through simpler elements.

A painting should be understood as a succession of objects located on different planes, even though only a couple of them need to be shown. When composing a painting, it is essential to observe the location of each element from the beginning. Representing a model in a painting can be a very complicated task if you start painting directly without previously blocking in the objects. The blocking-in technique allows the artist to synthesize the shapes of reality, transforming them into simple objects that can be easily drawn.

3. Once the main forms have been blocked in, you can start applying colors. This application is gradual and must conform to the way in which it was blocked in from the start. The nearer planes should be given more detail than the most distant ones.
▲

▼ *1. This sketch shows the logical location of the objects in the painting. The still life will evolve from these simple drawings. Each block will contain a fully developed element in the final painting.*

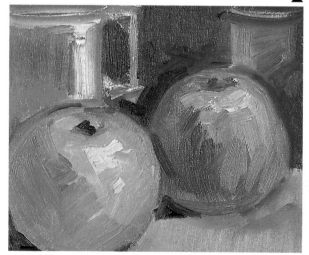

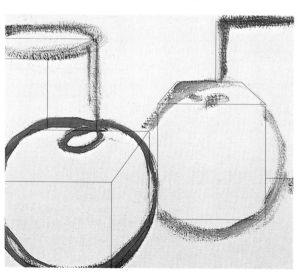

▶ *2. The still life will be based on the previous sketch. Start by painting the foreground, using a reddish color. The drawing technique should be fast and direct. Use a brush with turpentine to paint the first element: a circular shape that will eventually be a piece of fruit. The turpentine will help the color to spread quickly over the cardboard-covered canvas. Use an orange tone to draw another sphere in the next plane, slightly higher than the first. In the background, sketch in the containers in brown, using very basic lines.*

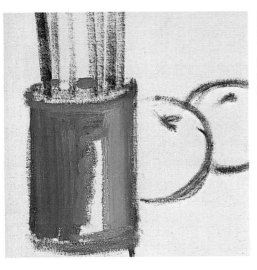

▶ **1.** *The first thing to do is to establish the shapes that make up the simple elements, such as a rectangle and two spheres. The foreground is always what determines the rest of the composition. The rest of the objects should be arranged in reference to this. Once the still life has been sketched, paint in the foreground. Different tones should be used for the other planes so that there is a contrast between the closer and farther objects.*

BLOCKING IN SHAPES AS GEOMETRICAL FIGURES

When painting with oils, an artist generally starts with the general and works towards the specific. In other words, the first strokes constitute a rough sketch of the basic shape, which will later be filled in with detail. The first colors applied are also general—the details are left for later. Blocking in and applying patches of color are two closely linked concepts in the evolution of a painting.

> The thickness of oils allows brush-strokes to create blends with only the color applied to the canvas. Having passed the brush several times over an area, it is possible to break the form of the background and make the planes of the shapes look as if they were out of focus.

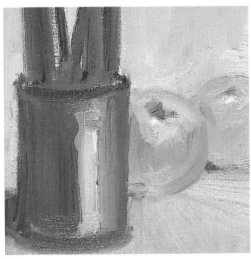

▼
2. *Thanks to the preliminary blocking in and the first applications of color, the object painted with oils can be outlined or suggested with loose strokes that mix with the background colors. Planes surrounding the foreground should be painted in clearly differentiated tones. The main subject should stand out against the background.*

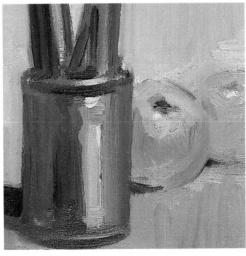

◀
3. *This exercise illustrates the importance of blocking in the first stage of the painting process. A sketch can sometimes be so essential that it would be impossible to develop the painting without one. Once you have applied color to the perfectly defined shapes, blur the profiles of the pieces of fruit in the background. This will increase the difference between the two planes.*

TAKING ADVANTAGE OF BLOCKING IN

B locking in is one of the most important aspects of painting. In fact, a correct blocking in procedure is the first step in any kind of painting, no matter what technique is being used.

This quick exercise deals with how to apply brush-strokes in the foreground after doing the main sketch. This will show how to take advantage of the sketch and develop it into a complete picture.

1. *After the main shape has been blocked, fill in the interior with the colors that will make up the color base. This will establish a clear difference between the areas of light and shadow. In this simple sketch, the areas of light remain unpainted.*

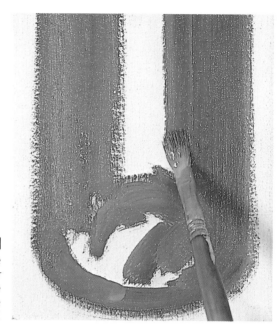

2. *On top of the first patches of color, apply short, horizontal brush-strokes to the front part of the object, which is also the brightest. It is essential to respect the shape of the sketch in spite of any modifications that may be made to the interior of the objects, since this is a detail of what might be a more complex still life. The preliminary sketch allows us to define each of the shapes and planes of the object.*

3. *The sides of the object should be painted with a long, vertical brush-stroke. If the contours and reflections of the object had not been previously sketched, it would have been impossible to develop the object freehand.*

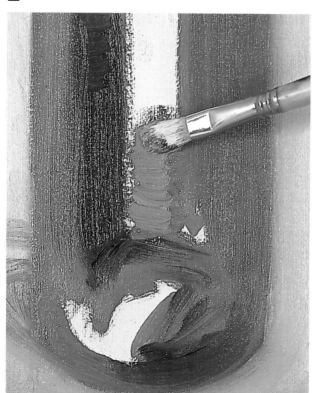

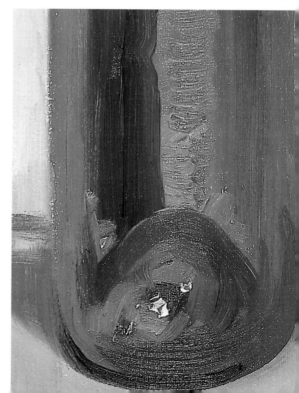

A SKETCH FOR EVERY METHOD OF WORK

The position of various objects in the painting allows the artist to assess the different possibilities in terms of the composition of the elements that make up the whole. How detailed the sketch needs to be depends on the precision each element requires.

▼ *1. The first sketch of this simple landscape allows us to put each element in its place and establish the various highlights.*

▼ *1. The most important highlights are treated with direct dabs of color or pure white. This characteristic will determine how the model is sketched. After sketching out the main shapes with free strokes, darken the background to isolate the main highlights, which in this case are focused on the objects.*

2. With oils, a light sketch is enough to sum up the shapes. The shapes in the background can be suggested with vague patches, whereas the contours of the objects in the foreground should be given more detail. The shapes in the background should also be smaller than those in the foreground. Shapes should be suggested with fresh, direct brush-strokes. ▲

▶ *2. The dark background painted in the first step of the sketch has isolated the main elements, perfectly defining their shape. The highlights are painted with free brushwork that does not mix with the underlying colors. Now the color and reflections can be established in the foreground. Sharp contrasts are created by alternating dark and light tones. This juxtaposition highlights both the light and dark tones.*

Step-by-step
Bottles with Tablecloth

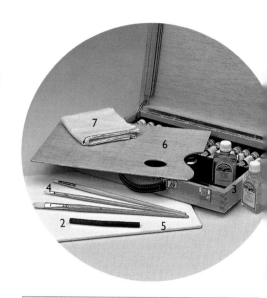

The sketch of the model is the first step toward the painting. Even the simplest subject should be prepared using this process, which consists of correctly positioning the main structural lines of the objects or shapes to be painted. Once the forms have been sketched, the closer planes will receive a more clearly defined treatment than the more distant ones. Each plane should be dealt with differently, in terms of both brush-strokes and color.

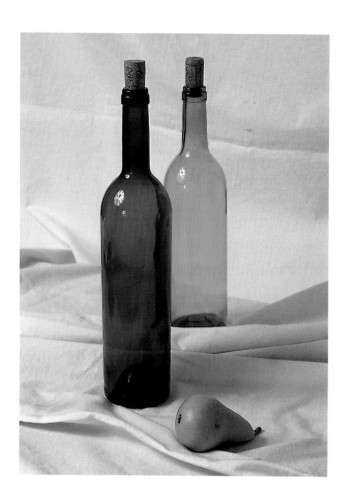

MATERIALS

Oil paints (1), charcoal (2), linseed oil and turpentine (3), paintbrushes for oils (4), canvas-covered cardboard, (5), a palette (6) and a rag for cleaning (7).

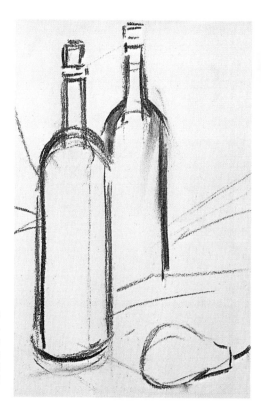

1. The first sketch distributes and positions the various elements in the painting. The main elements of this painting are the brown bottle and the pear. The green bottle is located in a more distant plane. The sketch should be concise, with only the essential lines. The shapes should be sufficiently defined with the strokes, since symmetrical objects like the bottle are always more difficult to draw.

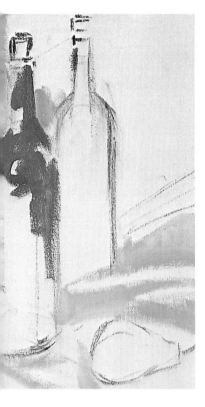

1. *Start painting the background area with blue mixed with a lot of white. The cloth in the foreground should be painted with a very dry brush, only suggesting the areas of shadow. Fill in the bottle in the foreground with a mixture of sienna and English red. This mixture should not be carried out on the palette, but rather on the painting itself, by dragging the latter over the former. When painting the bottle, leave the areas corresponding to the highlights blank. These areas will be painted later.*

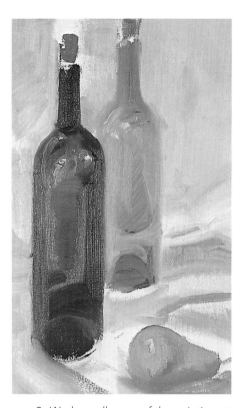

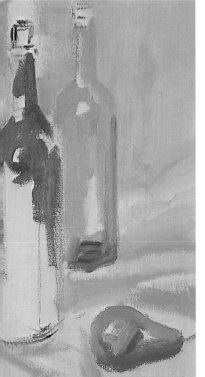

2. *Fill in the background with a bright mixture of cobalt blue, white, and Naples yellow. The neck of the bottle in the foreground should be painted with long, tightly-grouped brush-strokes. Use natural sienna for the central area of the bottle. Paint over the sienna with burnt umber, as well as English red mixed on the palette with some sienna. Then paint the pear in the foreground with bright yellow, Naples yellow, and green, using a purer green for the lower area. The bottle in the background should be less clearly defined than the objects in the foreground.*

3. *Work on all areas of the painting at the same time. Paint the center of the bottle using downward horizontal strokes which mix with the umber color from the previous step. The lower part of the bottle should be painted with curved brush-strokes that blend together with the previous colors. The bottle in the background should be painted in a similar way, but limit the tones to greens that have been mixed with a great deal of white and Naples yellow.*

When defining the planes, choose the colors according to the placement of each object in the still life. If the foreground is painted in dull colors, it would be illogical to use bright colors for the background.

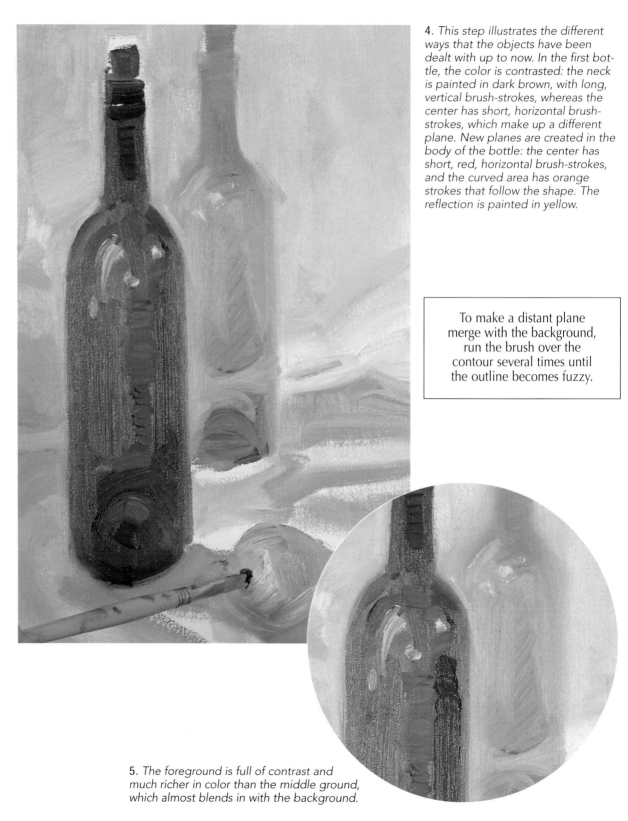

4. *This step illustrates the different ways that the objects have been dealt with up to now. In the first bottle, the color is contrasted: the neck is painted in dark brown, with long, vertical brush-strokes, whereas the center has short, horizontal brush-strokes, which make up a different plane. New planes are created in the body of the bottle: the center has short, red, horizontal brush-strokes, and the curved area has orange strokes that follow the shape. The reflection is painted in yellow.*

To make a distant plane merge with the background, run the brush over the contour several times until the outline becomes fuzzy.

5. *The foreground is full of contrast and much richer in color than the middle ground, which almost blends in with the background.*

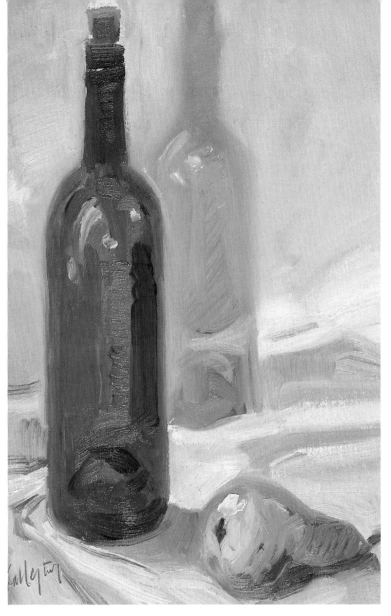

6. *Painting the tablecloth is simple, although the foreground requires more attention than the background. The preliminary sketch should have established the main lines, which will provide a clear path for the brush-strokes to follow. The light tones are much brighter and more pure in the foreground than in the background. Run the brush very lightly over the contours of the bottle in the background to give it an almost blurred appearance. This concludes this exercise in sketching and painting planes with oils.*

SUMMARY

The shadows and colors in the foreground are strong and contrasted, whereas those in the background are soft and tend to blend in with one another.

The highlights on the **main bottle** are painted with strong, bright colors.

Following the preliminary sketch, the contours of the bottle in the background are blurred, without a clearly defined shape.

In the background the colors tend to blend.

The tablecloth is more clearly defined in the foreground. The lines are more precise in this part of the painting.

The Palette Knife

APPLYING IMPASTOS

This topic provides several exercises to practice working with a palette knife. Even though the palette knife is nothing more than a steel blade attached to a handle, this tool can perform various tasks, such as laying on paint, modeling or applying small, thick quantities of pigment to the canvas (impastos).

The palette knife is a tool used almost exclusively in the oil medium. Its variety of uses makes it an invaluable tool for the artist and, though not as widespread as the brush, it can produce results that are just as interesting.

▶ The palette knife can be used to execute large impastos. The amount of paint needed must first be prepared before it is loaded onto the knife. Since oil paint does not shrink after drying, the form in which the impasto is applied to the canvas will remain intact after the paint has hardened.

◀ A color can be applied over another one in order to obtain unusual effects of mixed color. By drawing the palette knife flat over the paint with an even amount of pressure, you can create a smooth surface. Another layer of color can then be added. Thus, the texture created is smooth even though the colors will appear mottled and streaky.

▼ Textures like the ones reproduced here can be achieved with small quantities of paint. The most important aspect of working with the palette knife is the way in which the color is applied. Oil paint is very soft, even more so when it is manipulated with a metal instrument like the palette knife. The small amounts of paint can be applied consecutively, with soft touches that do not squash the color over the surface of the picture.

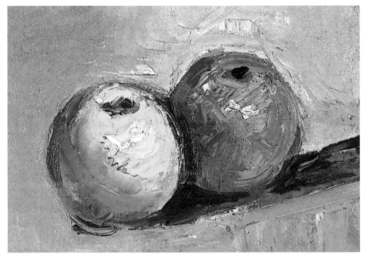

▶ **1.** *As a beginning painter, you may experience the following more than once: at a certain stage in the development of your painting you are no longer pleased with the results. You cannot remove the paint with a brush cleanly anymore because it will cause the color to expand and dirty the areas that you do not wish to alter.*

RECTIFYING

W ith oil paints, a color texture that is too complicated to correct with a brush is common. The palette knife comes in very handy for this purpose. The corner of the blade can be used to remove unwanted paint, provided it has not had time to dry. The following exercise demonstrates one of the various ways in which this tool can be used to correct an error.

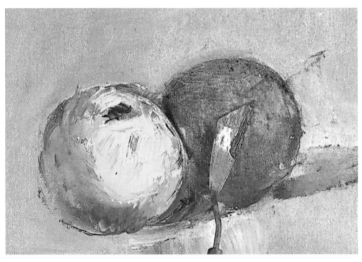

▶ **2.** *The palette knife is a perfect tool for removing paint cleanly from any surface. Just scrape away the unwanted color using the corner of the palette knife as often as necessary until there is no paint left in the zone. Once the layer of paint or the impasto has been removed, the surface is free to repaint without the danger of the previous color mixing with the new one.*

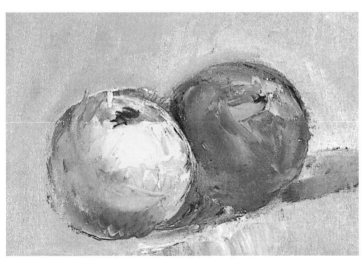

▶ **3.** *The use of the palette knife enables you to open up the necessary space in the right area, without affecting adjacent areas that are considered correct. It is easy to repaint the form over the clean area in oils. As you can see, the new applications of color have succesfully corrected the area in question.*

THE USE OF THE PALETTE KNIFE

The palette knife is easy to use and highly versatile—it can be employed in as many ways as the brush, although the impression it leaves on the support is completely different. This simple exercise will highlight the basic uses of this tool. The way paint is applied and dragged across the surface of the canvas is important, as is the amount of pressure applied to the palette knife.

1. This example demonstrates a simple method to obtain special effects using the palette knife. After scooping up a regular amount of paint, apply it to the canvas with the palette knife in long, sweeping strokes. It is not necessary to create thick impastos with the palette knife; the normal procedure is to apply the tool softly over a freshly painted surface.

2. The reflections on the water are painted by applying small touches of white with the palette knife. In this case, only the corner of the palette knife is used so as to leave just the right amount of paint on the surface. Compare this application of color with the one demonstrated in the last step; the texture of oil paint can be modeled very easily with the palette knife, often by dragging some of the underlying colors.

It is important to clean the palette knife thoroughly after each painting session. The best way to clean it, after removing any paint leftover, is by using a rag soaked in turpentine.

3. By holding the palette knife flat over the surface of the canvas, you can produce big impastos in the sky. As you can see, the application of one color over another always causes some blending. This allows you to obtain a variety of effects, very different from those produced with a brush.

THE TEXTURE OF OIL PAINT WITH THE PALETTE KNIFE

The palette knife is not only limited to a knife technique. It can be combined perfectly well with the brush-stroke. In fact, the palette knife is used exclusively to lend a specific texture to the painting´s finish. In this exercise you will learn how both techniques are combined; that is, by starting with the brush and then continuing on with the palette knife.

▶ 1. *The first step is to create the basic outline of the subject with a brush. As previously demonstrated, the first applications are diluted with more turpentine than subsequent ones. The brush is much easier to control than the palette knife, and thus allows the painter to obtain a more detailed base in less time. If you do plan on using the palette knife in your work, it is best not to apply thick impastos with the brush, since this is precisely what the palette knife should be used for.*

▶ 2. *Having roughed out the canvas with the brush, begin applying impastos using the palette knife. The techniques demonstrated up to this point can be used, but care must be taken when dragging the color, because if the initial applications are too diluted, it may be difficult to lay the paint correctly with the palette knife.*

▶ 3. *The finishing touches on the painting, as well as the textures produced in this case on the field, were done exclusively with the palette knife. This exercise demonstrates the wide range of techniques that you can practice in the following exercise using this implement.*

Step-by-Step
Landscape

Landscapes are the best motifs for practicing with the palette knife. They provide a space to work freely with impastos and dragging techniques. Unlike other genres, landscapes can be adapted according to the tastes of the artist. For instance, the color of the model and even the proportions of some of its elements can be changed without detracting from the final result.

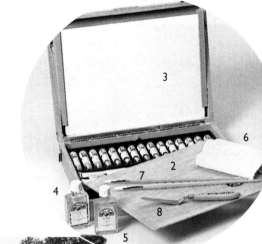

MATERIALS

Oil paints (1), palette (2), canvas-covered cardboard (3), linseed oil (4), turpentine (5), rag (6), brushes (7) and palette knife (8).

1. Before you begin painting with the palette knife, you must first rough out the most important elements using a brush thinned with a little turpentine. It is important that the brush be merely damp rather than wet, so that the color does not run over the surface of the canvas. The first impression left on the canvas should indicate clearly the main areas of the landscape. Its structure is very simple: above the line marking the end of the field, several dark patches are applied to indicate the area below the trees.

86

2. *Continue to use the brush, applying the colors with a little turpentine, but be sure to squeeze out excess paint with a rag before touching the tip on the canvas. The tones used in this stage include a wide variety of green tones. After filling in the background, begin work with the palette knife. Load some cobalt blue onto the tip of your knife and apply it below the trees to represent shadows.*

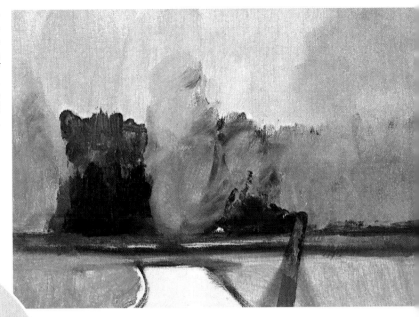

3. *After adding the dark tones that define the first contrasts in the trees, paint the lightest areas with tiny impastos. These new applications will blend with the underlying colors. Enrich the greens on the palette with tones of yellow and ochre. The dabs of luminous green painted in the foliage on the right are pure color applications. The palette knife can also be used to paint the sky, using the same color as before, this time thinned with turpentine.*

4. *Continue painting the trees with tiny impastos of yellow, green and blue. The various dabs of color create contrasts and differences in dimension. The darkest tones outline the lightest areas. Thanks to this contrast, the brightest areas can be clearly distinguished as points of light in the vegetation. Now we are ready to paint the path.*

5. *Paint the entire area with the palette knife; it should be applied much flatter in the field and path than to the texture of the trees. Using the same colors, shade the areas of foliage before defining the trunk.*

The most precise applications done with the palette knife are those that correct and form the details of the painting. For this reason, they are added toward the end of the session.

6. *Contrast the darkest areas of the trees with a very dark blue. Then use the tip of the palette knife to sketch the shadows on the field. The drag of the palette knife makes the blue mix slightly with the underlying tones. Once again, use the tip of the palette knife to scratch the surface of the still wet paint in order to draw the main branches of the tree on the right.*

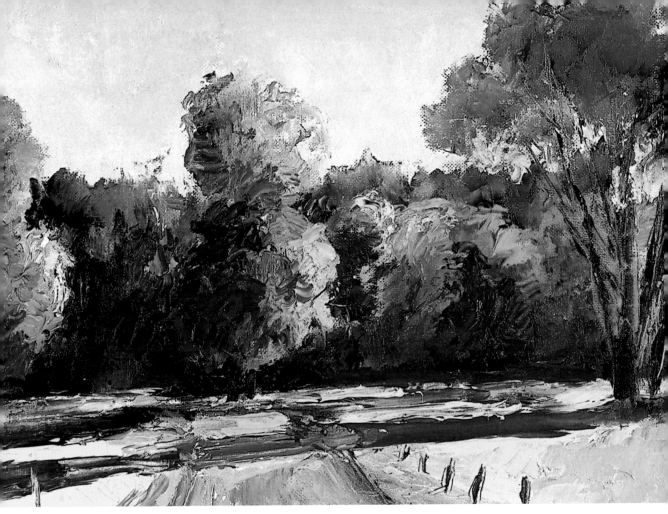

7. Apply the final contrasting colors to the trees. These dark areas bring out the most luminous tones. Paint the posts of the fence leading down the path with the tip of the palette knife. All that remains is to paint the definitive contrasts with the tip of the palette knife using dark blue.

SUMMARY

The preliminary outline is sketched with a brush dipped in dark blue thinned with turpentine.

The first applications of the palette knife define **the dark areas between the trees.**

The texture of the trees are created with tiny dabs of pure color.

The tree on the right is drawn by sketching with the tip of the palette knife directly on the canvas.

The path is painted with very flat and sweeping applications of the palette knife.

TOPIC

5 Applying the Color Base

COLORING THE BACKGROUND AND SUPERIMPOSING PLANES

Applying a color base is a simple way to obtain a background against which you can paint. It is always advisable to color the canvas with undefined brush-strokes prior to painting. It is essential, however, that these first layers, as well as the brushwork, be correctly applied. In this exercise we suggest a simple experiment: create a floral background and superimpose a flower in the foreground.

After the preliminary wash with highly diluted color, continue to define the forms and spaces. The opacity and texture of oil paint make this process a form of painting in itself, though still far removed from the perfection of the final product. There are as many ways to apply this color base as there are subjects; in this topic, we shall look at several of them.

1. *To suggest a plane of depth in a painting, an object in the foreground can be highlighted in perfect detail. This background of blue and crimson flowers toned down with white was created with free brushwork without detailing the form of the flowers; in this way, a background which appears slightly out of focus was obtained.*

▲

2. *Against this background, paint a flower with bright, pure colors that are not toned down with white. The brushwork suggests movement, as it has spread out some of the colors in the background. The preliminary application of the background provides a perfect chromatic base over which to paint the new lines that define the form of the petals.*

▲

90

▶ 1. *After drawing in the forms, begin to cover the canvas with paint. These preliminary bands of color are intended to cover the different areas of the painting as quickly as possible. It does not matter if this process covers up the original drawing, as this can be restored later. In any case, this preparation of the background should be done with fairly thin paint, so that the underlying drawing remains visible.*

The layers of color become more and more defined as the painting develops. The forms are constantly redrawn as the colors are applied to each of them.

▶ 2 *Every area of the painting, however small it is, should be painted in a particular way, working from the general to the specific. First paint the clouds, superimposing the color over the background with precise brush-strokes. The mountains should be painted with a certain amount of detail, though this is not yet the definitive layer, but instead will act as a base to which you can later add more detail. As you might expect, the colors become more and more defined, using an increasingly smaller amount of turpentine.*

DILUTED AREAS

Earlier we learned that oil paint should always be applied fat over lean; this allows artists to apply the first layers of paint very quickly. The preliminary coloring of the painting, lacking in detail, should cover the canvas as quickly as possible, establishing the main areas and overall color scheme. In such cases as this, the colors should be applied in large patches to unify the different areas of the painting.

3. *So far, no details have been added to this preparatory stage. Details should not be included until the background color has been fully established. First apply another layer of color to the mountains, including more detail in foreground. The shaded areas between the flowers should then be superimposed on the evenly shaded field. Once this background is finished, the group of flowers can be painted, using short brush-strokes.*

▲

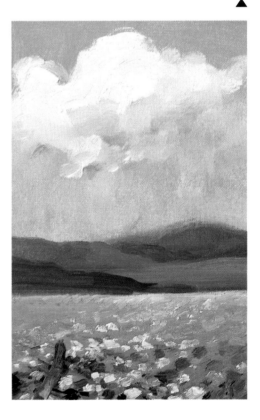

Topic 5: Applying the Color Base

BUILDING UP FORMS

Once artists know how colors interact, they can then apply them directly to the painting, so that these patches of color create the structure of the forms. This technique is applicable, above all, when the motif calls for a certain abstraction of form, such as a bunch of flowers, for example, in which the different patches of superimposed colors themselves create the form of the subject.

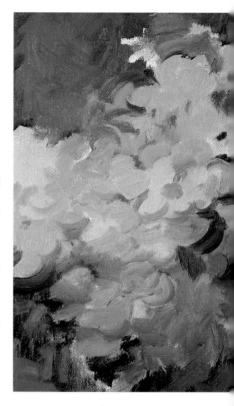

1. The first applications of color should be performed quickly, without paying too much attention to detail. The main aim at this stage is to cover the background with colors to provide a base upon which subsequent layers of color can be added. This process should be carried out gradually. In this exercise, the dimension of the subject is suggested by the more luminous tones.

2. All the work carried out during the preliminary stages of the painting is aimed at creating the tones and different colors over which successive layers of paint can be added later. During this process, the main colors merge together to produce new ones. These color mixes, created directly on the canvas, produce tonal variations within the same chromatic range—the cool range in this particular case.

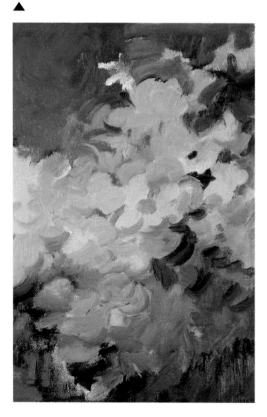

3. The contrasts painted over the luminous tones create the outline of the forms and intensify the details. These colors should be added gradually and should become more precise as the painting develops. They are then covered by new, denser brush-strokes. The same process should be used in any similar work. Detail should always be left to the final stage.

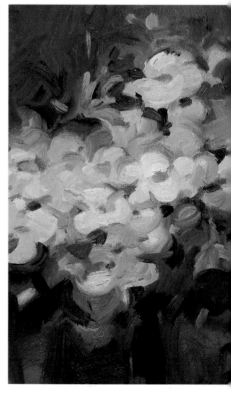

SUGGESTING FORMS WITH COLOR

A simple patch of color allows us to create forms which are not defined by the use of lines. A single brush-stroke is often all it takes to suggest an object or simply to enrich the canvas. This exercises shows that it is not necessary to paint objects or forms using excess detail; it is the context that provides the information necessary to understand the detail, without actually defining the forms or objects.

▼ 1. *In this exercise, the background has been covered with the colors that will form the base for subsequent work. During this preliminary stage, different shades of green should be used; this difference in tone helps to situate the two different planes present in the painting.*

2. *The color base sets the course for subsequent tones and colors. For example, the texture is suggested by the tones of the chosen range; this allows us to suggest forms in the bushes which would otherwise not stand out. It is not until all the colors are seen as a whole that the objects take on a recognizable form.*

▲

3. *The colors used as the base of this painting are primarily two tones of green. When red touches are added, they create a sharp chromatic contrast with the dark green. This red is too dark to be painted over the lighter green areas. To suggest the forms, the red used in these areas is much brighter. The contrasts in each of these areas should be balanced.*

▼

Step-by-Step
Landscape with Garden

The application of the preliminary color base should always be the first step. Sometimes, the base will be very general; other times it will conform to a perfectly defined structure. In this exercise, you can practice using different shades of color until the painting is considered finished. This model uses very simple forms, beginning with its symmetrical and elliptical composition. The real difficulty in a painting is often painting forms that require a high level of precision. The color sketch of the large green areas surrounding the pond provides an excellent base on which to work.

MATERIALS

Oil paints (1), canvas-covered cardboard (2), linseed oil and turpentine (3), brushes (4), palette (5), charcoal (6) and rag (7).

1. Start to block in the subject with a quick charcoal sketch. Then go over the lines with a brush dipped in black oil paint and a little turpentine to situate the forms within the frame. The pond is spherical in shape, though as a result of the perspective, it appears elliptical. Draw in the main shaded areas surrounding the columns, as well as the trees in the background. In this sketch, and in the following stages, all detail should be omitted. This stage can be completed very quickly, allowing you to situate the forms in accordance with the main contrasts in the painting.

2. *A large area of luminous green suggests the elements surrounding the pond. This process adds no texture or detail, as the only intention here is to cover each of the main areas of the painting. Painting quickly and freely, outline the forms of the trees to the right and shade the background with ochre.*

3. *The trees in the background should be painted in the same tone mixed with white. Once the background has been covered, new tones can be added and superimposed over the previous layers. During this process it is inevitable that the brush will pick up some of the underlying color. Add a more luminous tone over the ochre, mixing the new color with the previous ones. Many small brush-strokes can be applied around the pond to form the trees. These colors should be dark and opaque for the trees on the right, over which you may add several bright green notes.*

4. *Details should not be painted until the main forms of color have completely covered the background. After painting the treetops on the right, paint the shafts of light filtering through the foliage and between the tree trunks, superimposed over the large green area. Then continue to paint the vegetation on the left. After painting the grass with tiny brush-strokes, begin to outline the pilasters around the pond.*

5. *As the background is gradually filled in, new brush-strokes are superimposed to add texture or to correct errors. Although it may mix with some of the previous color, paint a vivid yellow over the brightest tree on the right; small, dark brush-strokes should also be applied to the area on the left.*

The paint and brushwork should have just the right thickness. Too much paint will spoil the finish in certain areas.

6. *The lines of color that form the columns should be retouched to give them the desired form; care should be taken not to color the inside of the pond, as its ochre tone should remain pure. Over the column in the background, a few red brush-strokes suggest the wildflowers. The base color of the background has to be completely finished before the details can be added.*

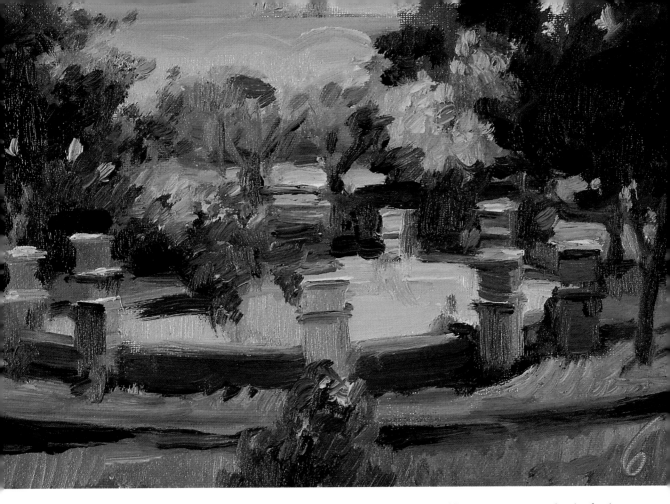

7. *Now paint in the definitive contrasts of the pond, first on the square columns, using blue and grayish colors for the shadows. No highlights should be added until all the details have been completed. The exterior of the pond should contrast sharply with the interior, which* *still possesses its original luminous tones. Make the final touches on the different contrasts on the ground and the vegetation in the foreground. Retouch the forms of the arches in the background and this will complete the exercise.*

SUMMARY

The colors should be perfectly distributed so as not to mix more of the underlying layer than is strictly necessary. The tree trunks are superimposed over the ground.

The red flowers are painted once the background is finished.

The first layers of paint should never be too pasty. Preliminary forms are painted with highly diluted paint, making no attempt to include any detail.

Several small contrasts can be added after the color in the background had prepared a sufficiently broad, stable base. Before painting the details of the trees, the trees themselves are painted using large, flat patches of color.

After the main colors have been applied to the background, it is possible to situate the forms in accordance with the contrasts they produce. The ground surrounding the pond is painted as one large swath of green.

Still Life: Glazes, Highlights and Shadows

TONAL WORK

The process of obtaining the right tones has been dealt with in earlier topics, but we must return to it, because the process of painting itself is largely based on this principle. It is not only important to learn to represent the highlights in a still life, but also to observe the model closely. This apparently simple exercise demonstrates one of the first mistakes beginners make when faced with a real model.

The still life is one of the most interesting subjects for learning the techniques of oil painting. The main interest lies in the study of highlights, shadows and the main representative methods. Some of the questions dealt with here can be applied to any of the other subjects in this book.

3. *The first brush-strokes are applied to the darkest shadow in this still life. When balancing the tones, artists do not usually use black as it reduces the shades of the adjacent colors. Instead of black, you can use burnt or dark umber. A more luminous note is added inside this dark area to underline the contrast.*

▶ *1. Before starting, study the model to see how the shadows define the different areas. Look closely at this apple and observe different light tones: a point of maximum brightness (1), an area of indirect light (2), a shaded area (3), reflected light (4) and the object's shadow (5).*

2. When creating the shadows, it is important to observe the model closely. Make a preliminary sketch in charcoal. After blocking in the form of the apple and the side of the box, draw in the darkest shadow. This is the shadow cast on the wall by the apple.

▶

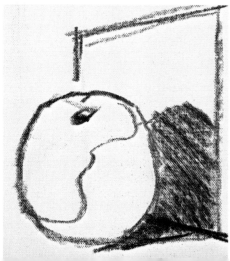

◀

4. Gently blend the light and dark areas together. The brushwork should shape the shadows depending on the plane in which they lie. These tones will merge delicately.

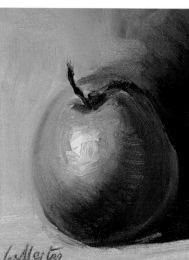

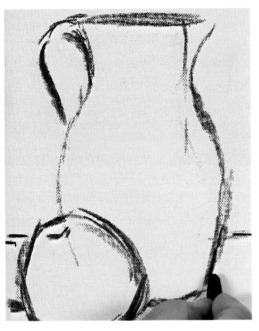

SHADOWS AND ATMOSPHERE

The range of possibilities offered by shadows allows the artist to create a very rich finish and lend the still life a certain atmosphere. This is done by representing the highlights of the motif in a very limited range of colors. Atmosphere is then created by representing the tones of light and shadow with a certain harmonic range of colors.

▶ 1. *Sketch the model using charcoal, which can be easily erased if you need to reposition the main elements. In this preliminary layout, define the forms of each element well so as to avoid subsequent mistakes when creating the shadows.*

3. *The highlights are precise lines or spots. The shadows are larger, occupying most of the painting. When painting the areas of light, bear in mind that the point of maximum brightness should be applied last. The colors of the highlights should be mixed on the palette, though they will blend with the intermediate tones when applied to the painting. A perfect sense of atmosphere can be achieved by using colors of the same range.*

▲

2. *Use burnt umber to paint the background against which the main forms of the still life will stand out. Use this tone to sketch the shadows of the two objects as well. Fading brush-strokes are useful for creating intermediate tones.*

▲

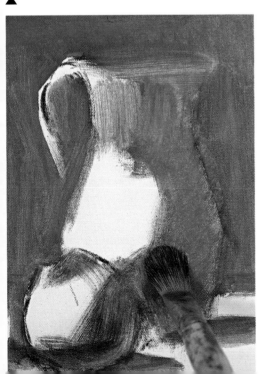

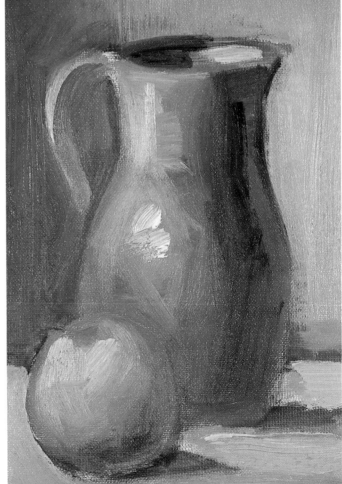

LIGHT AND SHADOW WITH GLAZES

A glaze is a layer of oil paint which is so transparent that colors beneath it will still remain visible. So far we have studied how to create shadows using tones that are darkened or gradated, but one of the greatest advantages of oil paint is its potential to be used as a transparent medium. This transparency can be used to create striking light effects.

1. As in all oil painting techniques, the first colors should be thinned down slightly. Each successive layer should be fatter than the previous one.

One way to obtain a glaze is to mix linseed oil, a few drops of Dutch varnish and a tiny amount of oil paint.

2. Glazes can be used in painting for different reasons, one is their transparency and luminosity, while dark glazes can be used to introduce modifications to the underlying color without covering it up entirely. Always apply glazes after the first layers of paint making sure, however, that these underlying colors are completely dry, otherwise the two layers will mix instead of being superimposed. Using semi-opaque cobalt blue, fill in part of the background; use the same color to apply a glaze to the shadow of the apple. This glaze should be spread out evenly over the painting with the brush to create a uniform layer.

SITUATING GLAZED TONES IN THE PAINTING

Using glazes is a slow process, as the color base of the painting must be totally dry. Nevertheless, it is one of the most interesting complementary techniques for creating subtle shadows. The tones of a glaze do not only affect those of the painting; they can also create a transparent atmosphere, interpreting the light that bathes the still life.

▶ 1. *Use a dark glaze to increase the contrast of the tones in shadow. If you apply another glaze over this one, their transparencies will reinforce one another. The resulting effect, however, is not one of greater luminosity, as this is obtained by using luminous colors. An additional glaze will add shades of the tones already present. A completely transparent color painted over a darker one will have no effect. Use a reddish glaze to retouch the shadowy areas on the right and obtain an intermediate tone.*

A good alternative for working with glazes is to paint the color base in acrylic since this dries quickly and is then ready for subsequent applications of oil.

▶ 2. *Create the volume by modeling the different tones created by the glazes. Add the highlights with direct touches of white and greenish yellow on the upper part of the apple. When these areas have dried, you can apply a new glaze to adjust the atmospheric illumination; this glaze should be a highly transparent blue. Reglaze the background to darken it and create a greater sensation of depth. Apply another glaze to adjust the shadow of the apple on the table.*

Step-by-Step
Still Life

As we have seen, shadows can be interpreted in different ways. Applying glazes is one alternative, although waiting throughout the process for the different layers to dry can be rather tedious. On the other hand, glazes are a means of extracting the full potential of oil paints to create shades of color and transparencies. To put this knowledge into practice, we now present an exercise consisting of a still life with glazes. We have chosen a model with an extremely simple composition.

MATERIALS

Oil paints (1), palette (2), turpentine (3), linseed oil (4), Dutch varnish (5), brushes (6), rag (7), canvas-covered cardboard (8) and container for mixing the glazes (9).

1. *First paint the dark area of the background to outline the more luminous forms in the still life. This dark color, a brown mixed with a little black, English red and cobalt blue, should be slightly diluted with turpentine, but not so much as to make it runny. Leave the lighter areas of the tablecloth unpainted and paint the dark areas with light blue and glaze of highly transparent violet. Do this by first applying the almost transparent cerulean blue. When this has dried, superimpose the violet-colored glaze. Paint the shadowy area of the pear green.*

102

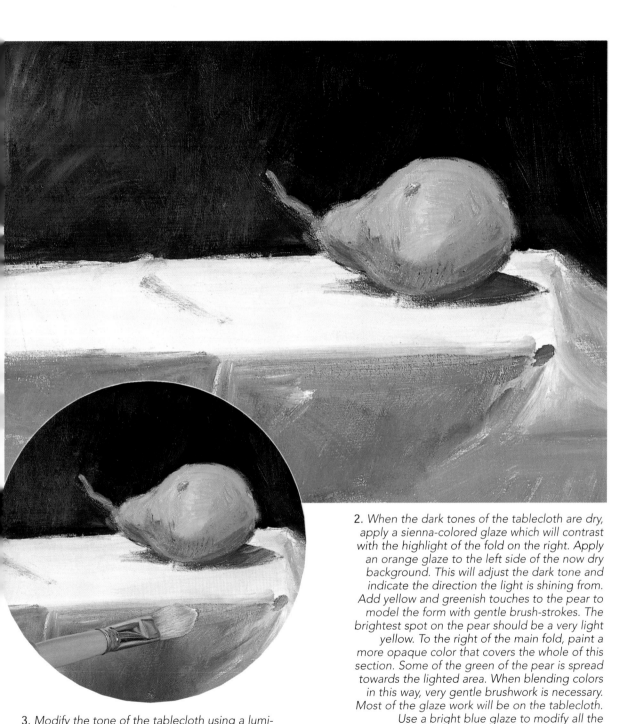

2. When the dark tones of the tablecloth are dry, apply a sienna-colored glaze which will contrast with the highlight of the fold on the right. Apply an orange glaze to the left side of the now dry background. This will adjust the dark tone and indicate the direction the light is shining from. Add yellow and greenish touches to the pear to model the form with gentle brush-strokes. The brightest spot on the pear should be a very light yellow. To the right of the main fold, paint a more opaque color that covers the whole of this section. Some of the green of the pear is spread towards the lighted area. When blending colors in this way, very gentle brushwork is necessary. Most of the glaze work will be on the tablecloth. Use a bright blue glaze to modify all the colors already present in the tablecloth.

3. Modify the tone of the tablecloth using a luminous, transparent glaze. This effect can only be obtained if the underlying colors are completely dry. Oil paints dry very slowly so we do not recommend using large amounts of color. Paint a very bright ochre glaze over the white. This glaze will also alter the original tone of the darker colors.

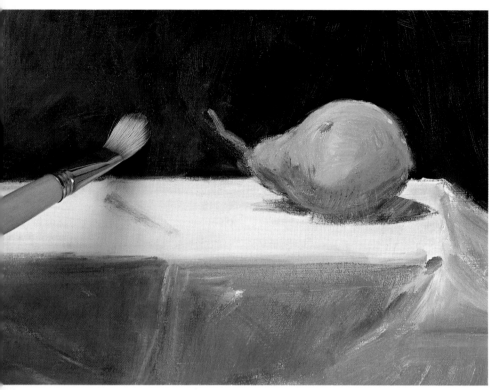

4. *Wait a whole day before resuming work. Paint the whole of the illuminated area of the tablecloth using sweeping, horizontal brush-strokes in white, yellow and ochre. A further, reddish, glaze can then be applied to modify the almost black tones; this color suggests a warm light that creates the atmosphere.*

Because glaze work on shadows can be so time consuming, you may want to work on two paintings at the same time. This means less time is spent waiting and more time is spent acquiring a greater understanding of shadows.

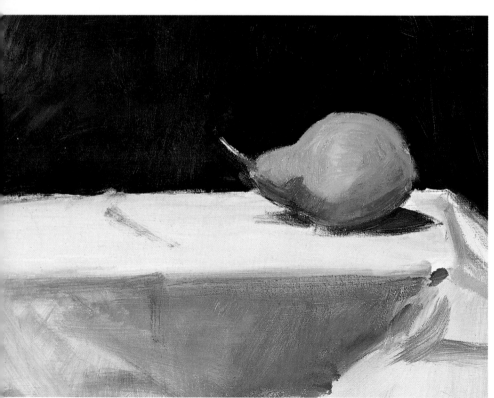

5. *When the previous stage is completely dry, paint over it again, without blending the colors already on the painting. Paint the dark shadows on the pear with a blue glaze on the right and a cadmium red glaze on the left. Then adjust the color of the tablecloth with glazes over the areas in shadow. Blend these glazes with opaque brush-strokes of a more luminous color. Paint the table-top bright white on the right and white tinged with Naples yellow on the left.*

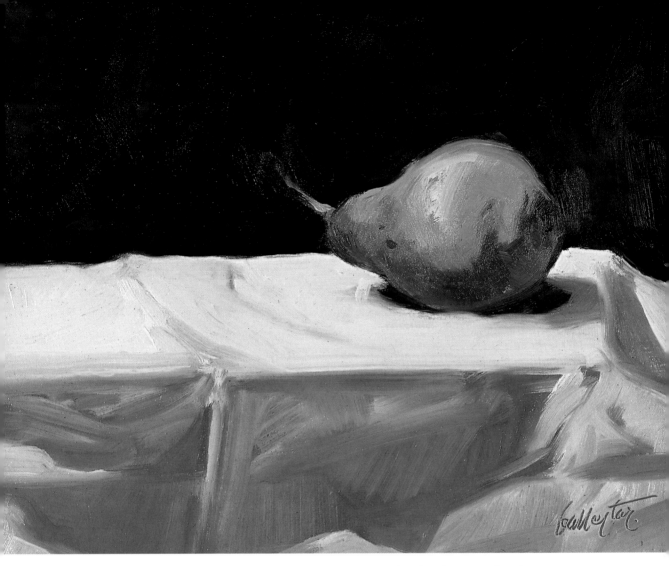

6. *Use luminous colors almost verging on white to paint the brightest highlights in the folds of the left side of the tablecloth. This is the final glaze in this exercise.*

As mentioned earlier, this type of work does not require great effort, but it does demand patience. Nevertheless, this may actually be an incentive for learning to paint in oils.

SUMMARY

The first colors are the darkest, outlining the form of the fruit and the table.

All colors should be perfectly dry before applying any glazes.

The first layers of color should be slightly diluted; thick layers of paint should never be used to shorten the drying time.

The glaze used to darken the shadow of the pear is blue and red; the modeling of the form should be done gently and gradually.

Different glazes were applied to the **tablecloth**. Their high transparency allows all the underlying tones to remain visible.

The brightest highlights are painted using opaque tones when the painting is almost finished.

The Way They Painted:

Claude Monet

(Paris 1840–Giverny 1926)

Water Lilies

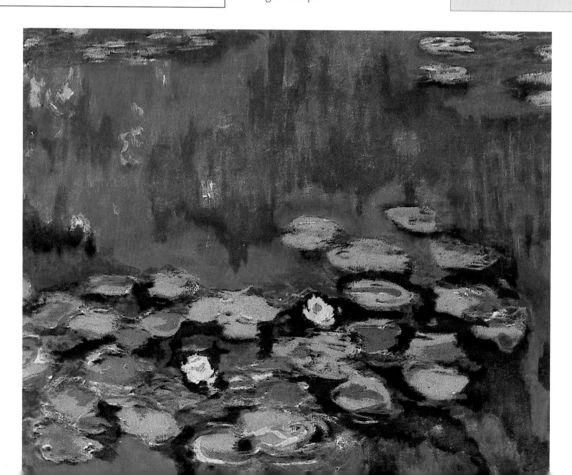

Monet was one of the most prolific artists of his time. The father of impressionism, he developed the theories that allowed the movement to break with previous academic tradition. In fact, all of today's pictorial movements stem to some degree from impressionism or the movements immediately following. Monet's work, like that of many other artists, is particularly useful for studying the different pictorial possibilities permitted by oil paints, since it does not involve complicated procedures.

In his works, Monet invested a great deal of time and interest in the study of light, one of the bastions of impressionism. For the subject of this painting, Monet had a large basin built with the sole purpose of growing water lilies in it in order to paint them from nature. He created an entire large format series on this subject, which he placed in a circular room to give the spectator the sensation of being enveloped.

MATERIALS

Oil paints (1), palette (2), paintbrushes (3), canvas-covered cardboard (4), turpentine thinner (5), and linseed oil (6).

1. *Monet's paintings are often very fresh and direct. In this work, we see an immediate impression of the subject, which makes a detailed drawing of the forms unnecessary. The work began with a very general and thinned roughing-out, with which the entire background of still water was done. The oil paint should be thinned with quite a lot of turpentine, but not enough to allow the colors to mix on the canvas. The original was quite large. Here we have reduced the format, but retained the principal techniques, such as the slight blending of the greens and blues in the background. This painting must be done on an upright canvas, so that the force of gravity carries the paint downwards.*

2. *The colors should be applied in nearly vertical brush-strokes, leaving the areas where the water lilies are to be blank. Strokes of very bright blue can be used to sketch in the shapes of the water lilies while providing dividing lines among them. Just as in any reproduction, it is important to note the main lines of the composition. If you observe the original attentively, you will notice that the water lilies are placed on the canvas in an S-shape.*

3. *The initial roughing out should be very diluted. The white background should still show through the first layers of paint. Once you have selected the colors that will cover this background (all of which should be in very cool tones, including the yellows), you can begin to paint with much more concrete strokes that situate the most distant floating lily pads in the upper left-hand corner. In this area, the brush-strokes should not define distinct forms.*

It is important to see the original works in museums or galleries. When you come into direct contact with the work, you can see the different techniques used by the artist much more clearly.

4. *The shapes of the lily pads are defined by color areas that are reflected in the surface of the water. If you look closely at this detail, you will see that each individual brush-stroke appears as a simple spot and its effect is meaningless. If, on the other hand, you observe the whole from a distance, you can see the points of light of the different areas of this landscape. This roughing-out requires colors that are previously mixed on the palette. The color is not pure green, but approximates a bluish gray.*

5. *Continue filling in the lily pads and their reflections on the left side of the painting. Mix cobalt blue with some ultramarine to contrast with the blue of the water. As you can see in this image, the water lilies appear much brighter due to the contrast, as the background becomes darker. With very short, precise brush-strokes, but without any definition, paint some flowers on the pond water.*

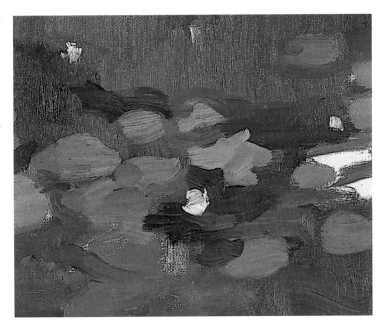

6. *Apply the colors making up the entire lower part of the painting with much more contrast. Your brush-strokes should continue to become thicker as you apply the paint directly, without blending the colors and tones in the layers beneath. Paint the blues around the leaves in the same manner. Also add some touches of yellow to the flower in the middle, using a very faded carmine to emphasize the contrast with the cold tones of the landscape.*

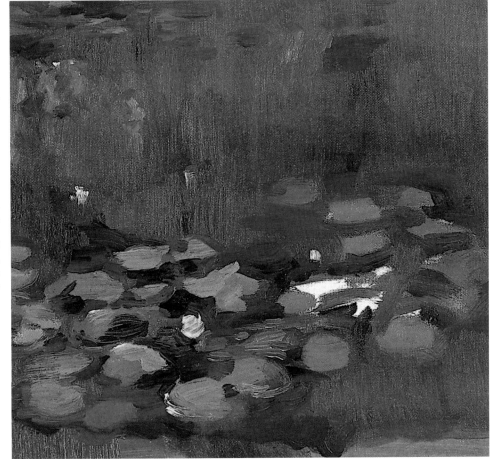

STEP-BY-STEP: *Water Lilies*, by Claude Monet

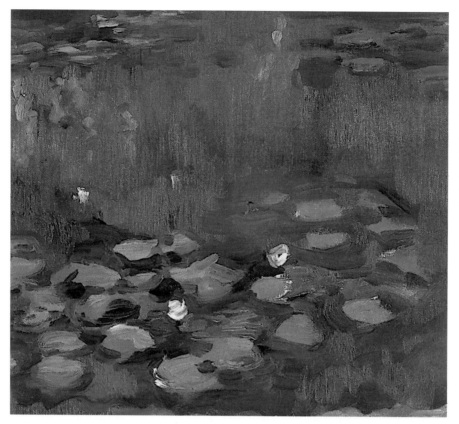

7. Add reflections to the upper area in soft, undulating brush-strokes that descend vertically. It is inevitable that some of the paint from previous layers will mix into these brush-strokes. After painting the central flower in the same way as the first yellow flower, develop the upper area. Here, with a few more patches of color, you can finish covering the entire surface of the water lily pads.

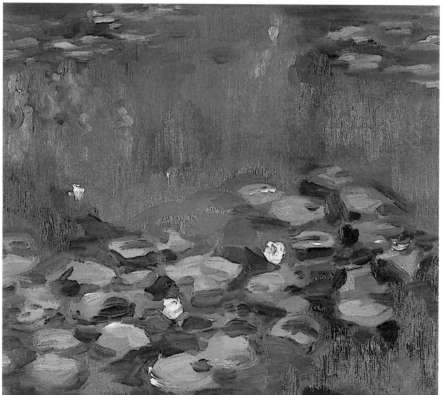

8. In the upper area, you can see how just a few very bright brush-strokes can perfectly define the floating lily pads. This time, the color contrasts well with the blues surrounding it. To heighten the contrast, add a dark blue. In the lower area of the painting, the contrast between the alternating light colors of the leaves and the darker background will complete the whole. Finish off the contours of the leaves in carmine and grayish green tones.

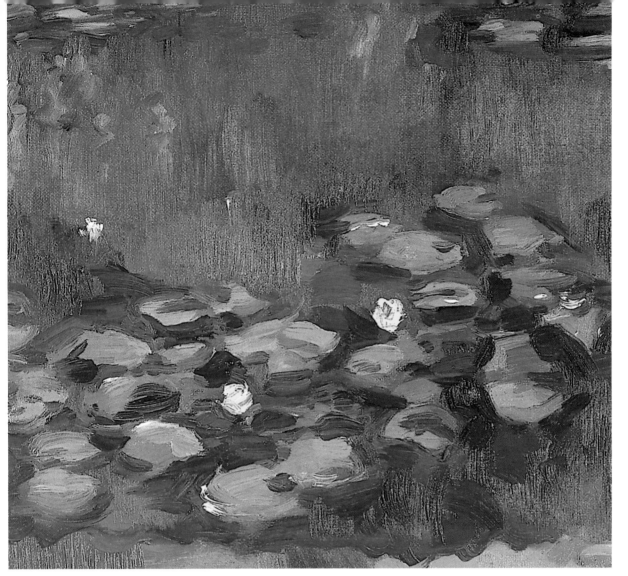

9. *Only the darkest and thickest contrasts have to be added to finish this painting. These final tones will help to emphasize some of the areas of medium luminosity.*

The dark greens applied in this final phase should not clearly define forms either, but will help to contrast the contours of the leaves against the surface of the water.

SUMMARY

The first colors added are thinned with turpentine. Since the paint is very liquid, it runs down the canvas, allowing the background to come through.

Bright blue outlines the shapes of the leaves, as well as establishes their separation.

The leaves are painted in a somewhat grayish tone, making them stand out from the dark colors of the water.

The flowers are painted with direct strokes of yellow.

The Way They Painted:
Vincent Van Gogh
(Groot Zundert 1853–Auvers 1890)

Pink Peach Tree in Bloom

MATERIALS

Charcoal (1), oil paints (2), canvas mounted on a stretcher (3), palette (4), brushes (5), turpentine, (6) and linseed oil (7).

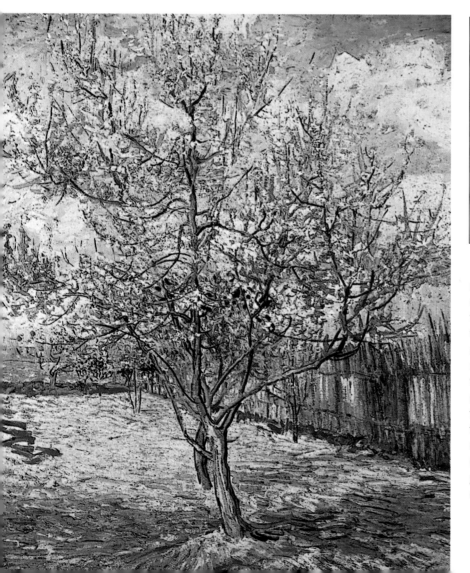

Van Gogh is one of the most controversial painters in history. This artist's work went unnoticed during his lifetime, and mental illness left him on the brink of madness. Despite this, many of today's artistic movements would not exist without Van Gogh. His invaluable contribution to art is the way he used color and the brush-stroke, which provided the first step toward expressionism.

Van Gogh´s paintings are energetic and full of feeling. Rather than a virtuoso of drawing, Van Gogh´s real mastery lies in the impressive force he was able to convey through his use of color and brushwork. Likewise, his motifs reflected his own particular view of reality. His twisted and expressive style is one of the characteristics that best define his work. This is one of the landscapes that the master painted. As you can see in the painting, he didn´t search for a complex or grandiose subjects a simple garden containing a peach tree was enough.

1. *Sometimes an apparently simple sketch requires even greater attention to detail. The composition of this painting can deceive the spectator, since the tree is slightly off center and its mass takes on a somewhat more precise form that could easily go unnoticed if its main lines are not studied with utmost care. A charcoal sketch will help you to understand these forms, as well as the general lines of the fence that encloses the garden.*

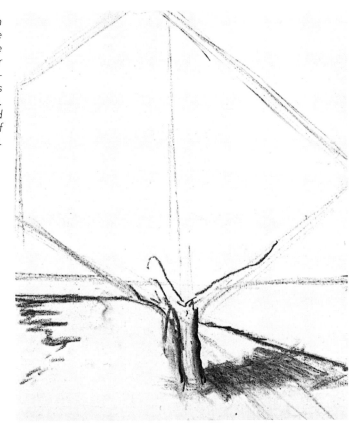

The brush-stroke played a very crucial role in Van Gogh's painting. When attempting to reproduce this effect, it is important to study how the thick layer of color merges with the others on the canvas.

2. *The first step is to paint the sky. This way you can rough out the entire area against which the florid branches of the peach tree will be situated. Do not define all of the clouds in the same way. Slightly contrast the uppermost ones against the blue sky, but, as you move towards the lower clouds, add a hint of cerulean blue to your mixture. Pure white is not very useful in this case, as it can clash with the Naples yellow. Van Gogh always began his paintings with a simple structure which he enriched with successive layers of color.*

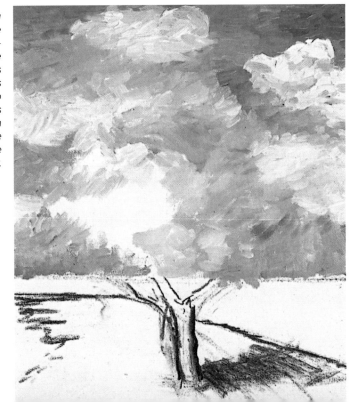

STEP-BY-STEP: *Pink Peach Tree in Bloom,* by Vincent Van Gogh

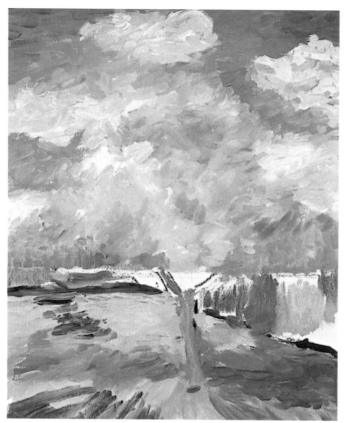

3. *Once you have roughed out the sky, paint in the ground and the fence. Just as Van Gogh did in the original, elaborate the ground with an interesting variation of tones and colors. The background color should be very bright; paint it with a base color of Naples yellow with a touch of yellow ochre and bright green. As you work towards the earth in the foreground, apply more leaden and slightly dark tones, always within the cool range. The colors used in the foreground should be earth tones. Paint this area with long directional strokes that lead toward the main tree. Paint the fence with vertical strokes, except the part in the background, where the brushwork tends to be somewhat more blended.*

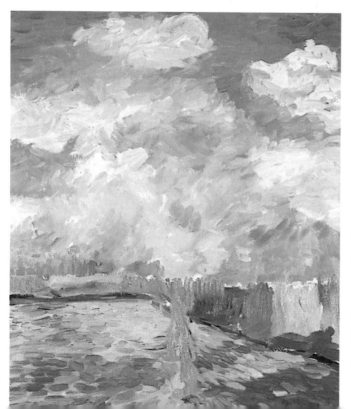

4. *Now that you have roughed out the background completely, it is time to define each one of the areas, studying the brush-stroke and color that must be applied within each one of them. Bear in mind that on most occasions, the new brush-strokes will drag up part of the underlying ones. In order to compensate for the tones in the foreground, Van Gogh applied short strokes in a variety of very bright green tones in the middle ground. Apply blue to the shadows cast on the ground, and paint the parts in direct sunlight with ochre tones.*

5. *With a fine brush, trace over the outline of the main tree, applying various colors: black and a sienna tone that will sometimes blend with the background and other times with the black of the original drawing. Just as the great painter did himself, apply color to the main branch, from which the others are then extended. Continue to paint the ground with strokes that alternate colors and tones that correspond to the luminosity of each part.*

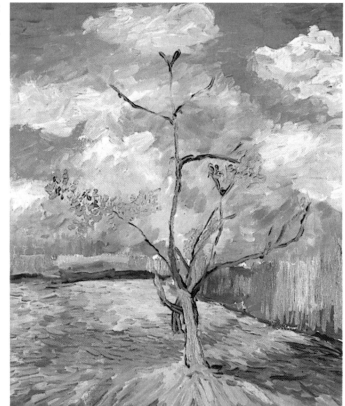

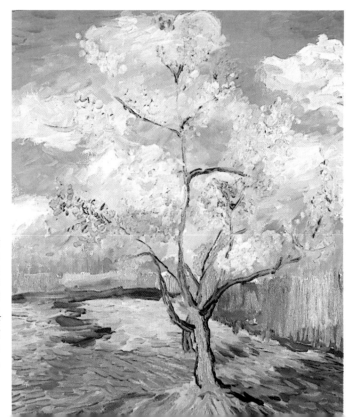

6. *Once you have painted the most significant branches move on to the leaves. This stage is especially complex, as there is a risk of applying too much paint to the treetop. Therefore, it is important to paint this picture energetically but with sufficient restraint. The colors used in the pink branches should be a combination of carmine, orange, ochre, Naples yellow and white. As you can see, several greenish tones were also included.*

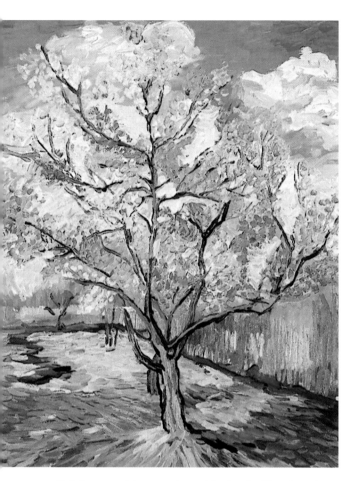

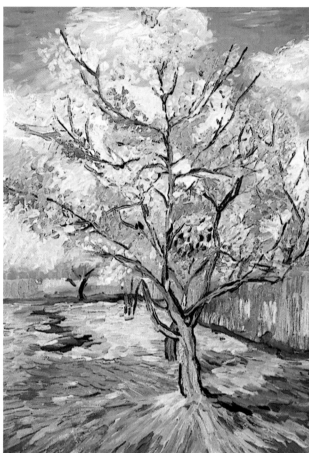

7. *It is essential to continue this detailed brushwork in each of the areas of the treetop. The brush-strokes must be short, but not so short as to be dots. Each one of these areas must be painted with a complete range of tones, applying different shades of color with each stroke. Paint the middle of the treetop with several orange tones, while red toned with Naples yellow should dominate on the right. As you gradually paint the crown of the tree, correct and add in the shape of certain branches, which should be represented as fine strokes inter-rupted by the pinkish foliage. Paint the trunk with bluish tones and a pumpkin color, without letting them superimpose the black lines that define it.*

8. *Continue with the tiny applications that give form to the crown of the peach tree. In certain areas apply small strokes of black, producing a stark contrast with the rest of the pastel-like tones that surround them. Draw the thinnest branches with your finest brush, without affect-ing the bright colors of the background.*

In works that contain color impas-tos, it is necessary to consider the mixture directly on the canvas as well as on the palette. On occa-sion, a tone can be corrected by adding direct color.

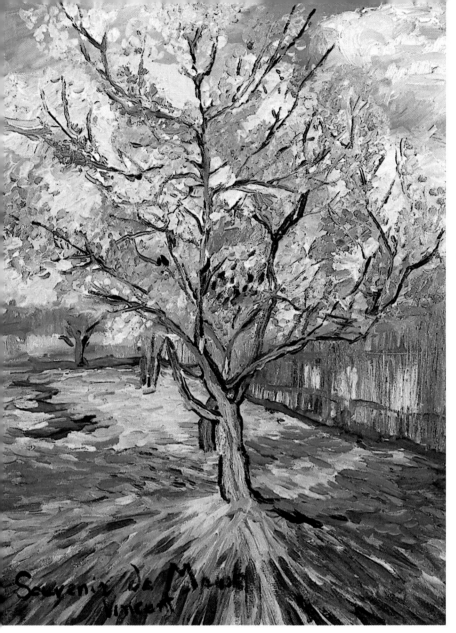

9. *The final and numerous brush-strokes applied to the treetop should gradually become purer in terms of color; you can even add pure tones of red and carmine that will produce a stark contrast with the whitish colors of what is now the background. The color work on the ground is meticulous, and should be painted with a much smaller brush than the one used so far. The work on the fence is also intense. The different degrees of light in each of its areas will help you to finish it.*

SUMMARY

The sky is painted with cerulean blue. The clouds are painted with a diverse range of very whitish tones.

The outline of the main tree is drawn and outlined with a contour that perfectly defines it.

The leaves are painted with pastel-like tones, mixed to a greater degree with white and Naples yellow.

The tone of the ground corresponds to the different qualities of light it reflects.

As the painting nears completion, **the strokes and colors of the ground** are applied more precisely.

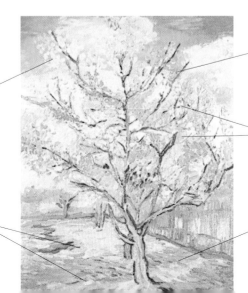

The Way They Painted:

Paul Cézanne

(Aix-en-Provence 1839–1906)

Still Life

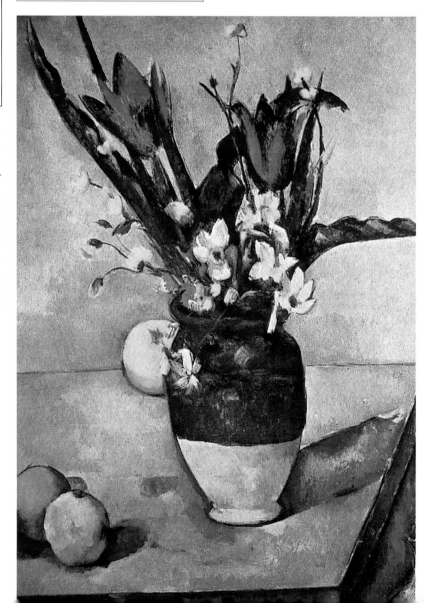

Cézanne was, along with Gauguin and Van Gogh, one of the principal precursors of the post-impressionism movement. Admired by his contemporaries to the point of being called *the genius,* Cézanne is key to contemporary painting. His contributions to technique and theory gave way to the logic with which Picasso developed cubism.

MATERIALS

Charcoal (1), oil paints (2), canvas-covered cardboard (3), palette (4), paintbrushes (5), turpentine thinner (6), linseed oil (7) and a rag (8).

Cézanne's works strive towards the synthesis of planes, i.e., showing all the possible views of an object in one painting. In this still life, the theories of this ingenious painter were not yet fully developed, although we can already appreciate a few details that approximate his ideas. Observe the plane of the table with respect to the rest of the objects in the still life, as well as the way in which the short brush-strokes construct forms through small planes.

1. *Cézanne always placed a special emphasis on the study of composition in all of his paintings. Nonetheless, Cézanne's compositional technique was based on a progressive construction of forms. Cézanne probably didn't sketch the still life before painting it, but it will be easier to interpret his work if you block in its essential lines in charcoal. Make straight lines with the flat side of the charcoal, holding the stick lengthwise. In any case, do not aim for a finished sketch, but simply an idea of the principal planes through the lines that define them.*

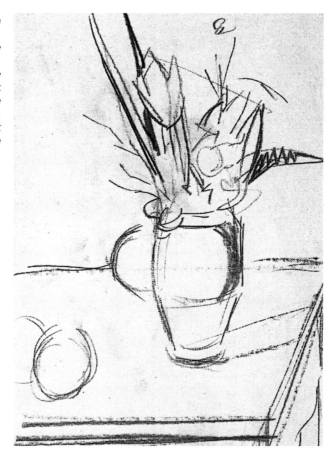

If you want to preserve the initial blocking in as the basic structure of the painting, you can spray it with fixative. If you paint over it or touch it up, the sketch will remain unchanged.

2. *Add the first color to the background, applying it very thin, so that the lines of the blocking beneath show through. The color should be applied irregularly, and not necessarily pure. Blue should be mixed with white and some touches of ochre. In this detail, you can see how the brush-stroke penetrates into the sketched forms. Subsequent, more diluted layers will be able to cover these first transparent background layers perfectly.*

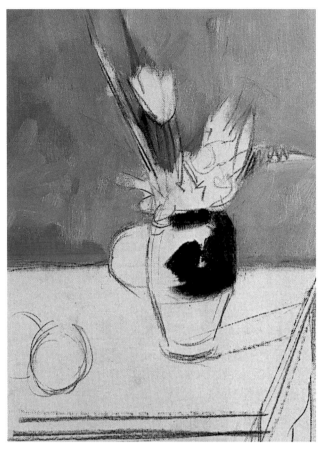

3. *Finish the background in different intensities of blue and a great variety of brush-strokes in different directions forming different planes. The color should be mixed on the palette as well as on the canvas itself, allowing the paintbrush to drag up some of the paint from the underlying layers. As Cézanne did, paint the vase in a great variety of planes, without modeling shapes. In this example, you can see how the wide brush-strokes do not blend with one another, but overlap. To prevent the colors from blending completely, it is important to avoid going over each brush-stroke excessively.*

The entire work should be roughed out as a whole, so that all of the areas will be finished at the same time and it will be easier to correct any mistakes.

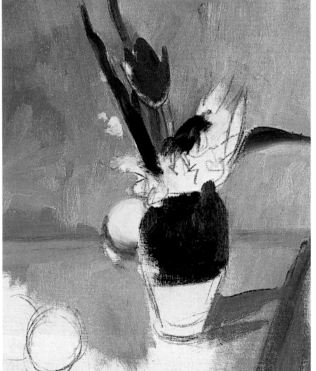

4. *Rough out the painting until the form of the vase is completed. The direction of the brush-stroke should provide the shape. The flower should be done in long, single brush-strokes with direct applications of color. As you can see, the color was applied flat, although the direction of the brush-stroke lends texture and form to the petals. Paint the yellow flowers in direct strokes without defined contours. Paint the fruit in the background directly in yellow, and apply its shadow in a direct stroke of red. Fill in the table with tones of sienna, umber and white. On the side in shadow, the color should be close to violet, very toned down with white to add a grayish tone.*

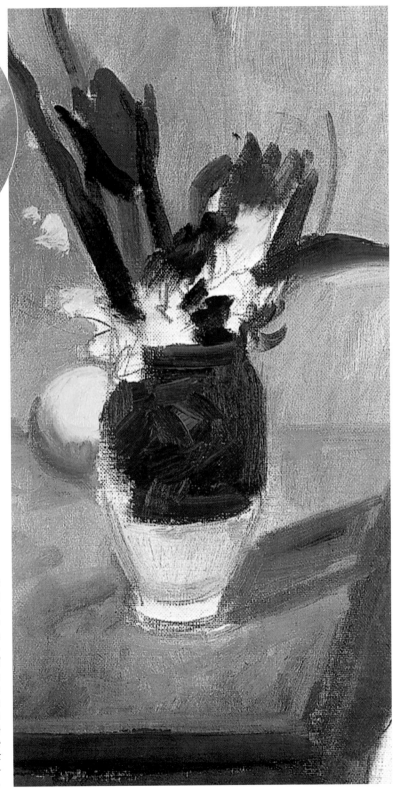

5. *In this detail, you can see the technique Cézanne used to construct the different planes of the table with brush-strokes. Some strokes are slightly bluish, some blue mixed with white, others reddish and orange. The different brush-strokes combine to form crisscrossing planes which let the background colors show through. Quickly rough out the orange on the left with slightly grayish colors that have been mixed with white. The presence of white in the color mixtures produces impure colors.*

6. *Apply new tones over the previous ones of the table, including carmine and various blue hues. When mixed on the palette with white, slightly violet pink tones can be produced. The shadow cast on the table can be reproduced with a reddish carmine toned down with some white and umber. Finish off the shape of the vase with some strokes of whitish paint along the base. Naples yellow, sienna and white can be used to make the mix for this part. The upper part of the vase should include some small areas of ochre. Paint the right flower in very light tones, which will contrast with later additions of pure colors.*

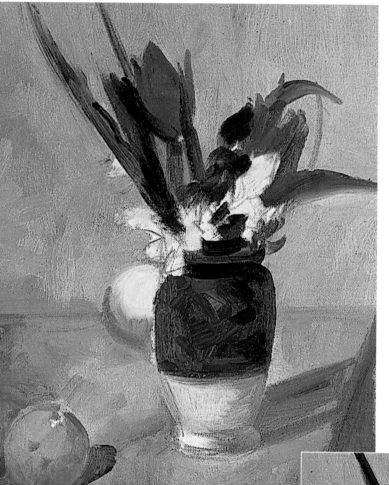

7. *Apply large areas of dark colors to the right side of the vase. Black, however, should not be used at all in this exercise. The dark tones are highlighted instead by the effects of simultaneous contrasts. Cézanne respected the theories of impressionism, which rejected the use of black in the study of light. Given that very bright colors are used in the rest of the painting, you can simply use a darker tone in this area to intensify the extremes: the lighter areas will appear even more luminous and the darker tones will appear more dense. Use dark brush-strokes to finish shaping the leaves. In the lighter area of the vase, shadows can also be suggested with loose brush-strokes which do not blend into the background colors.*

> One of Cézanne's theories was that all objects can be reduced to simple geometrical shapes. Each plane of an object can correspond to a color independent from the rest of the planes.

8. *The entire flower work should be done in pure colors and flat brush-strokes. The differences between each of the areas can be established through the application of completely different and very direct tones that are not blended together. Paint the smallest flowers in very direct, specific brush-strokes with no attempt at detailed contours.*

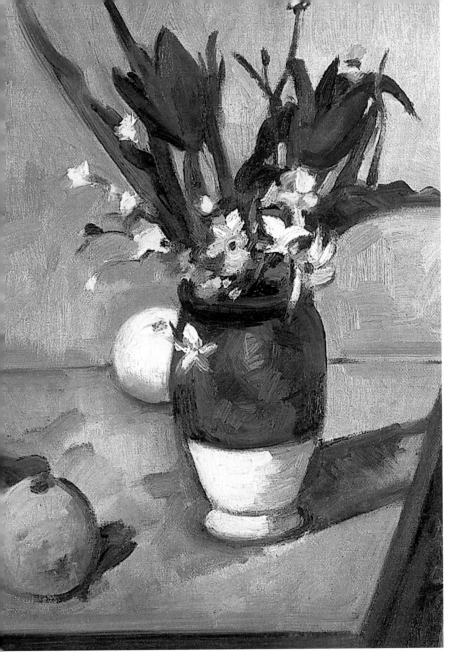

9. *To finish off the painting, the forms of each plane must be given more definition. Finish the contour of the vase by darkening the blue tones around it on the table. Lighten the fruit in the background with white to obtain tonalities closer to the original. Define the orange tones in the right by notably darkening the surrounding area with bluish tones. Give the different planes of the table the finishing touch by repeatedly darkening the dark areas.*

If necessary, allow the painting to dry overnight between each session to avoid undesired impastos. This allows for a much cleaner finish.

SUMMARY

The original sketch is based on simple geometrical elements which allow you to approximate the forms to those in the original and study the composition in depth.

The background is painted in blues toned down with abundant white. The brush-strokes are direct and the tones do not blend, but rather form independent planes.

The progression of colors in the flowers begins with a flat tone applied in different areas.

The small flowers are painted in very direct touches of yellow and white.

In the vase, each change in tone is carried out directly, blending together without the colors .

Strokes and Marks

OPENING STROKES

This first exercise deals with the first pastel strokes. As can be seen, all the edges and sides of the pastel can be used to draw lines as fine, or as thick as the stick itself, and from this base you can go on to explore pastel techniques.

Pastel is both a painting and a drawing medium that allows you to employ a wide range of effects. In this first topic we are going to delve into the elementary concepts of this marvelous technique. As will be discovered through the different topics of this book, pastel technique can be learned progressively. It is worthwhile for the beginner to work carefully through the exercises proposed and through the different points dealt with in every topic.

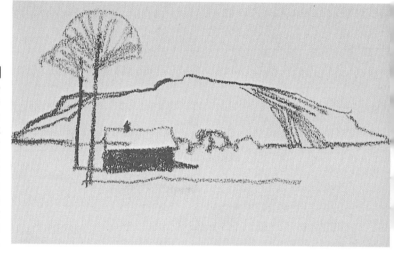

1. *It unnecessary to use a pencil or charcoal to do the layout of a piece that is going to be made in pastel. A pastel stick leaves a clean mark on the paper: you do not need to fall back on any other drawing media. As pastel paints with its entire surface, its strokes are similar to those of charcoal, although it is true that pastel is more stable and less prone to crumbling. This property is no setback, especially if the picture is going to be covered in color. The opaque quality of the pastel colors makes it possible to use all types of strokes and corrections.*

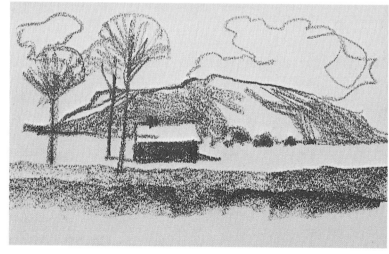

2. *In painting the amount of paint loaded on to the brush determines the color intensity, but this is impossible with pastels. Strokes can be done with the stick crosswise or vertically, but the pastel cannot be spread as if it were a liquid media. Use strokes to build the surface of the painting. These can be closer together or far apart, and they can be wide or narrow like the tip of the stick. Whatever way they are done, even with the pastel stub, the picture is made up of strokes.*

▲ 1. *Holding the pastel stick flat when you make the first strokes gives versatility. As can be seen, the strokes do not have to be straight. With a pastel stub stripped of the paper wrapper, work with the pastel flat between the fingers. Its shape favors the width of the stroke: the petals are soon covered. If you gently turn the stub without standing the pastel upright, the thick shading becomes a fine line. You can now work lengthwise.*

FINE LINES AND TRUNCATED STROKES

Many different strokes can be made with pastel. So many that the artist should start practicing with the different stroke possibilities before going on to work with different colors. Throughout the exercises presented you will be able to appreciate that strokes are often employed as simple lines, or as shadings which are cut short by a twist of the wrist. This exercise is about painting a flower. Pay a great deal of attention to the strokes in the different areas.

▼ 2. *When the pastel is held upright the quality of the stroke is very different. It becomes a fine line and responds to the delicate movements of the wrist and fingers. This can be seen in the flower stem exercise, where the leaf on the right has been drawn in a very loose, free way, without being too rigorous in the development.*

▼ 3. *Strokes made with the pastel held flat can vary both in intensity and in pressure. The gradation reflected in the stroke as it is dragged depends on the paper, the texture, and also on the pressure applied. Some areas seem to have a stronger color because the pastel has been pressed harder onto the paper.*

DRAWING WITH THE PASTEL FLAT AND WITH THE TIP

Although many different ways of drawing are possible with the pastel stick, basically it comes down to a choice between holding it upright, thus giving a line, or holding it flat and therefore rapidly covering wide areas of the paper. In this exercise we are going to experiment with the different possibilities.

1. To do the sky in this picture use a pastel stub held flat between the fingers but do not press down very hard so that the whiteness of the paper is not completely blocked out. The blue area should be covered, while the outlines of the clouds are left unshaded. This is called "reserving an area". It is the stain that outlines the white and gives it shape. The lower part is also painted with the pastel flat between the fingers, but now the stroke is lengthwise. Drawing like this enables the layout to be done quickly and ensure that it will turn out as planned.

2. This phase of the drawing is carried out with a flat stick to give a crosswise stroke, the best way of going about the landscape. You can now work with a much firmer stroke. Where you are seeking a greater contrast, press more intensely. In the areas that are going to have a softer tone use a flat stroke, pressing down very lightly on the paper.

> Pay attention to the effect of superimposing the layers on top of one another, and to how the stroke can be more or less opaque.

3. Once the layout of the landscape base has been completed, fresh touches that finish off the details can be added. Notes that the final strokes are much more descriptive than the beginning ones since they show the delicate profile of the mountain in the background and the tree in the foreground.

BLENDING COLORS

In the previous exercises we have studied some of the principal applications of pastel. The exercise that we are going to do now includes all of them and also deals with a new way of working with pastel: blending tones and colors. This is one of the most important effects used in pastel technique.

▶ 1. *In this exercise we are going to paint a piece of fruit. First, an orange shape is sketched with the pastel. Then the inside is colored with a golden yellow cadmium. On top of the yellow, paint in orange, dividing the fruit into two distinct parts. Without pressing more than is necessary so that the colors do not mix, gently rub over the right area until it is uniformly covered with the tone. When the fingers come to where the two colors meet, rub softly until they subtly merge together.*

▼ 2. *This stage is especially interesting for we can see how the blending of one color over another does not have to take in the entire surface. All that has to be done is to gently pass the finger over a light area without touching the upper part. This is an example of how the pastel retains its freshness.*

▼ 3. *As many layers as are necessary can be superimposed, provided that the colors are not mixed on top of each other. Take great care when you blend in the contours of the new tone. On one side the color is spread with a finger until it completely covers the contour of the fruit. Around the luminous area do a rough merging so that no fingerprint traces are left.*

Step-by-Step
A Still Life

Pastel is an ideal medium for translating what may begin as a mere thumbnail sketch into a full-blown painting. In this exercise we are going to use pastel with quite simple techniques. It is not fundamental that the result be identical to what is shown in the images. This will be achieved later, with practice. It is important that every step is followed carefully, making it easier to achieve a satisfactory result.

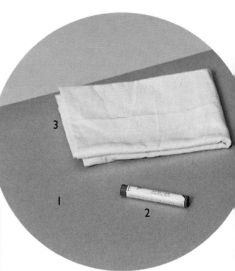

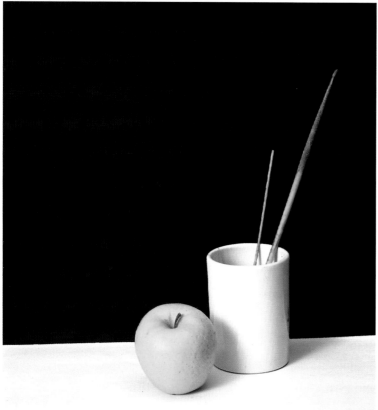

MATERIALS
Color paper (1), pastel stick (2), and a rag (3).

When you are painting in pastel, you must always be careful to avoid rubbing the hand against the paper, because it is a fresh medium.

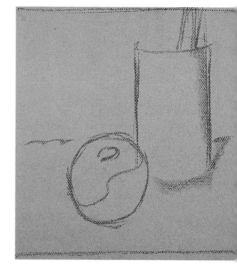

1. *The entire surface of pastel can be used, both the edge and the point. Although the result is different for every application, it is important to get the most out of each pastel application on the paper. Use the pastel flat to trace long, straight, highly precise lines; this is how the sides of the glass are drawn. If the stick is held upright, using the tip, the stroke can be more like handwriting. Start to carefully draw the apple by laying out a sphere.*

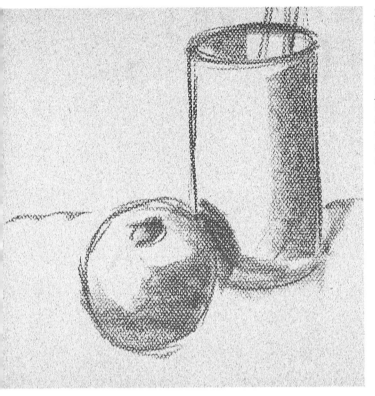

2. *The beginner must get used to working with stubs because pastel is fragile and breaks easily. It is more straightforward and stable to work with a little bit of pastel than with the whole stick. Break the stick in two and then, holding it flat, you can start to do a side stroke. To avoid blocking up the grain of the paper, do not press too hard. The jar is drawn with one vertical line. The apple stroke is done with a twist in the wrist. Once again, the pastel is flat between the fingers.*

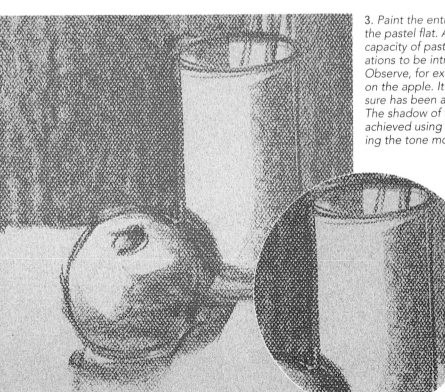

3. *Paint the entire background uniformly with the pastel flat. As can be seen, the shading capacity of pastel allows all types of variations to be introduced into the stroke. Observe, for example, the style of the stroke on the apple. It reveals that a certain pressure has been applied in the darkest areas. The shadow of the apple on the jar has been achieved using the tip of the pastel, darkening the tone more than the other areas.*

4. *In this close-up observe how the background is done with a pressure similar to the shading on the side of the jar. Until now the two tones have been identical. In the following step you will be able to see the effect that is produced when the two strokes are superimposed.*

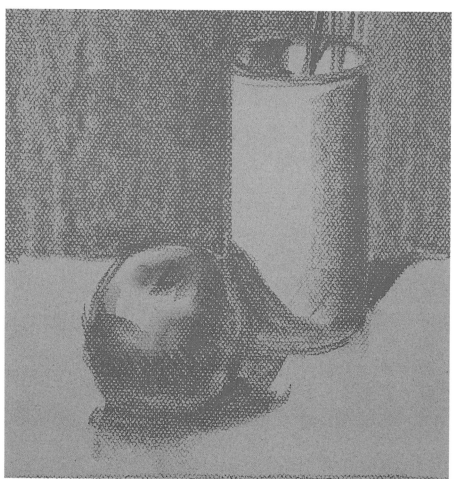

5. *Passing the pastel twice over an already painted area enables the tone to be darkened. This time, to get the darkness of the glass right, use the tip of the stick. This has a strong darkening effect and at the same time enables you to closely control the forms as you draw.*

If you do not exert too much pressure when painting, pastel can be removed with an eraser, or flicked off with a rag.

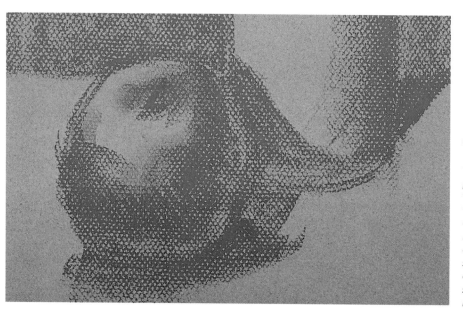

6. *Once the first strokes have been laid down on the paper you can start to paint in the deepest contrasts. Paint the apple with the tip of the stick, which offers a direct and spontaneous style. The hardness of the stroke allows the shadow areas to be made darker and denser. Also, since pastel is an unstable medium, it can be blended with the fingers.*

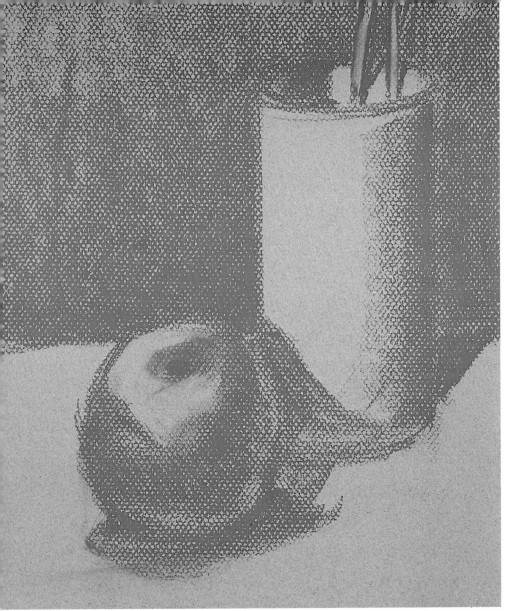

7. *To finish off this exercise, darken the background by going over it again with side strokes. Once these dark areas have been put in, they finish off the contrasting of the unpainted luminous tones.*

SUMMARY

The strokes that are drawn crosswise with the side of the stick allow areas to be covered with thick lines in an even texture.

When **the tip of the stick** is used, it enables you to draw in a gestural style. This is how the outline of the apple has been done.

The flat, lengthwise stroke helps you to do firm, straight lines.

Superimposing strokes on top of each other enables the paper pores to be covered.

Initial Layout

DRAWING WITH PASTEL

When the pastel technique is explored for the first time what stands out is the possibility that this medium offers for working with the strokes on the paper. On one hand, you can draw perfectly, as if it were a pencil. Alternatively, the colors can be superimposed, both with the tip of the pastel or with it flat between the fingers.

In the pastel technique the way the stick is held and applied to the paper is very similar to any other drawing media, like charcoal or sanguine. Pastel is not a drawing medium, although it can be used as such. It is a method of painting. In light of its properties, the approach to it must be fresh and spontaneous. Therefore, whatever happens, avoid mixing the colors to get other colors. Art supply shops will have the exact pastel tint you require.

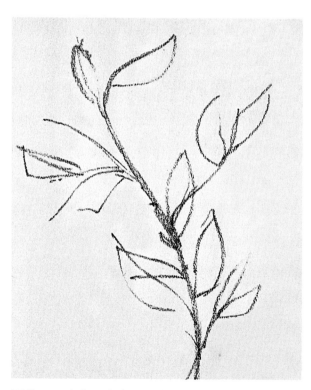

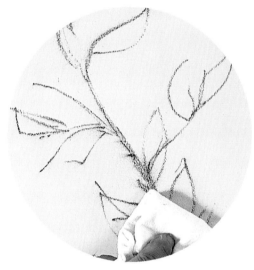

▼ The powdery texture of pastel allows the artist to draw, to shade, and to rub out like any other drawing media. All types of strokes can be erased with a simple flick of a cloth or the hand. This is why doing the layout for the drawing is not difficult: the technique permits ongoing corrections to be made. The cloth should be made of cotton and clean so that it does not dirty the other colors.

▼ The pastel allows the layout to be made with a clean and direct stroke, the exact definition of which depends on the way it is used. As the pastel can paint with all its surfaces, the strokes achieved are similar to those of charcoal, both by painting with the pastel flat or by using the tip of the pastel. At the same time the opaqueness of the pastel colors allows any stroke or correction to be covered over.

Just passing the pastel over the paper surface is sufficient to do a line. If you pressed the pastel stick too hard against the paper you would either break the pastel or clog the support up with too much color, which is totally unnecessary in the early stages.

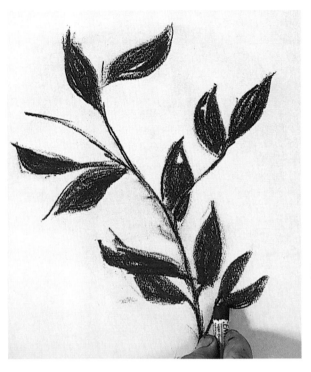

BUILDING UP THE PICTURE

In pastel painting, the work has to be done progressively. This is due in part to the opaqueness of the method and also, because it is possibe to correct as you go along. This is clearly demonstrated in this exercise. On the previous page we looked at how to arrange the layout and how easy it was to correct it. Now, starting out from these lightly sketched lines, go over the forms with a firmer stroke. This is called "restating".

▶ 1. *The painting of the picture is based on lines. These can be joined together or separated, and can be as can be wide as the tip of the pastel or the pastel stub, whichever is being used. To quickly color each and every one of the leaves that have just been drawn, use a dark green. The lines are still visible during this process. This is one of the characteristics of pastel painting.*

▶ 2. *Pastel does not need drying time so it is not necessary to wait before painting a fresh color. This is a property that gives it great expressivity. Some other painting media do not permit a certain layering of color unless the underpainting has dried. As can be seen in this sequence, it is possible to paint a lighter color on top of a darker color without it becoming transparent or mixing with the color underneath. On top of the dark color, paint the most luminous area of each leaf in a bright green.*

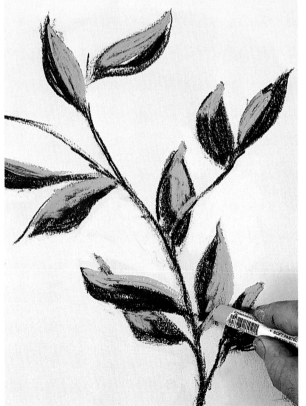

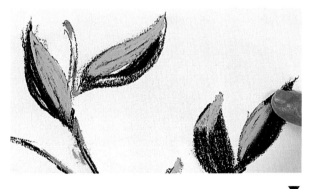

▼
3. *Just running a finger along the dividing line between two colors is enough to blend the strokes together. Do not rub so much that the colors mix. Gently rub where they meet to blend their edges together.*

COMPOSITION

We have studied how pastel painting is started with an initial layout, and how very simple elements like leaves are rendered. These are some of the most elementary effects. The last exercise showed how the initial layout must be done carefully and precisely. If the elements are simple and do not require a marked structure to develop them, a drawing like the ones on the previous pages is sufficient. However, this exercise only aimed at practicing the stroke and constructing the forms. When the model is more complicated it is necessary to do a plan before going on to sketch the painting.

It is advisable to do the layout of the forms with the pastel stick flat and using a lengthwise stroke.

1. The layout is done on the drawing paper. Within this plan the most elementary forms are developed. The aim is to see the unity of the composition, as if it were just one object. This example is a simple still life of two lemons. Doing a layout will add realism to the picture: if you start with a general plan of a few lines it is much easier to place them in the picture. The internal forms have not been put in yet. First, we have to get the box shape, in which they will later be placed.

▼ 2. Inside this very simple form, the basic shape of the lemons can be more fully sketched. When drawing them, their relative sizes and forms must be considered—the initial layout has to be respected. In this step and in the previous one, we have first done a straight line layout, then we divided it and went on to do more descriptive drawing.

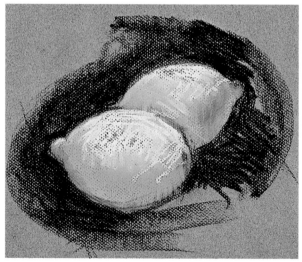

▼ 3. By now the forms of the lemons are perfectly defined. At the start of this chapter we saw how pastel could be corrected easily. In this exercise it is not necessary to rub out the lines of the layout: you can paint directly on top since the new color will cover them completely. As can be seen, the layout is very important to ensure that the picture evolves smoothly.

WORKING OUT THE COMPOSITION

When the forms of the model are even more complicated, you must be able to fall back on a more thorough layout. The most difficult forms to do are the symmetrical ones, and shapes that are nearly pure geometric figures. In fact, it is much more complex to do a simple white plate than to do a very exotic flower or a stormy sky. Whenever you have to do a geometric object, it is best to do a well-structured layout.

▶ 1. *This could appear to be a very simple exercise since "all" we are going to paint is a plain teapot and a flower. In fact, it is more complicated than it seems because the teapot has very precise forms in which every line of its structure has to be perfectly balanced with the overall image. In contrast, the flower does not have to be developed so accurately. First, do a layout of all the forms. The sketch of the teapot must have simple lines that make a square. The flower lying on the table can be sketched as a circle, and the stem as a simple line.*

▶ 2. *Even though we do not yet have sufficient visual references to do all the teapot, the initial drawing of the flower is finished. Inside the square form that has just been outlined, a cross is drawn, centered in the middle of it—it will be the symmetrical axis of the definitive drawing. Using this axis, outline the spherical form of the teapot. The vertical axis is used to establish both the center of the lid and of the base. The horizontal axis is a reference point to position the spout.*

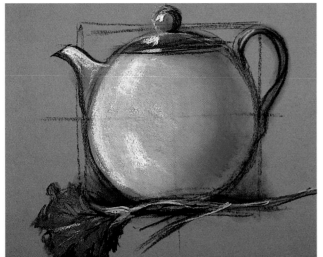

▶ 3. *The drawing is now finished off. Without the initial layout structured into different parts it would have been difficult to develop the form of the teapot. However, to do the flower just a few strokes are necessary.*

Step-by-Step
A Still Life

Pastel is not only one of the most complete painting methods that exists, it is also the medium which most resembles drawing. It is fundamental to learn to use all of the strokes and marks possible. In this exercise we are going to try out these possibilities with one color only, creating a monochrome while studying still life composition. In future exercises we will include all the colors that this medium offers. Pay special attention to the simple forms for they help us to tackle the more complicated and elaborated forms.

3

1

2

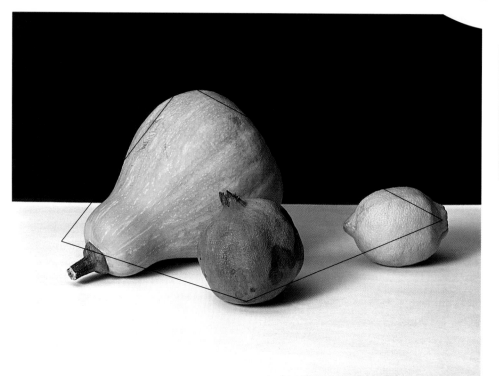

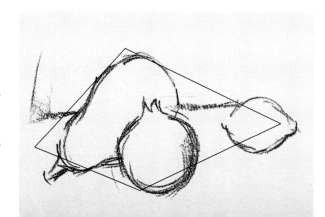

1. *All drawings must be started with a carefully plannned layout. This will be the base on which all pastel pieces will be developed. However complicated a painting may appear, it is always based on simple, well-structured forms. Use the tip of the stick to do the layout.*

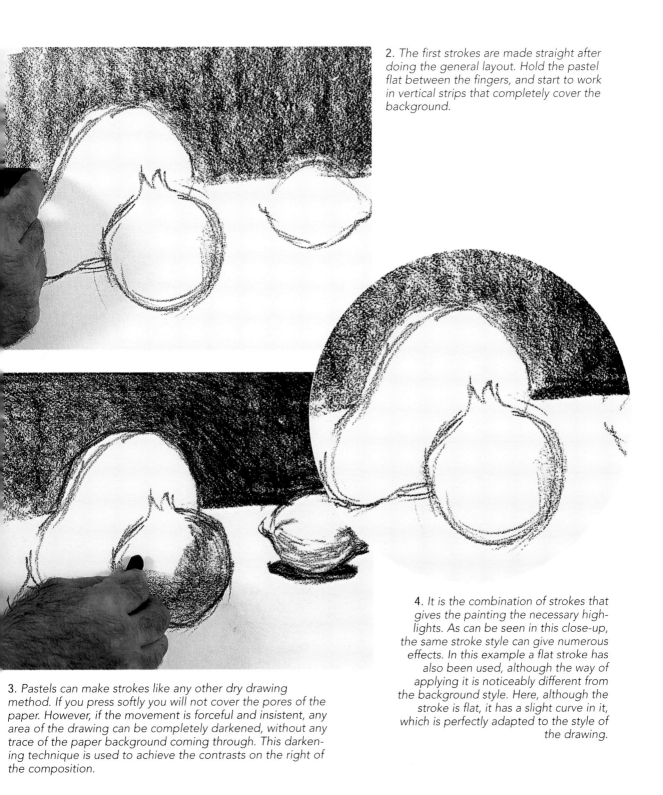

2. *The first strokes are made straight after doing the general layout. Hold the pastel flat between the fingers, and start to work in vertical strips that completely cover the background.*

3. *Pastels can make strokes like any other dry drawing method. If you press softly you will not cover the pores of the paper. However, if the movement is forceful and insistent, any area of the drawing can be completely darkened, without any trace of the paper background coming through. This darkening technique is used to achieve the contrasts on the right of the composition.*

4. *It is the combination of strokes that gives the painting the necessary highlights. As can be seen in this close-up, the same stroke style can give numerous effects. In this example a flat stroke has also been used, although the way of applying it is noticeably different from the background style. Here, although the stroke is flat, it has a slight curve in it, which is perfectly adapted to the style of the drawing.*

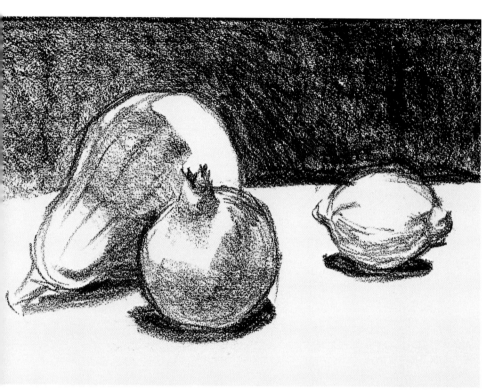

5. *As we have seen in different exercises, using the pastel flat can give a great variety of effects. Depending on the stroke, in some areas the pores of the paper will be completely covered by the pastel, and in other areas the stroke will be adapted to the design of the form. Use a flat stroke to shade the pumpkin. Go around the shape applying minimum pressure so as not to block up the pores of the paper. On top of this stroke do the furrows with the tip of the stick.*

Soft pastels are especially suitable for pieces which need shading. Although, they crumble very easily, do not throw away the little stubs because they can be used to paint small nuanced details.

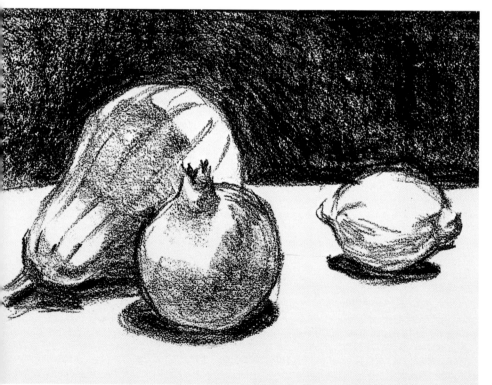

6. *When you want to darken a previously shaded area, another pastel application is made. The shade of darkness that is achieved will depend on the type of stroke used. In the background the still life forms are re-stated, but this time on the left where the stroke was much weaker.*

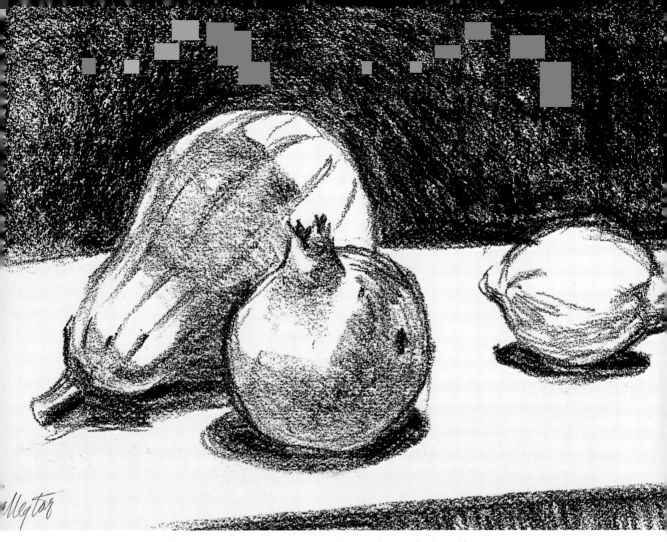

7. *To complete the exercise, all that remains are some final strokes in the lower part of the composition using the tip of the stick. Throughout this exercise we have seen how different stroke styles can be applied, and how layout is developed. This same technique can be useful in any of the exercises that are presented in the following topics.*

SUMMARY

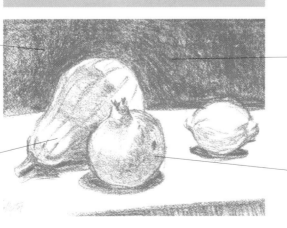

Pastel can paint with its entire surface. The stick is used flat to color the background; the strokes are vertical.

Superimposing strokes on top of one another produces dark areas. If you press down hard enough, the pores of the paper will be covered completely.

The stroke obtained with the tip of the stick helps to draw lines and fine marks, in the same way as if one were drawing with a pencil.

If a low pressure stroke is made, the paper grain shows through. The areas in which the texture is noticeable are gone over very gently.

3

Layout and Shading

STARTING THE LAYOUT

The layout of any picture is always started with the essential lines, which are indispensable for establishing the basic structure of the picture. For example, if you are going to paint a bunch of flowers, the first lines do not reveal the small details, rather they establish the context and the areas of light and shade. The first lines have to be the basis for later work which will build on the simple forms done in the preliminary sketches.

To paint a picture well, it is necessary to begin it correctly. A good initial construction is a perfect base for what follows after, whatever the theme may be. In this chapter we are going to place special emphasis on the construction of the model. It is fundamental to learn the processes that are explained. If these become part of the routine of work, the rest of the process will be easier and more successful.

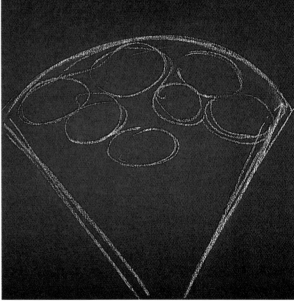

▼ 1. *Starting out from an initial sketch like this one, which any beginner can easily do, you can draw the lines for the internal structure of the picture. These lines do not have to be definitive. Just as on the clean paper, the initial plan was sketched, now inside this plan the forms of the flowers are laid out. The first form is triangular and inside this shape more precise elements can be included.*

▼ 2. *When the structure of the picture has been defined, the finish will be much more precise. This work process will help the artist to attempt any model, no matter how complicated it may appear. With practice, the first steps of the layout can be omitted, although the image of every step must be born in mind.*

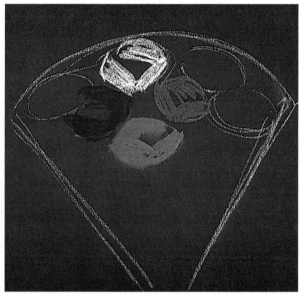

SHADING AND WORKING ON THE COLOR

Once the layout has been completed on the paper you can start the shading work in the picture. The first thing to do is remove all supplementary lines used to construct the still life. Depending on the method being used for the picture, these lines can be either erased or painted over with other colors.

▶ 1. *Once this first stage has been completed, use a spray fixative. However, bear in mind that if you fix the layout, it cannot be changed later.*

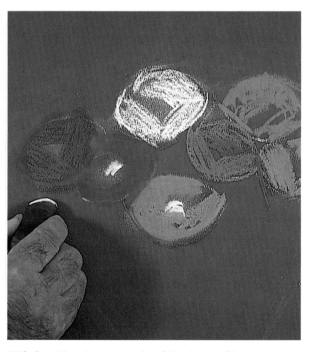

▼ 2. *Pastel has the great quality of blending or of behaving almost like a line drawing. Both these effects must be well controlled from the beginning of the shading process. The areas that have been blended can then receive new firm strokes. On top of these first marks new lines can be added that define the contrasts. Use an eraser to rub out strokes that overrun the flower contours.*

▼ 3. *There is one exception to the no mixing rule. As it is very difficult for the artist to have all the colors on the market, a practical and common trick for the majority of pastelists is to use black to develop tone ranges. Observe the wide range of tones that can be achieved with black as a darkening agent, but, of course, when it blends, the colors below the stroke become less noticeable.*

COLOR NUANCES. THE ABSENCE OF MIXES

As we have studied so far colors are not mixed in pastels. The artist's palette is what he or she has in the box. Mixing would just spoil the colors. Having applied the first colors, the artist will go on to need more and more colors to enrich the painting. Although some of the tones may vary slightly, they will give freshness to the picture.

◄

1. *In the pastel technique, more than in any other, the color nuance is of fundamental interest. This is a straight-forward exercise in which the importance of different pastel tones can be appreciated. As you can see, mixes are not necessary to achieve numerous nuances. First, paint with the color that will be the base. In this first layer a gradation of three different tones can be achieved.*

◄

2. *Run the fingers gently over the top of the tones to blend the colors together. This is blending, not mixing. It simply allows the definition of a tone base on which direct strokes and nuances will be done. Take care to only soften the edges.*

> As it is not possible to have all the colors that are available in pastel, blending colors with black is a good option to establish tones and scales.

◄

3. *The color base allows new tones to be added. This time the tip of the pastel is used so that direct strokes can be superimposed on the underlying gradations. This is one of the most interesting pastel techniques that can be created. As you can see in this example, the different tones distinguish the different planes.*

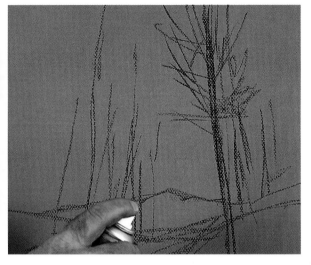

WAYS OF KEEPING THE PICTURE CLEAN

Pastel is a medium that is always vulnerable to being rubbed off. Being able to modify a picture also has advantages. However, sometimes this is a drawback: the picture is constantly vulnerable to being smudged accidently. In the early stages of a picture this may not matter much. However, as the painting develops, a mishap can mean that many work hours are lost. To prevent this from happening, several easy measures can be taken.

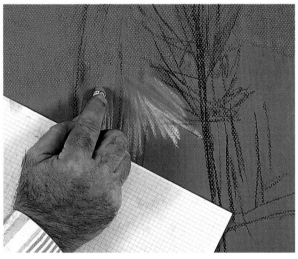

▶ *One of the most common and surest measures is to fix the pastel at an early stage. A light spray will prevent the first layers from becoming unstuck if they are inadvertently scuffed with the hand or another pastel stick. However, this measure should only be taken in the paintings early stages.*

▶ *When you paint with pastel it is quite easy to drag a hand over the picture and spoil the colors. However, preventing this is simple: just put a sheet of clean paper between the picture and your hand. Take care that you do not drag this paper across the painting.*

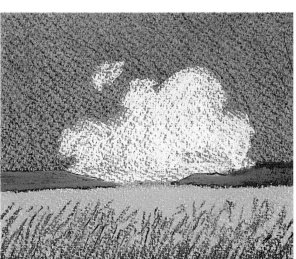

▶ *With the clean paper underneath your hand you can paint resting your hand against the picture without smudging the colored areas. Change the paper as often as is necessary to protect the brightest colors.*

Step-by-Step
Flowers

In any painting technique layout is a fundamental issue. It is curious to think that just a few lines to set out the shape are sufficient as a base for the most elaborate work of art. Pastel, as an opaque painting medium, is suited to doing the picture progressively. Corrections to the layout can be done as you go along, just like color application. In this exercise we are going to do a flower arrangement starting out from the initial sketch.

MATERIALS
Pastels (1), colored paper (2), and a rag (3).

1. *The layout must be structured. Just a few strokes are necessary to do these almost geometric elements. Starting from these forms you can go on to do a much more accurate construction.*

2. *Use the same pastel to further elaborate the layout. The forms are defined much more easily from the strokes of the first plan. It is not necessary to do an exact drawing because the opaque quality of the pastel allows it to be constantly retouched.*

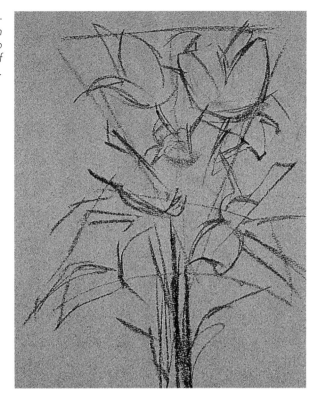

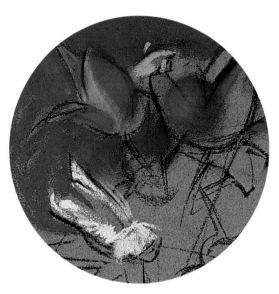

3. *Start painting the background in gray. Outline the forms of the upper flowers and cover over the initial layout lines. Start shading the upper flowers: the darkest petals with orange, and the lightest with a more luminous tone. Use white to give luminous tones to the flowers in the middle, but do not cover the paper completely.*

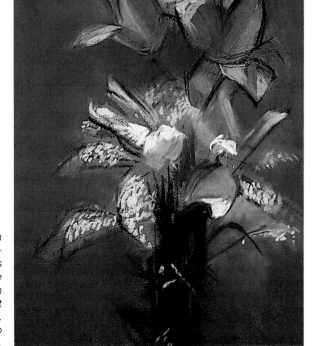

4. *The painting of the background is finished off with blue and gray. Start to blend the strokes with the fingertips. The shading of the flowers in the upper parts is continued with orange, leaving areas in which the paper color can be glimpsed through. Start to work on the texture of the small flowers by making direct strokes in yellow pastel. Two different yellows are used. Black is used on the stems of the flowers, and on top of this color, different green tone marks are made.*

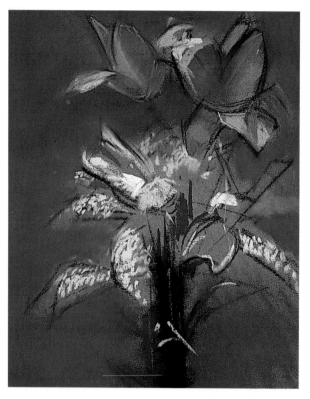

5. *Complete the blending of the gray background tones. All this area is unified by the fingertips, but without touching the flowers. Color touches are added to the yellows that were previously blended into the background. Yellow is now the base for further applications. The white flowers are also softly blended, but do not completely remove the glimpses of the colored paper.*

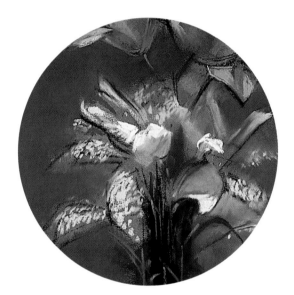

6. *The first applications of color have now been completed. All new additions are going to define and describe details of the forms in some areas, like, for example, the flower stems. As can be seen, the opaqueness of the pastel allows luminous blue strokes to be painted over the black background.*

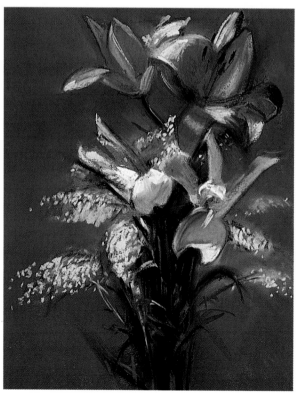

7. *On top of the tones of the upper flowers, do new strokes combining different colors, but without doing any blending. The highlights are applied directly: you do not have to use your fingers.*

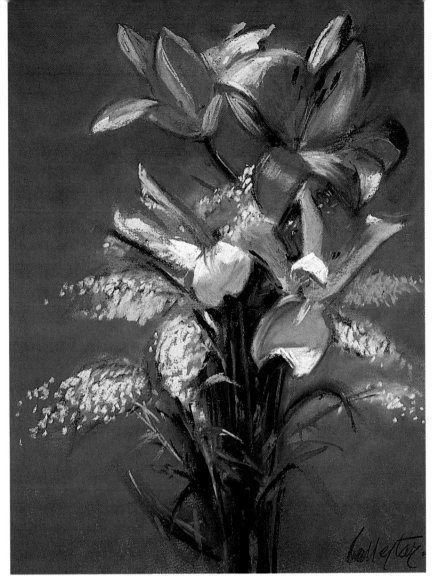

8. *The painting of the flower stems is finished off in a great variety of green tones and colors. The dark parts in this area are a perfect base to represent the depth of the shadows. Complete the outline of the white flowers with the dark tones and colors around them. Finally, numerous direct yellow strokes are added, which end up mixing with the earlier ones and the tones blend into the background.*

SUMMARY

The initial layout is completely geometric. In this way you can set out the whole composition without entering the details.

The shading of the upper flowers is very manneristic. Start with just two colors.

The white flowers are outlined by the tones that surround them.

On top of the initial black color of the stems, paint in luminous green.

4 Blurred Edges and Outlines

SEPARATING THE COLORS

Tricks do not really exist in painting; they are just correctly used effects. In this chapter we are going to do various examples that show the advantages of pastel: how and when to use them. Some areas are to contain blended tones. Other areas are to be linear, formed by unblended strokes and stains. In the following example both methods can be studied.

One of the most widely used effects in the pastel technique is blending tones by rubbing the fingertips across the surface of the paper. This topic presents a series of important issues that must be kept in mind when developing a picture. A beginner must learn how to use each effect to the right degree in each area. Due to a lack of experience, some artists construct the whole picture only by blending, which means that the stroke marks and the freshness disappear completely. Others prefer to use strokes but go too far and convert the piece into a pastiche of marks.

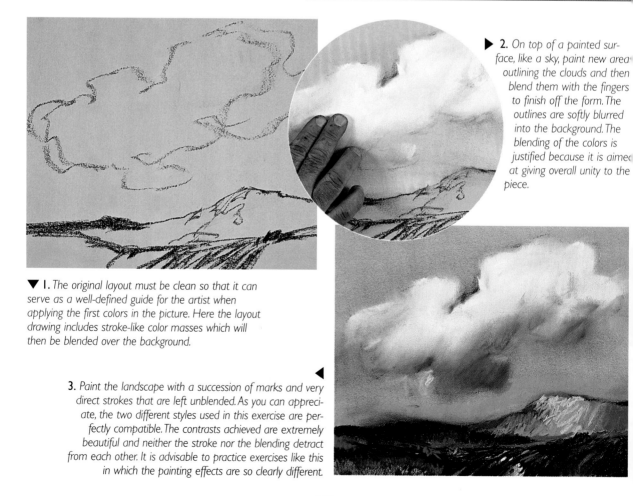

▶ 2. On top of a painted surface, like a sky, paint new areas outlining the clouds and then blend them with the fingers to finish off the form. The outlines are softly blurred into the background. The blending of the colors is justified because it is aimed at giving overall unity to the piece.

▼ 1. The original layout must be clean so that it can serve as a well-defined guide for the artist when applying the first colors in the picture. Here the layout drawing includes stroke-like color masses which will then be blended over the background.

3. Paint the landscape with a succession of marks and very direct strokes that are left unblended. As you can appreciate, the two different styles used in this exercise are perfectly compatible. The contrasts achieved are extremely beautiful and neither the stroke nor the blending detract from each other. It is advisable to practice exercises like this in which the painting effects are so clearly different.

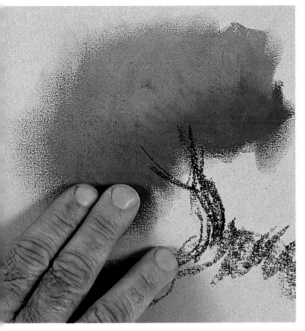

PROFILE OF THE AREAS

In the previous section we studied an exercise in which we practiced blurring and using different strokes in different areas of the picture. However, both work styles can be combined to bring out the best of the pastel properties. On this page we are going to show an example of how one style of painting can be combined with another.

▶ **1.** *When you paint with pastel you can choose to leave the stroke on the paper as it comes off the stick, or you can spread it with the aid of the fingers. Spreading a mark with the fingers helps to model forms like the base of the treetop. First, make a pastel mark, and then spread the color out with your fingers until it blends with the background. The blending is slightly blurred at the edges.*

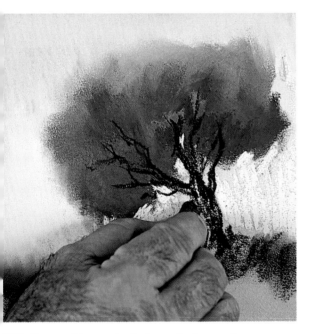

▼ **2.** *On top of the smudged color, apply direct strokes. The background color on which they are laid enables the definitive forms of the trees to be outlined. The colors painted earlier provide a perfect base as they show through the peeks left between the color masses. One of the interesting effects in pastel painting are firm strokes which leave a mark and a mass of color on the paper.*

▼ **3.** *After outlining the branches, do the same with the rest of the picture areas. Superimposing layers of color will be one of the most widely used effects from now on, as well as painting with softened edges and building up layers that are left more fresh and spontaneous.*

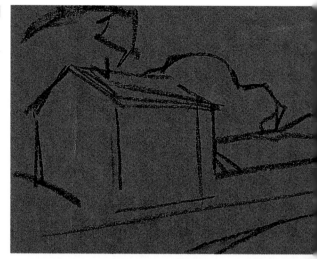

1. Before starting the landscape contrasts, it is important that each of the areas be specified in the drawing, otherwise the colors will end up getting mixed, which must never happen with pastel.

SIMULTANEOUS CONTRASTS

B ehind this complicated title there is a technique that is common to all drawing and painting methods. It refers to the optical effect created between tones and colors in the picture. In reality, it refers to the laws of optics and the way the human eye functions. When a luminous tone is painted between dark tones or colors the former will be seen much more clearly because of the contrast effect with the darker tones. This also happens when a dark tone is placed between light tones. The dark part will appear much denser. In this exercise we are going to practice this interesting visual effect.

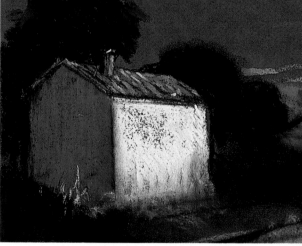

2. When the initial sketch has been set out, the marks must be added according to the way you intend to use the contrasts. In this example the highlight is going to be on the small house in the center left. Do the rest in darker and more contrasted tones and colors to increase the luminous tone of the building.

In the pastel technique, the tone of the paper is important when the other colors come into play. Dark tones painted over dark paper will seem darker than they actually are.

3. As can be seen, although the white of the house is the most luminous tone, it does not have to be painted completely pure. Other clear tones like Naples yellow can play a role. The contrast provoked by the darker tones that surround this tone allow it to be appreciated as a highlight.

TESTS ON PAPER

The two methods that are being explored in this exercise will be tried out with a common subject but on different colored papers. The pastels used to do these horses' heads are the same. The aim is to show the extent to which the paper color can influence the result. In this exercise it is important to bear in mind the value of the tones since color values change with their background. Each of the paper colors responds in a different way to the stumping, although the same color pastels are used.

▶ *Draw this first head on gray colored paper. On this paper the colors stand out with great luminosity as gray is considered a neutral tone: it only influences the other tones through the simultaneous contrasts created by the lighter tones. The background color comes perfectly through the initial stumping. On top of this blurred color, draw with direct, strong strokes which will integrate well on this tone.*

▼ *The exercise here is the same as the last one, although in this example the paper used is red. As you can appreciate, the contrasts between the dark parts and the clear areas show through with great naturalness.*

▼ *Cream-colored paper allows the greatest naturalism in the tones and colors used, as it is not at all compromised by the contrasts created by the paper background tone.*

151

Step-by-Step
A Loaf of Bread

As you will come to realize in this exercise, an ordinary loaf of bread can be a good model to practice the several painting techniques presented in this topic. The model choice is always important, although it should not be the question that determines whether you start painting or not. This would be a great error because the most ordinary object can be represented in such a way that it takes on a new dimension and is worthy of being considered.

MATERIALS
Pastels (1), gray colored paper (2), and a rag (3).

1. *The layout is started with a luminous color that stands out markedly on the paper. Once the corrections to the drawing have been made, the first contrasts with black pastel are started. The stroke has a very noticeable drawing style. It goes along the lower line marking out the definitive form of the bread.*

2. *Use the black pastel stick to strongly darken the background and to mark out completely the form of the bread. Use your fingertips to smudge the entire background. Inside the bread, paint golden yellow strokes and observe their characteristics. Each group of lines follows the form of the plane. On top of these recently drawn lines, the first contrasts are painted in red. They are softly blended with the fingers, but do not go all the way.*

4. *In this close up you can see how important it is that some painted areas remain fresh and intact. The contrast between completely blended strokes and others which remain untouched during the painting process is the key to painting in pastel.*

3. *Darken the upper part of the background totally, without shading the inside of the bread. This makes the contrast absolute. In the lower part, blend the dark color, and on top of it paint in blue. The shadow of the bread is painted in an umber color, but without totally filling the area. The finger work helps the distribution of the shadows over the tones in the lower part.*

5. *Contrast the entire background by completely blending the tones used. However, to get some luminous nuances, especially in the foreground, add some blue strokes. On top of the blended surface of the bread, you can start new strokes that allow glimpses of the color underneath to come through. This time the color employed is a very clear ochre orange which stands out against the hazy shadow tones because of its purity.*

When you are doing the main contrasts, do not use extreme colors like black or white, at least not during the first stages. This will enable you to improve the color composition as you work with gradations of the same color.

6. *As has been discussed already, colors that blend with each other produce dirty tones due to the mixing. To solve the lack of luminosity, paint the blue in the mid-ground once again. This time the area takes on a multitude of nuances. Then, apply direct yellow dashes onto the bread to restore the luminosity to these areas. Also, paint some emerald green touches to enrich the texture of the bread.*

7. Paint the table with cobalt blue in direct strokes that saturate the most luminous shadow area and increase the contrasts of the dark parts. The upper background, which was painted in violet carmine, will stand out much more because of the effect of the contrasts between the tones. To finish off, some luminous dashes are made on the hardest part of the crust. This will give the bread the floury look of having just been taken out of the oven.

SUMMARY

While some strokes are almost completely **blended** others remain intact during the painting process.

Paint the most luminous impacts at the end and leave them unblended.

In the lower area, blend the dark color. On top of it, paint in blue.

The colors that blend together produce dirty tones due to the mix. This effect enhances some areas.

Contrasts and Colors

GRADATIONS

The possibility of doing gradations, the way one tone gradually turns into another, is one of the principal stet aspects of pastel. We have practiced various types of gradations. Here we are going to work on gradations and contrasts with colors. Gradations are useful because they offer a succession of tones, or of different colors blended together, to form a harmonious color composition.

No medium is better than pastel in creating color blending effects. However, blending must not be confused with mixing, which must never be done. Blending, which forms part of the pastel technique, allows us to do more precise shapes. However, if we do not blend we can juxtapose colors that act as contrasting planes.

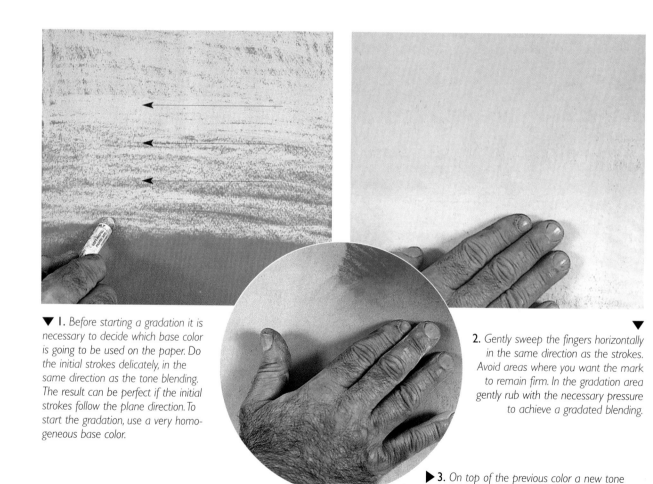

▼ 1. Before starting a gradation it is necessary to decide which base color is going to be used on the paper. Do the initial strokes delicately, in the same direction as the tone blending. The result can be perfect if the initial strokes follow the plane direction. To start the gradation, use a very homogeneous base color.

2. Gently sweep the fingers horizontally in the same direction as the strokes. Avoid areas where you want the mark to remain firm. In the gradation area gently rub with the necessary pressure to achieve a gradated blending. ▼

▶ 3. On top of the previous color a new tone has been painted with the objective of gradating and blending it with the fingers. Note that the objective is not to do a mix between the two colors: this would just make them dirty. You simply have to blend the upper and lower tones.

TONES

Tones are the reflection of the fact that a color or a family of colors can gradate. With pastel, as with other drawing media, different tones can be achieved by studying value and the blending of one tone on top of another. However, pastel is different in one way from the other drawing media in that it can be completely pictorial: by combining tones and playing them off each other pastel can produce mixing effects normally associated with strokes or shadings. In this exercise we are going to be working with tones, blending dark over light.

▶ 1. *Doing this tone exercise with fruit as the subject ties in well with many different drawing concepts. However, as soon as the paper color background forms part of the chromatics of the picture, the initial concept of the drawing varies as the guidelines of painting take over. Once the first shading is made, the parts of the background that show through blend in with this luminous color.*

▶ 2. *On top of the first yellow tone, add in a dark color. Later this tone will be blended with the first color but this does not mean that the whole range of pastel colors will vary because you are not going to mix any colors; you are only going to blend warm tones together.*

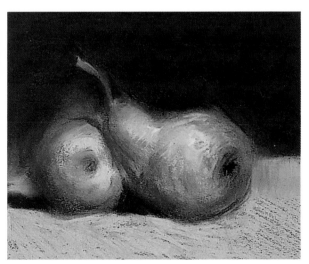

▶ 3. *Paint the entire background in such a way that a strong contrast is created between the foreground colors and those behind them. Paint the foreground of the table in an orange tone to finish off the color composition. Do the color blending with your fingers, rubbing one tone over another. To gradate the tones it is advisable to use a palette of colors of the same range.*

TONE AND COLOR CONTRASTS

Colors can be approached in two very different ways. As we have seen, blending two colors as if they were tones can easily become a modeling exercise. Nonetheless, you can also opt for a different work style: the contrasts do not have to be produced by directly blending the tones; you can produce them by directly contrasting colors. Working like this gives eye-catching results which are enhanced by the pastel technique. In this exercise the work will be twofold. The first stage is blending the tones, and the second phase is the direct color contrast.

To check on the optical effect of some contrasts it is wise to do a test beforehand on paper prepared for this type of work. When white paper is being worked on, the tests can be carried out on everyday paper.

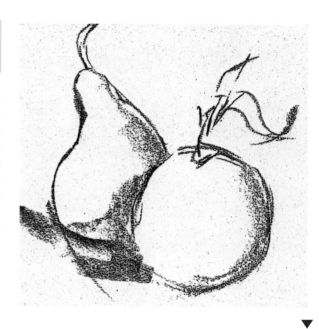

▼

1. *Whatever the pastel piece may be, the preliminary sketch is of vital importance to the construction of the composition. This layout style can be used in the following two exercises. Just a few lines are required to suggest the forms of the two pieces of fruit. At this stage all painting methods are the same.*

▼ 2. *In this amplified close-up of the painting you can appreciate the blending of the tones and the way the dark areas gradate over the light areas until they are perfectly merged. Both the deeper shadows and the light half tones blend softly with the lower layers to give tonal contrasts.*

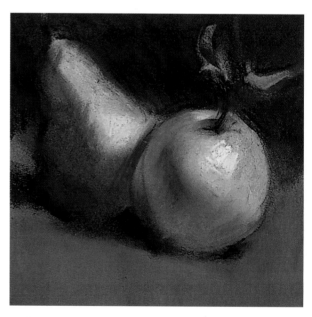

▼ 3. *When the piece is finished, you can observe how the shadows blend with the most luminous tones. The light tones do not make a striking color contrast, rather they are differentiated by the complemetary contrasts. Summing up: the light areas and the dark areas mutually strengthen each other.*

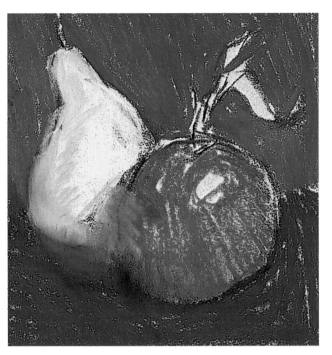

CHROMATIC CONTRASTS

In the first part of this exercise we studied how light areas and dark areas can be blended together following the same tone scale. This second exercise aims at working on the same topic as before, but with a completely different understanding of color. This time the contrast created is not tonal but chromatic. Pay special attention to the different planes and how the colors react to each other.

▼ 1. *This exercise starts with an identical layout as before. The opening lines allow you to start conceiving the work, regardless of how it will be continued later. Start the exercise by applying very defined colors that contrast strongly with each other. The first strokes are direct and spontaneous.*

▼

2. *In this close-up you can observe that although some areas blend together, others have a fresh and direct finish. The areas that merge are next to others which still have the original stroke pattern, through which the paper grain and color can be seen.*

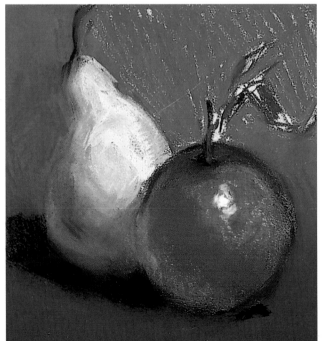

▶ 3. *Although it is important that the colors contrast strongly with each other, the tone mixes also play a role. For example, in the background the brightest blue is mixed with a less intense and much darker blue area. It is crucial that the different colors do not interfere with each other, or if they do, that it is as discrete as possible to avoid the danger of the different colors becoming mixed up. A blue can mix and blend with another blue, but it must never do so over an orange.*

Step-by-Step
Seascape

The blending and contrast of tones is a constant aspect of all pastel techniques. Sometimes the color can be treated as if it were cloud-like and expanded over the paper without fixed limits. At other times the color will have perfectly marked forms and the stroke mark will be visible. To put the blending and stroke contrasting techniques into practice we are going to do a seascape. This is a straightforward exercise despite the intimidatingly magnificent result below.

MATERIALS
Pastels (1), blue colored paper (2), and a rag (3).

1. *Painting in pastel can often seem like drawing. However, at this stage, since the painting develops in opaque color layers, this first layout does not have to be an accurate drawing. To start this exercise, put in a high horizontal line, leaving a vast expanse of sea which is more than sufficient to practice all types of blending and tone superposition exercises.*

2. *The color range that is going to be used to elaborate this seascape belongs to the harmonious cool range, which consists of greens and blues. Using this restricted scale, and taking advantage of the color of the paper, the contrasts that are applied will not be chromatic but tonal. Firstly, paint in the narrow strip that corresponds to the sky. Work on the sea with a strong luminous blue that contrasts with the paper. Paint the foam where the waves break directly in white. Then immediately tone down the stroke with your fingers.*

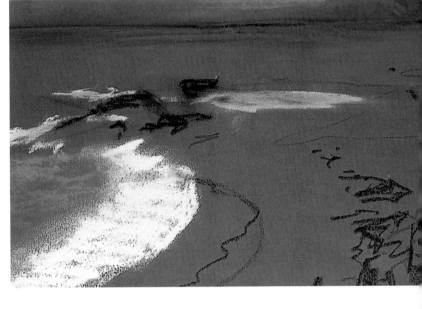

3. *On top of the white foam of the sea put in some blue marks. These are perfect for blending with the fingers. Outline the frothy edge of the sea in a greenish tone, and next to this color paint in blue before finishing off the blending. On the right you can start the waves splashing against the cliffs in jabbing little white strokes.*

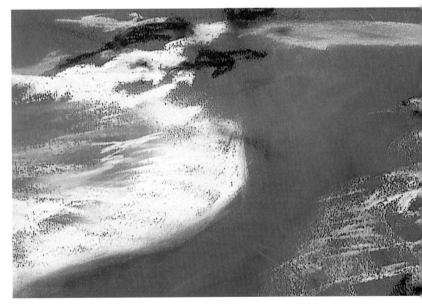

4. *A progressive blending of blue tones starts out from the horizon using ultramarine blue. However, do not let it cover the paper completely, allow its color to show through in some places. You can see that there is a clear difference between planes: they are separated by a horizontal whiteish line and the rocks on the left. All the frothy parts are painted with direct white strokes and little dashes.*

Remember to reserve the brightest areas, where the highlights will go, because together with the maximum contrasts, they will be painted last.

STEP BY STEP: Seascape

5. *In the lower area where the waves break against the reef do a color blending of the white against the background. Then immediately draw with the white pastel stick. This time the stroke is direct. On top of the rocks in the foreground, which were stumped in black, lay down blue strokes and then softly blend them with the darkness already on the paper. This will give shape to every rock. In the background, above the line of the horizon, the form outlines can be finished off. As you want to avoid the stroke marks being too direct, gently blend them with the fingers.*

Blend the base color in the background to create an initial layer of colors without a definitive outline.

6. *Direct strokes and blending are very important to represent the sea foam. This step is not difficult, although it is necessary that the base white color be gently integrated over the blue background tones. Once the different tone blendings have been done you can add new white jabbing strokes.*

162

7. *In the intermediate area between the foam do some new color blendings. However, make these more subtle. In the upper part of this area, the pastel stick is used flat and lightly, thereby enhancing the effect of the texture. Outline the dark parts of the rocks with the pastel point. All that remains to be done are some direct white touches above the horizontal sea spray line to create the impression of splashing.*

SUMMARY

The middle distance marks the difference between the two planes in the picture. Below this line the work will be much more meticulous.

Once the wave tones have been blended you can do new direct additions that bring out the texture and contrasts.

Blend the first white color addition into the blue tone background.

Over the black rocks paint in blue.

TOPIC
6

Fixing Pastel

FIXING THE FIRST LAYER

The first layer can be fixed provided that it will not have to be corrected later, or if the picture is going to be covered completely with color. Spray fixative is a good tool if it is used in moderation and at the right moment. In this first exercise we will show some of the effects that can be used before and after the first layer, which may only be the design drawing before being colored is fixed.

On several occasions in this book we have mentioned that pastel is a fresh and spontaneous medium, however this characteristic could be lost if it is fixed. Using fixative can be very helpful when you are doing the first layers. It is worth pointing out that the finished painting should never be fixed. The methods explained in this chapter will help you to get the most out of pastel and the effects you can use.

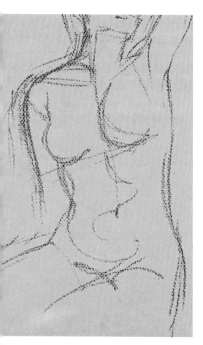

▼ 1. The sketch can be done in line or side strokes. It can easily be corrected by rubbing out or by drawing over the lines. Do not press too hard with the pastel stick so that corrections can be made later without leaving the stroke too marked on the paper.

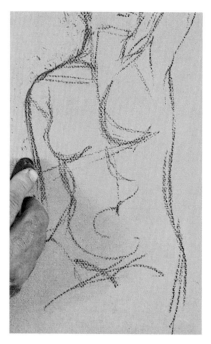

▼ 2. The eraser can restore the definitive lines. Thus the sketch will become much more defined and can serve as a firm base on which to paint. The fundamental lines have to be kept clean of all extra strokes.

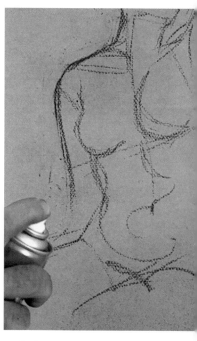

▼ 3. Once you consider your layout drawing to be complete, you can fix it. The fixative must be sufficiently far from the paper so that the spray forms an even film, without leaving drops. Once the drawing has been fixed you can only correct it by painting on top of the varnished drawing.

▶ **I.** *Fixative dries very quickly and allows you to continue using pastel almost immediately. If any area is damp, it is wise to wait for a few moments until it is completely dry. The wet areas shine a little until the moistness completely dries them up.*

SECOND LAYERS ON TOP OF A FIXED BACKGROUND

The fixing process guarantees that the initial strokes are preserved. However, it also allows you to establish certain shading and color effects as a base for the final finish. The new compositions that you make will not affect the lines fixed beforehand.

3. *Fixing the first layer means that it is possible to redo the painting as many times as you need to, adding either contrasts that outline the principal motif against the background or highlights that give volume to the forms. Use direct stains or strokes, letting the underlying color show through. Applying another layer of fixative would just clog up the stroke.*

▲

> You can make new pastel strokes on top of the perfectly fixed drawing. The effects for this exercise have been chosen to demonstrate different composition and fixing techniques.

▶ **2.** *As can be seen, when the color just put down is spread with the fingers, the drawing that was fixed in the first part of the exercise remains stable and visible. Regardless of how much you rub it, neither the background nor the new colors will disturb it.*

Topic 6: Fixing Pastel

COMPOSITION AND CONSTRUCTING THE PAINTING

The unique properties of pastel open up a wide range of possibilities and effects. Bright, vibrant colors can be placed next to each other. You can then overlay them, correcting as you go along. Pastel fixing enables you to secure entire layers that will be the color base for later layers, no matter how many you may lay down.

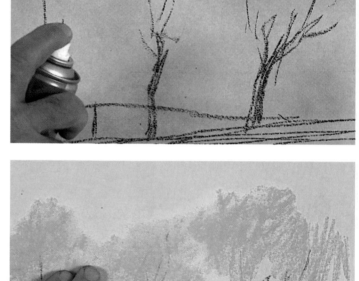

1. As you could appreciate from the last exercise, the layout can be fixed once it is totally finished. Fixing can be very useful for even a simple landscape sketch. As you will now see, the color effects created on this perfectly-defined linear drawing do not alter the original forms. It is not important if a few preliminary sketch lines remain, as is the case here, because later the colors applied will cover them up. ◄

2. Once the support sketch has been fixed the first color applications can be made. These strokes are then blurred with the hand but the layout beneath remains unaffected. The preliminary sketch references enable us to rectify and retouch the landscape forms. If you have to flick off some pastel, the lower levels will remain stable. ◄

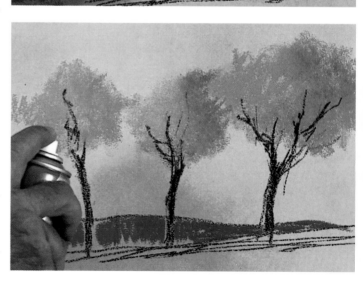

3. As we are going to continue working on the picture, putting in more interesting color layers, spray on another very faint layer of fixative to ensure that you have a solid base on which to work a whole range of effects without altering lower layers. Above all, bear in mind that you must never fix pastel when the piece is finished. ◄

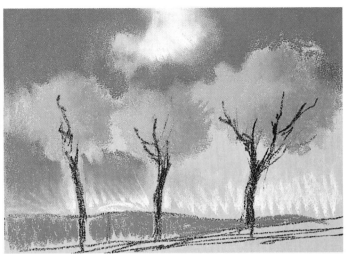

EFFECTS OVER A FIXED BACKGROUND

A color base is the best support that can be used with pastel: the new colors will be enhanced if the chromatic base increases the contrasts and the effectiveness of the blendings. In any case, as we have said before, fixative can only be used during the first additions because we want to preserve the freshness and spontaneity of the final strokes.

▶ 1. *The previous color base is perfect to continue the picture by adding new color or tones. Here, you can observe how the clouds are painted and blended on the background without the color mixing. From now onwards, any correction will have to be resolved by adding a new color layer above it. Just as the clouds were painted without altering the layer underneath, strokes and shading are added to the tree allowing the under layer to show through in some areas.*

▶ 2. *For the ground, the details can be resolved with a direct style. The background color is a very apt base for new tones that are applied in pastel. In this area of the picture the different effects can be combined with direct strokes or color blending.*

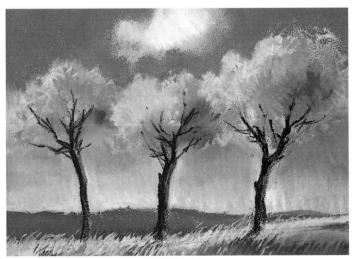

> Painted layers of fixed colors make a good base to which pastels can stick, rather like a primed surface.

▶ 3. *A direct or fresh finish can be the ideal solution when using the effect of fixative at different stages. As can be seen, the lower layers show through the perfectly marked off and constructed new areas. The new blendings do not mix with the background colors, thus giving the pastel an incomparable freshness.*

Step-by-Step
Flowers

The pastel technique is the freshest and most spontaneous pictorial method, provided that you use it correctly. If you do not master the technique, or if you go beyond your limits, a picture that began with color and style could be spoiled simply by spraying fixative at the end of the piece. Timing is very important: never apply it at the end of the process. In this exercise we are going to paint some delicate flowers, with an emphasis on expressing the delicacy of color.

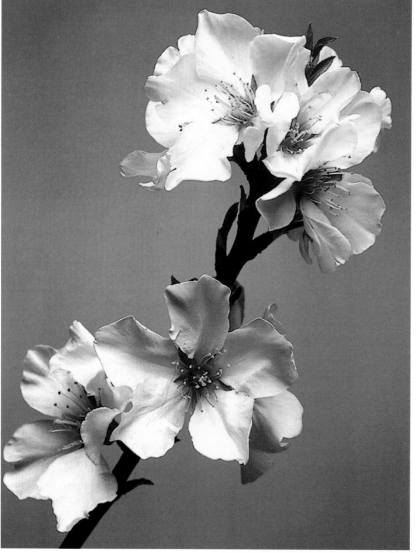

MATERIALS

Pastels (1), dark blue colored paper (2), spray fixative (3), and a rag (4).

1. *As we have chosen dark colored paper, the best way to sketch the drawing is starting with a very luminous color, like white pastel. Sketch the principal lines with rapid strokes, only working on the planes. You can leave out the details for the time being.*

2. *Start the painting of the upper flower in a gray tone, which will appear to be luminous, even on the dark background. This color is perfect for the areas of the flower which are in shadow, using a series of lines drawn closely together to give a shading effect. Use pure white for the brightest areas of the flowers: all the tones that are going to be developed are now in place. Outline the form of the flower by painting the background in marine blue, one of the most beautiful and luminous pastel colors. Use your fingers to blend the white over the blue background to give a much more white-ish blue than before.*

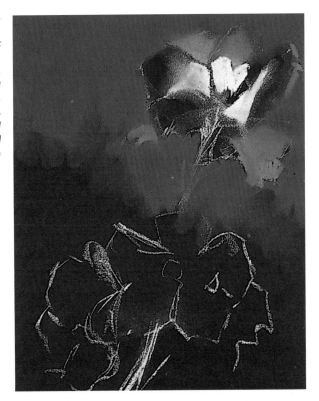

3. *Continue painting the upper flower applying direct white color. Above this, paint gray to obtain the medium shadow tones. Without going so far as to completely block out the drawing form of the petals, blend the contrasts which appear overly brusque. This blending is extremely easy. The background paper color acts as a dark contrast between the petals.*

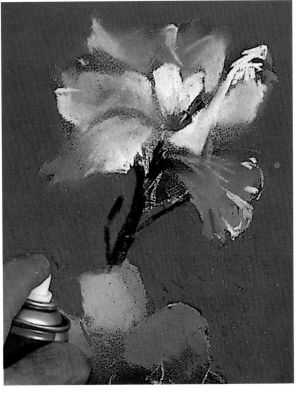

4. *On the upper flower, start to paint some very direct white strokes to position the highlights. Bright orange and yellow strokes depict the center of the flower. Paint the stem with rapid strokes in dark green. Do not go into details. Apply a layer of fixative to the entire piece. Hold the spray can far enough away so that the fixative does not clog up the paper surface or make the pastel sticky. A light spray will suffice to protect the work against dirt or friction.*

169

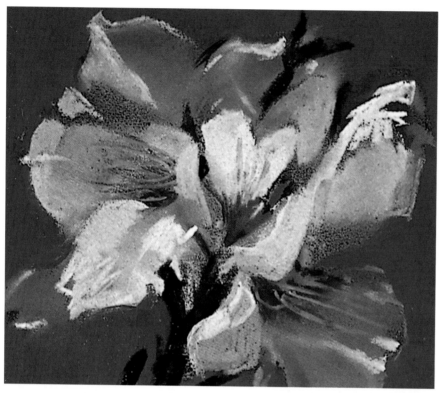

5. *The previous base has been fixed with the aim of protecting it as you continue working. For example, the new gray that has been painted on the petal of the upper left flower can be spread over the lower colors without dragging them in the process. Finish off the highlights of the petals that touch the background in this same way. The same approach is also valid for new orange touches that enrich the shadows.*

When you use a pastel fixative it is advisable to choose a well-known brand. Good quality manufacturers go to great lengths to ensure that their products do not interfere with the techniques or media used.

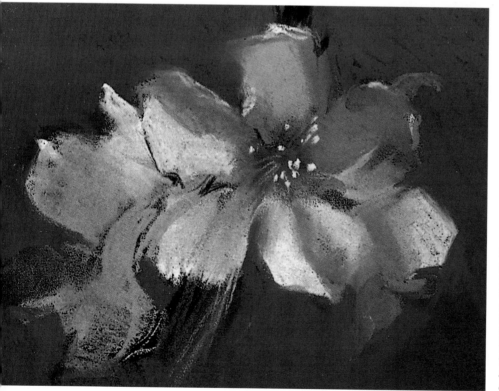

6. *While painting the upper area, you used the tones as the base for new color additions. You can do the same with the grays on the lower flower. When they have been fixed use them as a base for fresh tones. The blending of these colors will in no way affect the lower colors. Fixed colors do not mix.*

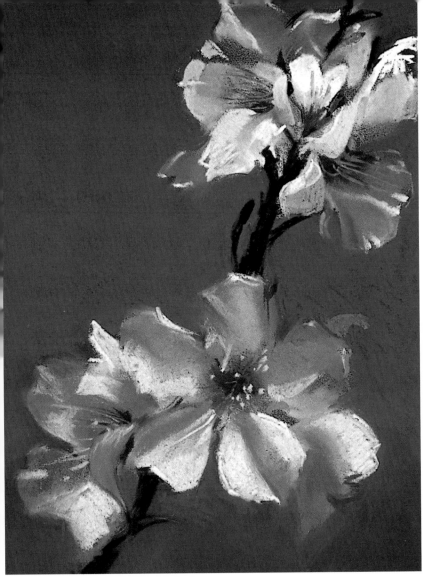

7. Paint nuances of color that blend in with the edges of the colors underneath. This allows you to overlay new grays and very precise highlights. Lastly, all that remains to be done is paint direct red strokes and a few yellow dashes.

SUMMARY

A dark paper color means that the composition layout will be luminous. Here it is done in white pastel.

A blue much brighter than the background allows us to outline the flower forms. Establish highlights by painting the lightest tones.

Very luminous white details emphasize the flower outlines as well as the highlights.

Paint the grays of the lower flower over the already fixed pastel layers.

The Way They Painted

Degas

(Paris 1834–1917)

Ballerinas

Degas was one of the most important impressionist artists, recognized for his drawings, paintings and sculptures. His first creative period was of marked significance and included meeting Manet, who introduced him to impression-ism. The interest that he arouses in the plastic arts comes from the way he treated light and seemed to freeze time. Highly subtle blendings are combined with expressive direct strokes. His style enabled him to work on artificial lighting and the tex-tures that abound in theater.

Degas was especially fascinated by ballet dancers and musicals for two reasons: first, he could study the dif-ferent effects of artificial light, and second, he could try to make time stand still. Degas was one of the most important pastel painters . If you study his work you can see how he used color to express light and forms, working in a direct and pure style. The light creates strong con-trasts, although we cannot define them as chiaroscuro because there are hardly any subtle changes between the tones. This characteris-tic of his painting is enhanced by the fact that pastel technique allows you to work with a direct style, superimposing light tones on top of dark ones.

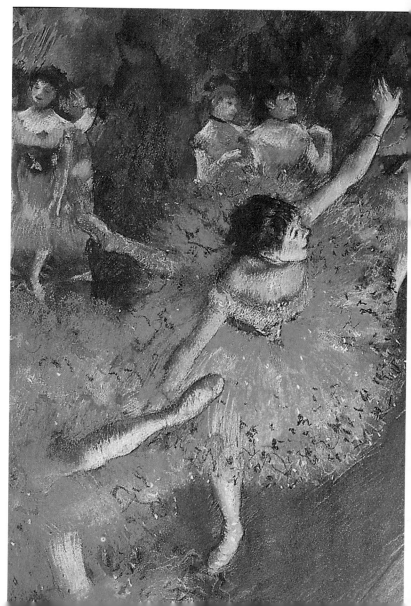

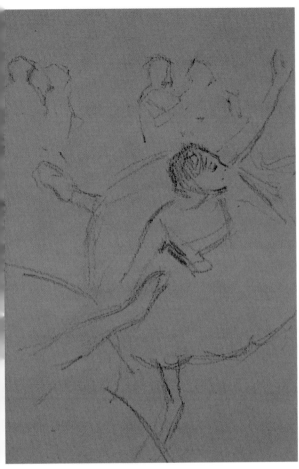

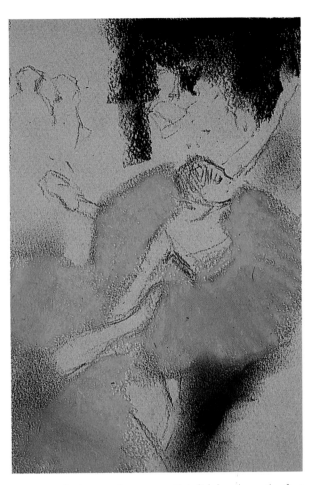

1. *The preliminary sketch is very important in this exercise, otherwise it would be impossible to position the different elements in the composition. As the drawing above shows, the first step is linear. Although you could do it in pencil, try using the tip of the pastel stick. What is important is that the line is pure and simple. You can tell that Degas approached the placing and the planning of the composition at the same time. Use a brisk stroke, suitable for figures in movement, to start the painting.*

2. *Just as the great artist did, lay down the first color shadings as a base for later colors and to outline the color of the paper. Once both the proportions and composition of the drawing are complete—this exercise is only a fragment of Degas' work—you can start to paint in the first color strokes. First, do the areas that appear to be the least complicated, such as the dark background parts. Also, you can paint the dancers' tutus moving about their legs. The effect created is interesting because it is started in blue and then green is drawn over it to produce a luminous emerald green, as in the original piece.*

The colors must be blended in a very controlled way to avoid mixing them. The slightly off tones can be alternated with bright areas.

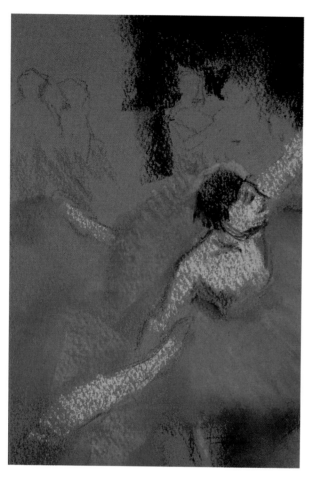

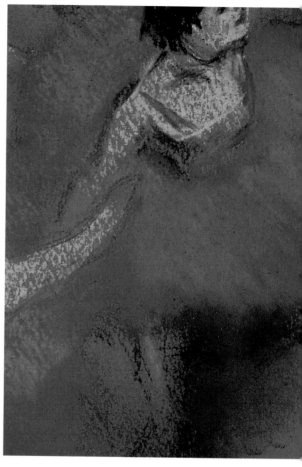

3. Degas used his vast knowledge of the technique to capture the moment. The combination of the striking color and the reserved background is effective. Where the paper grain has not been blocked out by the pressure exercised its color optically interacts. Use this technique to paint the figures in a very luminous pink, flesh color. In the background, start work on the dresses of the ballerinas with loose orange strokes that you must blend later.

4. Paint all the lower right area in a slightly off color obtained by directly mixing blue and black on the paper with the fingers. Only stop when the pores are covered and the background color does not show through. Before doing impacting color strokes, Degas would blend some of the colors, for example on the tutus where the light is somewhat diffused. The off-gray in the foreground is allowed to penetrate into the outline of the tutu, making the form less defined.

The color of the paper must show slightly through the densest pastel strokes so as to give the special atmosphere created by Degas.

5. *One of Degas' great contributions to Impressionism was the way he made light fall on the figures. Sometimes he simply depicted the distant ground with semi-blended shading. The brown color painted at the beginning outlined the two dancers hazily. Now, when the lighter flesh colors are applied, they become more defined. Due to the size of the drawing it is far simpler to do the colors with a pastel crayon. The stroke is somewhat harder and the tip will help you to do the fine, graphic details.*

Pastel crayons are delicate tools which must be treated carefully. When the point becomes blunt, do not use a pencil sharpener; a cutter works far better.

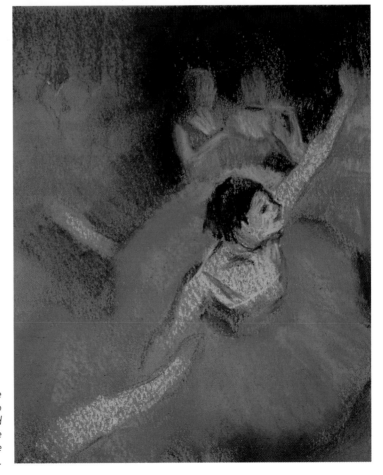

6. *Use two shades of green to define the background on the left behind the two figures. Keep the forms that are blended over the background very simple: it is the surrounding color that must insinuate them. Do not introduce the details yet.*

175

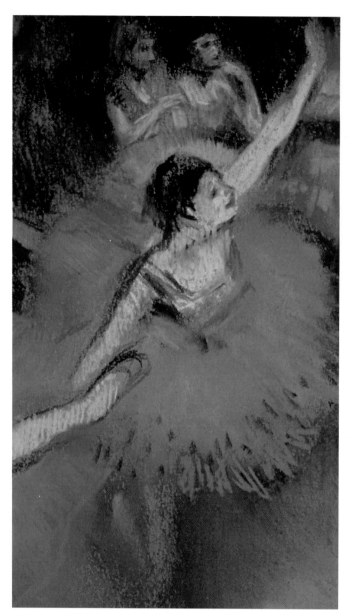

7. *Use a dark pastel crayon to start outlining the figures in the background. These small contrasts, together with the short marks, outline the heads and arms; they stand out for their luminosity, and define the features. You can produce a very characteristic texture as you are combining crayon strokes with the pastel stick. Shade in different directions in each area. With loose, bright strokes start to paint the adornments of the tutu.*

8. *When you paint the figures, the color of the paper begins to be more prominent in their outline. Just a few touches with light colors and a few low definition blacks will give the figures the desired look. Paint the highlights almost white, without ever using pure white, pastel tones.*

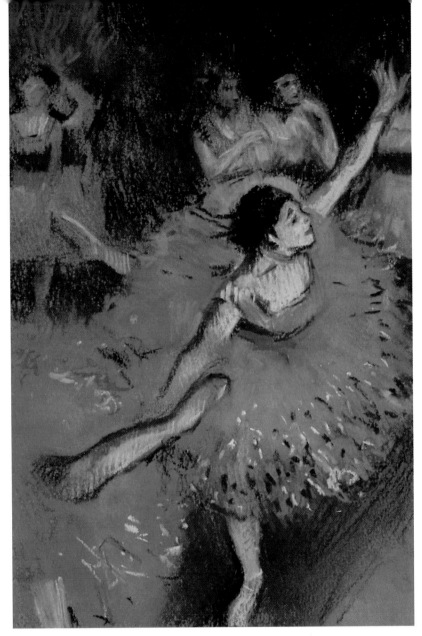

9. *It was in this final step that Degas showed his Impressionist side by using pure colors that contrast with each other. Paint them with direct, superimposed strokes. The tutu is now made more luminous than before, this time using the pastel stick, which gives a much more expressive and direct stroke than the pencil. Outline the face of the lead ballerina and the body parts of the other dancers again. Use blue pastel to shade some areas on the dresses and the skin to reflect the colors of the ambience. Finally, use a bright, diagonal stroke to finish off the painting of the floor.*

SUMMARY

The contrast between the figures and the background which outlines them makes the background appear brighter.

The strokes of the leading ballerina's tutu are brilliant.

The flesh hue is very luminous. The color of the paper filters through.

Paint the tutu in two different colors to obtain emerald green. They do not have to be mixed excessively.

A diagonal stroke is used on the floor to give it texture.

The Way They Painted
Claude Monet
(Paris 1840–Giverny 1926)

Waterloo Bridge, London

Monet was one of the leading impressionst painters. The name of the movement comes from his painting "Impression; Dawn", 1872. He never tired of working and developing his impressionist concepts throughout his career: his understanding of light, especially moving and dancing on the surface of the water and *alla prima* color touches. Consequently, his work has been highly influential on every generation of painters that followed.

Pastel can be applied in as many different ways as there are forms of working with fine arts. It offers as great a painting capacity as oil or any other media or technique, but, as you can see in this quick sketch, it also allows you to do direct, free and spontaneous drawings. Moreover, pastel has another advantage: it has its own unique technical effects, like the overlaying of light tones over dark ones, and the blending of colors. Monet offers a fine display of the technique of simultaneous contrasts in this spectacular but straightforward exercise in light.

MATERIALS
Sienna-colored paper (1), pastels (2), and a rag (3).

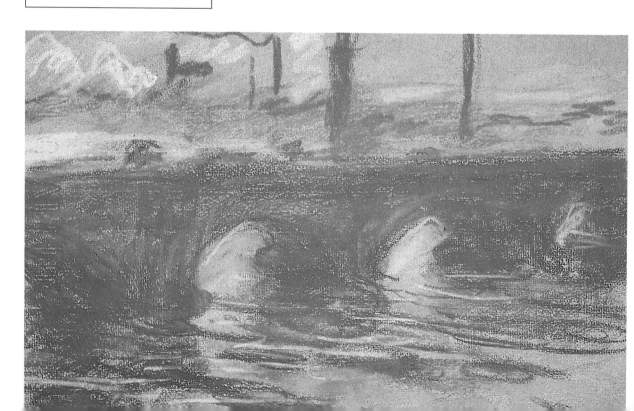

1. *As pastel has a fresh stroke it can be used to draw just like other drawing media. This is a very quick preliminary sketch in which we will try to capture the essence of this famous bridge without focusing on the finer details. Although the bridge, amidst the London fog, appears simple, you must take a lot of care. Use loose strokes, superimposing them but without defining the forms.*

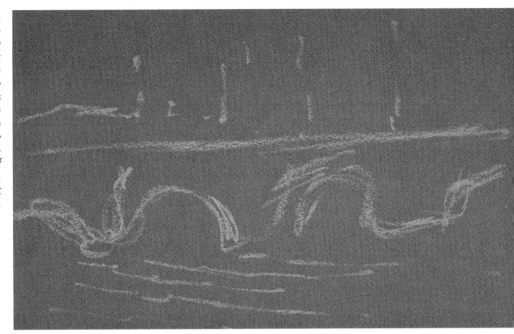

2. *Monet worked on this painting with hardly any reference drawing, as can be seen here. The area where the Thames flows in the foreground can be shaded in white and then stumped. You must not press too hard on the stick because you do not want to cover the background color of the paper. The best approach is to use the stick flat and widthwise. Blend the tone immediately with the fingers. Paint the bridge in the same way that you have painted the water, using very luminous colors. Violet will give a clear tone under the bridge and can also be used on the right, but this time with a direct stroke.*

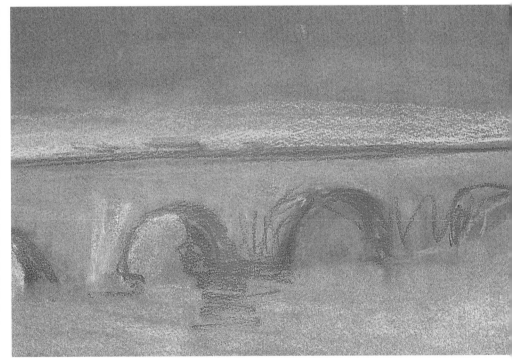

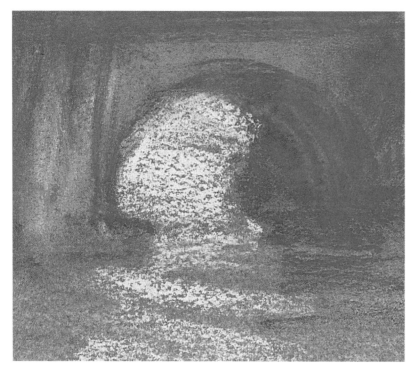

3. *In this painting, Monet aims to develop not so much the objects themselves but rather the luminosity. He achieved this with the contrasts produced by the light and by not excessively defining the forms. In this close-up, you can observe how the reflections on the water have been done. Draw the bridge over the water with a rapid zigzag using the tip of the pastel stick. Reduce the pressure exerted as you work down. If the stroke is too obvious, gently rub it with a finger to blend it into the paper background.*

4. *Using effects on top of each other is an ever-present feature in the pastel technique. This meant that it was easier for Monet to use direct strokes of light to create simultaneous contrasts. On top of a layer which is immediately diffused, put down a direct and precise layer. With the same blue that was used to sketch out the bridge, mark out the more direct areas. The strokes must now be laid over the blended tone beneath, which will become the background color.*

5. *Go over the arches of the bridge with a strong, blue contrast and increase the clarity of the light parts. As you are working on top of the color of the paper, paint until you almost block out the paper grain to ensure that the colors and tones are pure and luminous. Here the paper must not influence the shading by filtering through. Do as Monet did: leave the initial layout in place but allow the light effects to suggest the forms.*

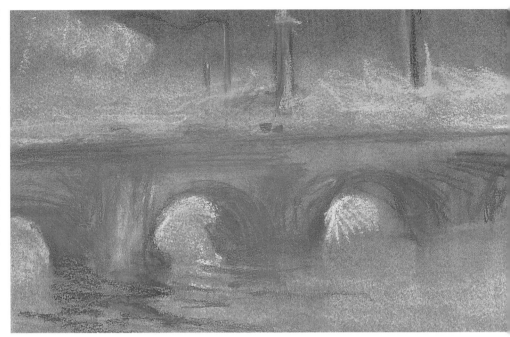

6. *The major part of the bridge is covered with rapid, gestural strokes. The pastel colors are vibrant when they come into contact with the background color. In the upper area, paint in very luminous tones, including light violet and ivory without over using white so that strong contrasts are not produced. Use your fingertips to blend some areas of the picture. This will give the picture a foggy look.*

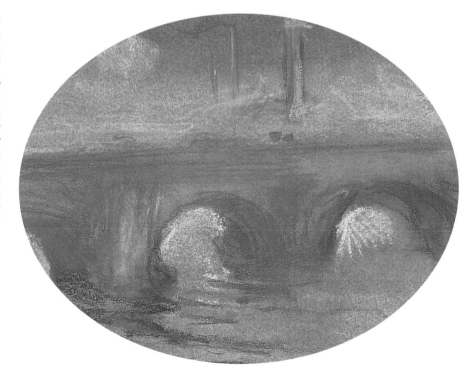

STEP-BY-STEP: *Waterloo Bridge, London,* by Claude Monet

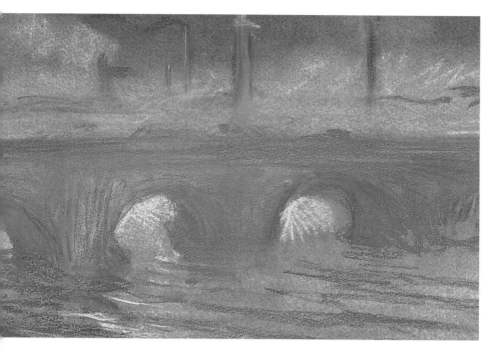

7. *In this step, the drawing is more evident than in the previous ones. Up until now the shading and the strokes have been used as a base. Some areas are intensely blended, others less so, but what counts is that we have deliberately avoided marking the contrasts of the forms. In this painting it is the contrasts between the different light planes that play the key role, although in some areas, like the left-hand arch, you can observe volume effects. In these areas you must work more insistently so that the shadow is more noticeable. Intensify the highlights and the contrast with the dark areas at the same time. The painting style on the water is very graphic, so use the tip of the pastel stick.*

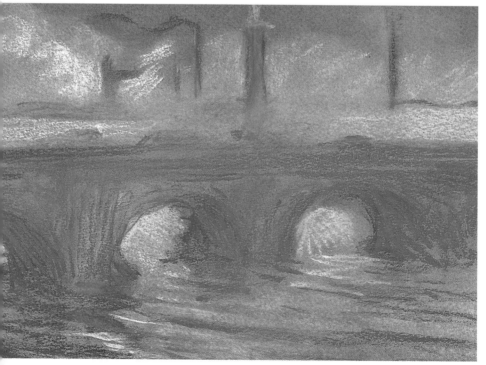

8. *The areas where the highlights are most luminous need not stand out yet. Although pastel can be corrected at any moment, in this piece of quick work, where the nuances are blended into the background, it is important to know how to apply the lights in the right order. Be restrained in the way you paint the direct white strokes: the contrasts with the blue, and even with the background, are sure to be noticeable. Monet's main concern was to represent the effects of the light on the objects. Observe how the direct white strokes give the necessary depth to the atmosphere.*

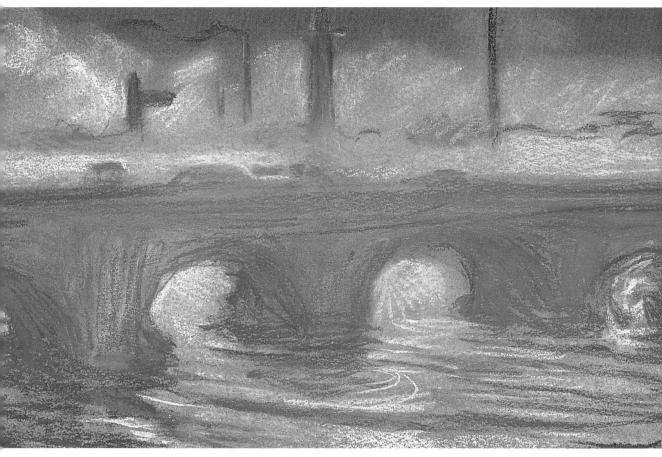

9. *The waves on the water require more luminous colors to make the contrasts between the blues and the light areas stand out more. Moreover, by doing so, the light coming through under the bridge is more real. The color of the paper is left reserved for the foggiest areas. Restate the areas in blue where you want to attract the viewer's eye, while the other areas can be left clouded in fog.*

SUMMARY

The drawing is direct so that it shows the different parts of the bridge. The strokes are not concrete; instead they aim at being vibrant.

The direct strokes on the bridge enable the background to be used like the other colors.

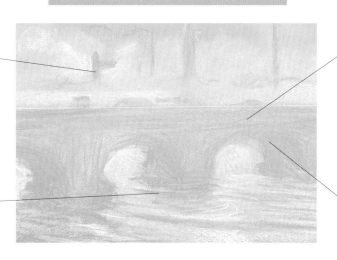

The water reflects part of the bridge in zigzagging strokes.

The boldest contrasts are the shadows under the arches and the light that comes through them.

The Way They Painted

Odilon Redon

(Bordeaux 1840–Paris 1916)

The Conch

Odilon Redon played an important role in the artistic vanguard of his generation. Together with Gustave Moureau he started the symbolist movement, which later led on to surrealism as practiced by Salvador Dalí, among others.

Owing to its blending properties and impacting color contrasts, pastel was probably Redon's favorite medium. He did the greater part of his work in pastel. The realism of his paintings contrasted strongly with elements that are barely hinted at. To appreciate his work, it is also important to note the emphasis given to integrating the color of the paper into the palette.

MATERIALS

Sienna-colored paper (1), pastels (2), and a rag (3).

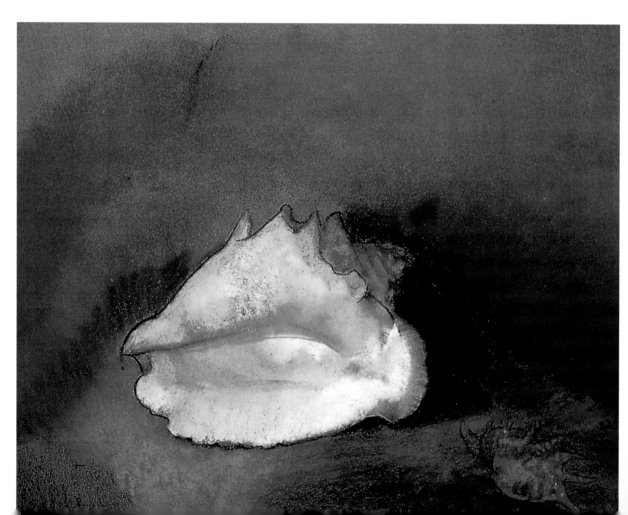

1. *One of the greatest merits of this piece is the perfect combination of shading and drawing pastel techniques. However, the drawing is not evident, nor continuous, in all areas of the picture. Instead, it appears and disappears, bestowing mystery and interest on this still life. Start the drawing with the tip of the pastel stick. Only the main lines and forms are suggested. Later on some lines, like the ones in the upper left corner, will be covered up by the paint.*

2. *How can you set about using the color? It seems that Odilon Redon preferred starting with the most evident contrasts, creating a base of both light and dark areas on which to work later. In this close up, you can see how a luminous pink color is integrated on top of the color of the paper, which will be used afterwards as the base for the pearly shell interior.*

You must be as careful when using light colors as you are with the dark ones. Working on colored paper means that both stand out strongly.

STEP-BY-STEP: *The Conch*, by Odilon Redon

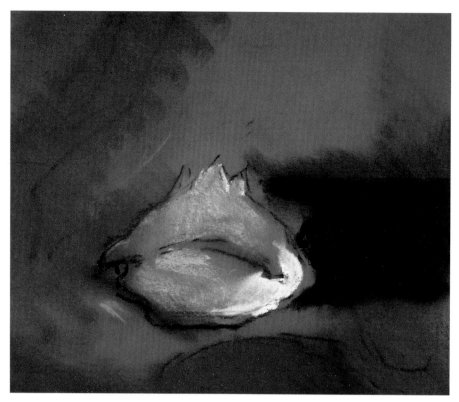

3. *Paint the background around the conch in slightly grayish green tones. When you pass your fingers over these color shadings, part of the color underneath, previously used as the initial drawing, is dragged away. The brightest areas of the conch are painted in ochre and then blended with the fingers. As can be seen, the color of the paper forms part of the picture.*

4. *It is important to carefully study the different effects of blending tones and superimposing layers. This close up is a good example of how an impasted area can just be blended at the edges with the color of the paper, leaving another area outlined against the background. Redon liked to combine blending some areas with outlining, creating an almost unreal atmosphere.*

5. *Paint an intensely dark area on the right of the conch. This black tone, which is blended into the background with the fingertips, makes the conch more realistic, enhancing it with the effect of the light and dark contrast. All the background is stumped around the shading so the attention is focused on the main object, which will be painted with visible strokes throughout the exercise.*

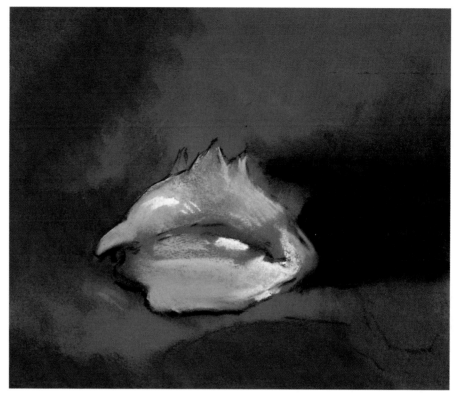

6. *Instead of allowing the stroke to disappear, make the edges more marked, increasing the impact of the contrast between the two styles. After diffusing the white-ish tones, including pink and a bone-like color inside the conch, paint the left of the conch ochre. This addition is blended over the background before putting in a few new bone-colored touches. The edges of the inside of the conch are restated and then the lighter tones are diffused.*

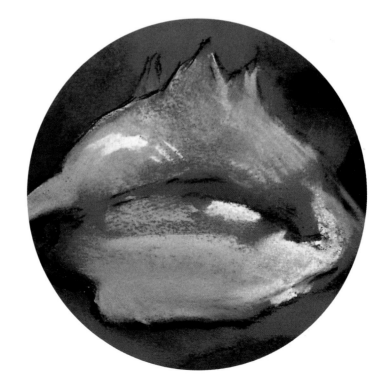

STEP-BY-STEP: *The Conch*, by Odilon Redon

7. *Pastel is easy to handle since it never has to dry on the paper. This permits you to merely wipe it quickly with a cloth to open up a clear space in which to redraw the small conch on the right. It is not a strong focal point, but it adds balance to the picture. If the black becomes too clogged when you wipe it, use the eraser. However, do not make the light space too bold.*

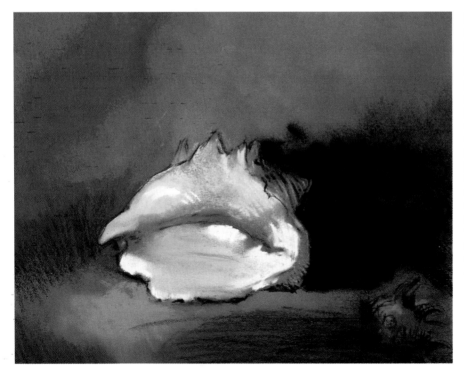

8. *Now the work is focused on the background around the conch. Paint it in blue tones, adding a little black and a color similar to the color of the paper. In this step you can appreciate how Redon approached the subtle blending of a great variety of pastel tints. Playing with the colors in this way creates a fascinating visual rhythm all over the picture. Inside the conch, use your finger tips to diffuse any edges which are too hard.*

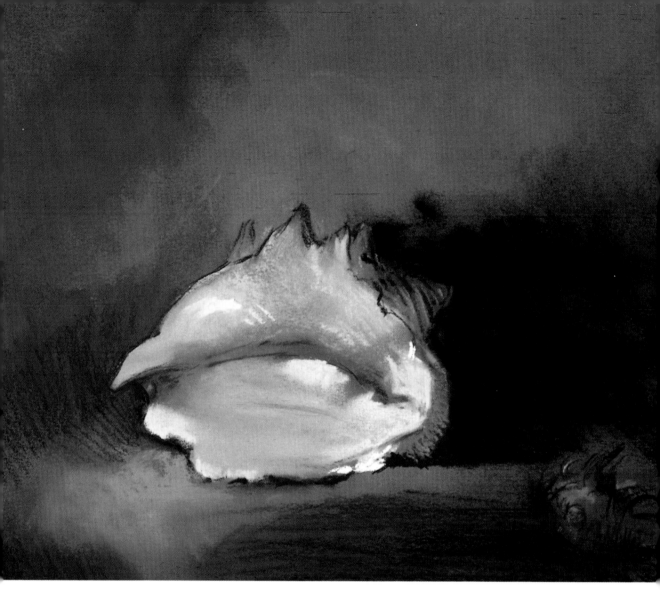

9. *Do the definitive contrasts for the whole picture. The background is painted again to avoid unnecessary mixes. Use black to darken the deepest shadows and sanguine-colored pastel to paint the brightest parts, allowing the color of the paper to filter through. To increase the contrast of the conch in the lower part of the background, use a more orangy tone.*

SUMMARY

Do the drawing in black pastel. Some of the areas will later be covered by the background.

In the background there are colors that strongly contrast with the highlights on the conch.

The edges of the conch are constantly restated, but let the stroke remain visible.

Inside the conch the very luminous, diffused color is a base for other more varied and precise tones.

TOPIC

1 Color Theory with Watercolor

WASH WITH THREE COLORS

The three basic colors, also known as primary colors, are yellow, magenta and cyan. By mixing these three colors in different amounts you can obtain all the other colors. You can paint with the three primary colors without ever having to mix colors together. The pure colors are treated as if they were independent washes of three different colors. Nonetheless, this is not entirely true, since wash can only be made with one color or with a mix of two. This question will be examined later.

There are an infinite number of colors, but all of them are comprised of the three basic colors, the primary colors: yellow, magenta and cyan. By mixing two primary colors together we obtain secondary colors. All painters should understand how these colors behave when mixed together in differing amounts. Such knowledge allows the artist to obtain a good palette and ensures that the hues applied to the painting appear planned, rather than improvised.

▶ 1. *Place the three primary colors on the palette. Separate them in order to avoid mixing them together. First practice a simple exercise. You are going to gradate each one of the three colors in order to see the kind of tones each color can produce. Begin with the most luminous color, yellow. Dampen the brush, and load the color onto the hairs of the brush.*

2. *Gradate the yellow, the most luminous color of the three, since it is brighter and thus reflects the light. Gradate the other two colors, magenta and cyan, without allowing any of the three stripes to blend together. These three colors allow you to obtain a wide range of tones.*
▲

3. *The last part of this exercise involves painting a simple flower without allowing any one of the three colors to come into contact with one another. It is slightly difficult, since wet tones mix and change into other colors. So what are these colors produced by the mixes?*
▲

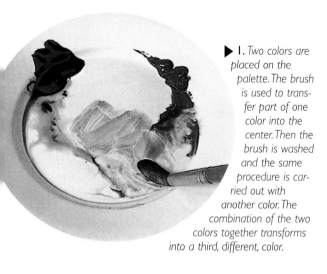

▶ **1.** *Two colors are placed on the palette. The brush is used to transfer part of one color into the center. Then the brush is washed and the same procedure is carried out with another color. The combination of the two colors together transforms into a third, different, color.*

TWO COLORS IN THE PALETTE

By mixing two colors together you obtain a third color, but the pureness of the color depends on how much of each of the two colors are used. With a wash containing two colors the resulting color may be different to the two used to produce it. Equally, by gradating the color change, you can create intermediate tones that gradually take on the definitive color of the mix.

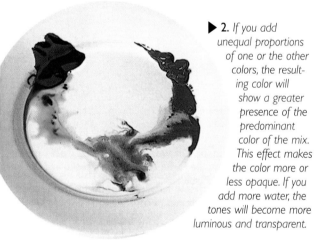

▶ **2.** *If you add unequal proportions of one or the other colors, the resulting color will show a greater presence of the predominant color of the mix. This effect makes the color more or less opaque. If you add more water, the tones will become more luminous and transparent.*

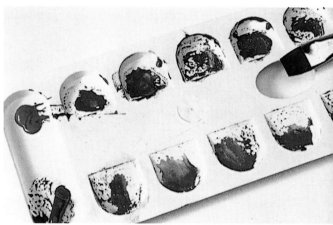

▼ *From the mixes obtained on the palette, you can organize an enormous palette from two colors, which, in reality, is far more complete since it comprises all the possible intermediate tones between the two colors and the intensity of each color according to its transparency on the paper.*

This is an interesting exercise to understand the transition from one color to another. Gradually add small amounts of the secondary color to the main color. The effect can be observed in each gradation.

▲

3. *Here you have tested the colors on paper. The tones are never completely definitive on the palette; on the contrary, they look much better on the paper, since they can be seen as they really are, once they have dried.*

▲

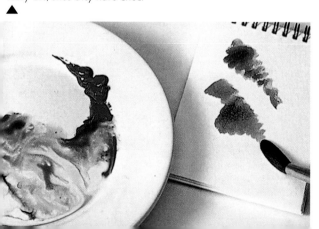

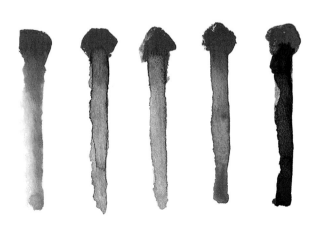

SECONDARY COLORS

Up to this point you have studied how to paint with one color, with two primary colors, and with a combination of two colors. When you mix two primary colors together, you obtain a secondary color. At first you may find the mixing of colors to be rather difficult, but with a little practice you will quickly master it. Try the exercises reproduced on this page ond the theory will be better understood in practice.

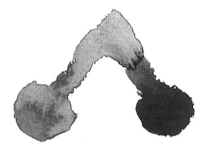

◀

1. *The artist always requires two primary colors to obtain a secondary color. In this exercise, use the same colors that were employed in the previous exercise. This time mix the colors together in the center of the palette. A secondary color can only be obtained by mixing two primary colors together, so choose a combination of yellow and cyan which produces the secondary color, green.*

3. *By mixing the primary colors in different proportions you get secondary colors. Thus with only three colors you can obtain all the colors of nature. If you compare this flower with the one done in this topic (see page 190) you can see that the color combinations have produced a wealth of colors.* ▲

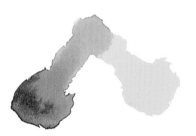

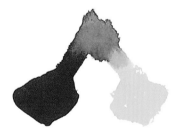

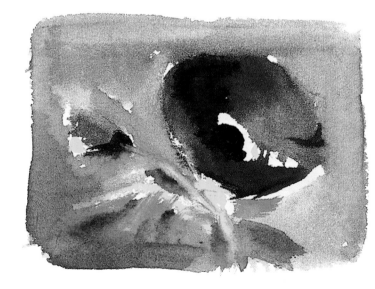

▼ 2. *You can practice obtaining secondary colors on the palette, but it is better to carry out the tests on paper. Reproduced here are three possibilities. The first is a mix of yellow and magenta, which produces the secondary color, orange. The second mix of yellow and cyan gives way to green, another secondary color. Lastly, the combination of magenta and cyan produces violet, another secondary color.*

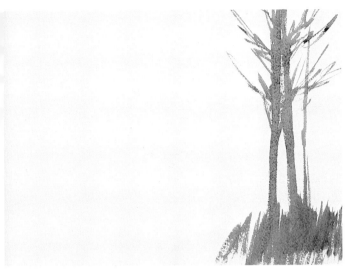

▶ 1. *First paint with one primary color, cyan blue, to begin this entertaining exercise. There is no need to wet the paper. Load the brush with color and apply several long vertical strokes. Then, at the bottom, paint short energetic strokes in zigzag fashion. Lastly, with a touch of paint – there is only a little paint left on the brush – paint the thin branches.*

FROM MONOCHROME TO CHROMATIC RICHNESS

Beginners should regularly experiment with their colors, both on the palette and on paper. The more mixes you try out, the more colors you will obtain. With your three primary colors you can produce a wide range of colors. This exercise will help you to consolidate what you have learned up to this point. First you learned to paint with one color; then you combined two to obtain a third color; finally you learned how the three primary colors can be mixed to obtain all the colors of the rainbow.

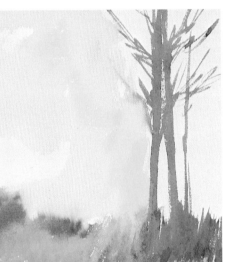

▶ 2. *Straight away, so as not to give the cyan paint time to dry, load some yellow and paint the background. The contact between the two primary colors produces a secondary color in the area of the grass and the areas where the color dampens the blue branches. A broad patch of magenta is painted on the left-hand side. Paint yellow around this color, applying more quantity in some areas and less in others. The result of the combination of magenta and yellow is a variety of orange tones, another secondary color.*

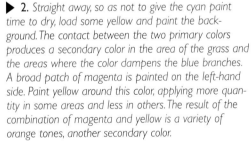

▶ 3. *Place some blue paint over the magenta on the palette. The result of this mix is another secondary color, violet. With the diferent tones of violet, paint the small trees on the left and darken the trunk on the right.*

Step-by-step
Flowers with Three Colors

The best subject for a beginner to study color with is a small bunch of flowers. The primary colors are yellow, cyan, and magenta. With these colors you can create all the colors of nature. The bunch of flowers we have chosen contains a great variety of colors and tones, but we are going to place three basic colors on our palette. Nonetheless, with a little concentration, we will obtain all the necessary colors for this still life.

MATERIALS

Watercolor paper (1), white plate (2), watercolors: yellow (3), magenta (4), and cyan (5), pencil (6), watercolor brush (7), water container (8).

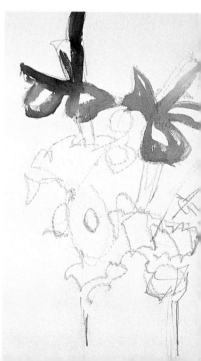

1. Draw the model as accurately as possible. Since watercolor is transparent, the drawing will provide you with a guide to the different areas of color. The drawing should not include shaded areas or too many details: it must be simple and concise, although each of the areas you are going to paint in must be indicated. Once you have finished drawing the subject, mix some blue and magenta on the palette. The result is violet which is used to paint the uppermost flowers. Use two intensities, one with abundant paint and little water, and the other one more transparent.

194

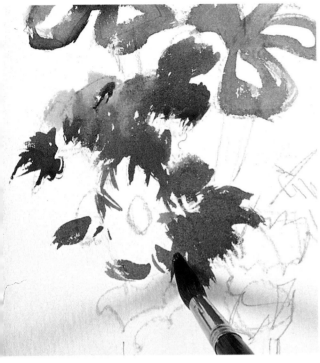

2. *Begin to paint the red flowers with pure magenta. The brightest and pinkest are painted with watered-down magenta. The darkest flowers are also painted with this color, but with less diluted paint. Since there is no white in watercolor, the color white is the color of the paper itself. Trace with your brush the shape of the daisy.*

Once the color has been mixed, it can be made more transparent on the palette by adding water with a brush.

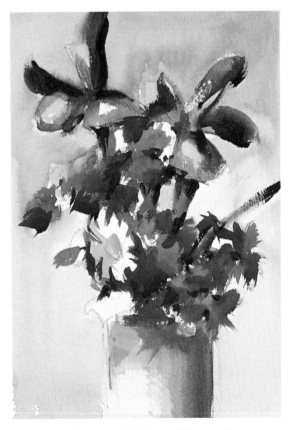

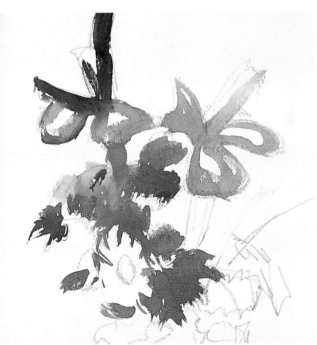

3. *A mix of yellow and cyan produces a yellowish green. To make the tone more yellow, add a smaller amount of blue. In order to control the proportions, always add dark colors to a mix in small doses to the light color of your combination. This way you can decide how intense you want the tone to be.*

4. *The combination of yellow and blue produces green. If you add a touch of red to this color, you obtain an orangy tone. The tone is first watered down and then used to paint the background. Remember to allow the previously applied color to dry first, otherwise the two colors will mix together. When painting the background, do not enter the areas where light or very luminous colors are to be applied, neither should you touch areas reserved as highlights.*

195

STEP-BY-STEP: Flowers with Three Colors

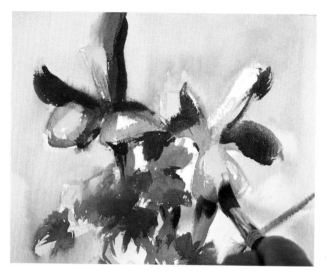

5. *In the same way as the violet was applied, now work with another tone, this time much darker. The best way to obtain such dense tones is to load the paint onto the brush straight from the tube. Here you are painting with a violet tone tending toward magenta. Use this tone to paint the uppermost flowers. Now, with a pure, not too diluted yellow, paint the flowers' lighter areas.*

The mixture of two primary colors produces a secondary color. Therefore, yellow mixed with cyan gives the color green. Yellow mixed with magenta gives orange. Magenta mixed with cyan makes violet.

6. *This is the palette that has been used up until now. Observe how the colors have been mixed. In the zone on the left you can see the green that has been used for the stems. On the right, on top of a blue tone, a yellow tone appears, in this case to make the green darker. In the center of the palette the much more liquid colors are placed. You can also see the colored edge of the plate. This is due to the number of times that the painting brush has been squeezed out.*

7. *The stems and the leaves are painted with two tones of green, one very luminous tone in which yellow dominates, the other very dark and dense, obtained with more blue and a touch of magenta. From this, mixed with yellow, the various orange tones of the flowers in the lower area are obtained. First the orangy colors are painted; then before they dry, superimpose several magenta strokes that softly blend over the orange. Once again with the violet mix obtained with magenta and cyan, paint the petals of the uppermost flowers. Now with almost pure magenta, barely watering it down, paint the darkest petals of the reddish flowers.*

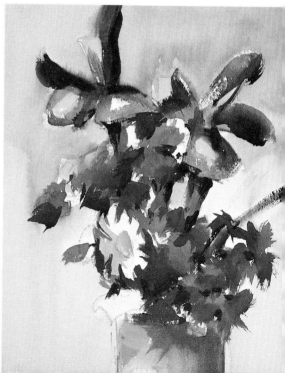

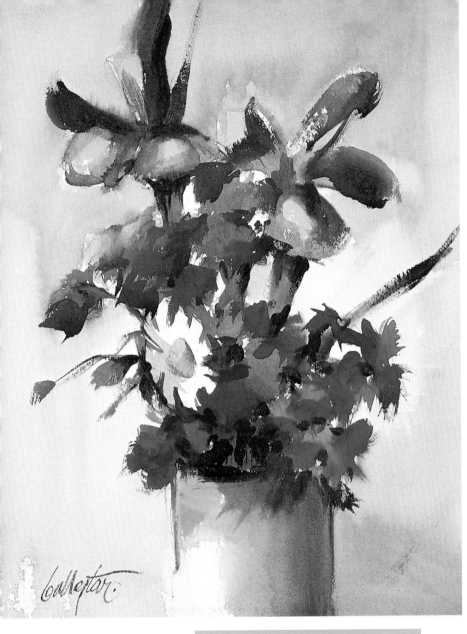

8. *Finish the lower parts of the flowers with magenta. It is necessary to paint another even darker tone over this one. Therefore, on the palette mix a touch of blue with the magenta. In order to paint the jar, mix magenta and yellow, to obtain an orangy color. Over this add a touch of blue; the mix becomes a more orangy color. Using this color, paint a gradation from right to left, leaving the brightness unpainted. You can now consider this floral still life, painted with only three basic colors, finished.*

SUMMARY

The yellow is completely pure here. In order to avoid dulling it, it should only be applied once the underlying colors have dried.

Green obtained with a mix of cyan and yellow.

Orange obtained with a combination of magenta and yellow.

Luminous violet. First the violet is painted with cyan and magenta, after first watering it down on the palette.

Dark violet with a magenta tendency. It is obtained by mixing violet with a greater amount of magenta. In order to avoid transparency, it has been mixed with very little water.

Color Ranges

THE COOL RANGE

Depending on the chromatic "temperature", colors can be classified into ranges. A range is a group of colors that share certain characteristics and form a harmony. When you look at a monochromatic gradation, what you see is the tonal harmony of this color. If you put together two similar colors that contain some of the aforementioned color, we can be said to be building a chromatic range or harmoony. To summarize, a color range is comprised of colors that are classified according to coolness, warmth or neutrality. The first are cool colors, the second, warm, while the last are called dirty or broken colors.

▼ *The cool range of colors encompasses everything that begins as a mix of yellow and cyan, from which an entire range of yellows, greens, and blues can be obtained. You can also add magenta to this mix in combinations that turn blues into violets. There is also the possiblility of painting transparencies with this color range. It is essential to try some simple tests in order to understand the nature of the colors.*

You can mix together colors from different color ranges. For instance, a warm color range can include green in order to obtain yellowish greens or warmer greens by means of mixes.

1. The area of this landscape corresponding to the sky is painted with blue and green. The clouds are left unpainted. The intermediate zone is painted with a very dark bluish violet.

2. Paint the lower area with a watered-down green. Over this add various tones of cobalt blue; thus the foreground is significantly darker than the previous color. With the same blue, paint the trees and the wall of the house in shadow. In this way, all the luminosity of the paper is reflected. As you can see, in this example you have worked only with the cool range of colors. This is called the cool harmonic range.

THE WARM RANGE

The warm range of colors comprises red, magenta, yellow and the mixes obtained from them. Therefore, you can include red in the range of cool colors in order to obtain violet. Likewise, you can also add a cool color such as blue to obtain a specific warm tone or to obtain a green of a warm tendency.

▶ *This is a good example of the warm range. The colors do not have to be pure, but they must always share a common harmonious factor. Even when green is used, the color does not appear excessively cool. Yellow is added, and a touch of orange to tone down the contrast with the rest of the range. Colors from other ranges can be included with a warm range of colors, as long as they do not appear too dominant.*

▶ *1. A combination of red and yellow produces a very luminous orange which is used to paint the landscape's entire sky. On the right-hand side paint a sienna-umber tone. Earth colors form part of the warm range, although certain earth tones, such as green oxide, approach the cool range of colors. In the lower area apply green; but to continue with the warm range of colors, orange has been added. This results in a warm tone akin to ochre.*

> Complementary colors are those of the chromatic circle that face or oppose one another. Complementary colors create enormous visual impact; examples of complementary colors are yellow and deep blue, magenta and green, cyan and red. These colors are used in all color ranges in order to achieve effects of contrast to reduce the monotony.

▶ *2. The background is painted with sienna mixed with red. Over this, paint an almost black tone that separates the focal planes, but the tree trunks are left unpainted. The path is painted ochre. Over the greenish tone, now apply a somewhat darker green, but without allowing it to appear entirely cool. In certain areas sienna is painted with the green to make it appear warmer. Lastly, the trunks are painted with dark colors of the palette. The treetops are painted with short, supple strokes of orangy green.*

Topic 2: Color Ranges

BROKEN COLORS

A broken color is an undefined and "grayish" color. A broken color is nothing more than a "dirtied" color. Colors dirty when two secondary colors are mixed together or a secondary color is mixed with a primary color. This chromatic range is somewhat ambiguous and can include both the cool and warm ranges of colors.

1. A simple exercise to practice painting with broken colors: With a violet "broken" with green you obtain brown. Make a pale wash and paint the sky. Add some sienna to red and use it to paint the strip in the middle, leaving other areas destined for other colors unpainted. You then produce a broken green stained with ochre; it is diluted on the palette and painted over the foreground.

▲

Broken colors are obtained by mixing two secondary colors together. For ▼ instance, the combination of magenta and yellow produces orange. If a little green is added, you get a broken earth tone. Dark blue can also be broken by adding a touch of brown to the mix. Earth colors are ideal for obtaining broken ranges with watercolors.

◄
The top row of colors are those that create the color patches below. You can carry out this kind of test on the palette and on paper.

▼ 2. Give the paint time to dry before painting over it, without blending the two layers together. On the palette, the same green used before is now mixed with a touch of blue and a little slightly darker green. If the result is too clean, add ochre in order to break the tone.

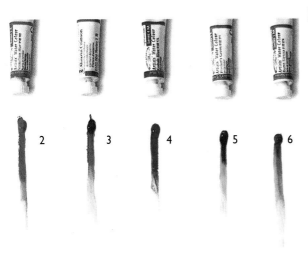

▶ In the last chapter, you learned how to paint a picture using only primary colors. It is true, you can obtain many colors using only yellow, magenta, and cyan. But there are countless other colors that cannot be obtained, either due to their complicated composition or because they can only be produced from a specific pigment. The basic colors the artists should have on their palette are: *cadmium yellow light (1), orange (2), carmine red (3), cobalt blue (4), Hooker's green (5) and burnt sienna (6).*

THE BASIC PALETTE

The colors required by watercolorists depend on what they want to paint. An artist who enjoys monochrome wash paintings will not need a wide range of colors, but he or she should at least have a minimum range which allows them to create the necessary tones. A wide range of paints is necessary when the subject requires difficult colors or those that are impossible to obtain from simple mixes.

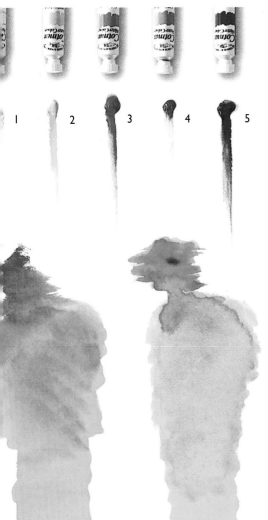

▶In this small sample you can see the result of the application of a warm or cool color on another . A touch of red has been added to the first yellow; it is essential not to let the yellow lose its chromatic quality in either of the two examples. A little green has been added to the second yellow. Both colors continue to be yellow, but one has acquired a warm tendency while the other has a cool tendency.

▼

As beginners acquire more experience in color, they will need a more complete palette. Watercolor is a medium that is sensitive to any color hue. For this reason it is advisable to increase the number of colors on your palette. This range is considered the most appropriate: *Chinese white (1), cadmium lemon light (2), red vermilion (3), azure blue (4), Prussian blue (5), cobalt blue (6), Hooker's green (7), yellow ochre (8), sienna (9), burnt umber (10), and black (11).*

Step-by-Step
A Landscape in a Warm Range

The range of colors do not necessarily have to conform to those of the subject. When artists choose a certain color range, they use it to interpret the subject with the chosen color. In this exercise you are going to paint a simple landscape with a range of warm colors. Don't rule out the possibility of using cool colors, but if they are included, they must never dominate.

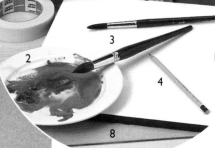

MATERIALS

Watercolor paper (1), paints (2), watercolor brush (3), pencil (4), water container (5), adhesive tape (6), rag (7), a support (8).

1. As you gain more experience in watercolor, you will see how important the preliminary drawing is and how, without it, the watercolor paints would lack any support and guide. This subject is sketched with a pencil, although you can also use charcoal for the task. The drawing must be precise enough while not including unnecessary details.

2. *First paint the entire area of the sky with a gradation, a technique explained in the topic on wash. Wet the paper, making sure not to touch the tree; and then apply the brush loaded with an orangy ochre tone in the top part. With long sweeping strokes applied from side to side, extend the color over the wet zone. Once the background has dried, paint the mountains on the horizon with sienna. Once this area has dried, the entire length of the tree is painted with cadmium yellow.*

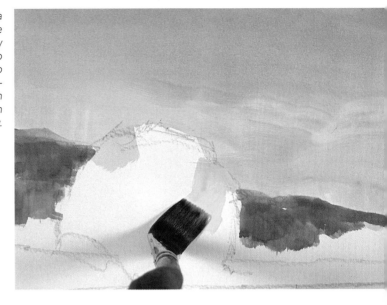

Colors from other ranges can be included within a specific range. This serves as a complement and contrasts with the colors applied.

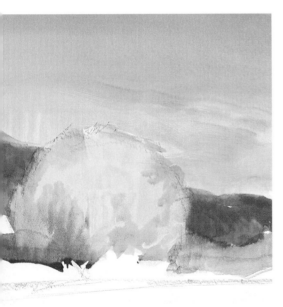

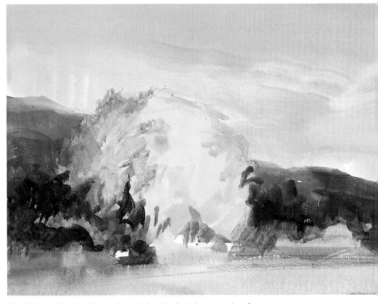

3. *A touch of green is added to the yellow on the palette, and is mixed until a slightly darker tone is obtained. Cadmium yellow is an intense color; which belongs to the warm range of colors; by adding a dash of green, the tone can be altered enough to paint several uncontrasted shadows. With a very luminous green, paint the vegetation at the edge of the road. Although this is not the definitive color, it serves as a base over which other warm colors can be applied.*

4. *With a barely damp brush loaded with a touch of very transparent sienna, apply abrupt strokes in the darker part of the tree. Continue with this work until part of the yellow base is removed. Now with magenta, sienna and a touch of blue, you obtain a very warm, violet tone which is used to paint the intermediate area. Since the underlying color is dry, the tones do not blend together. Now the green is almost entirely covered with this new warm, dark color.*

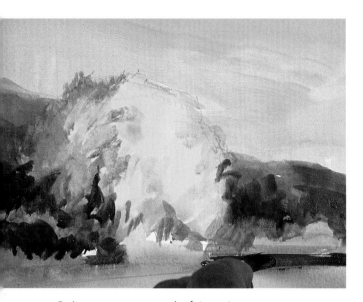

5. *A very transparent wash of sienna is applied and the white of the paper is tinted in all the lower part. This color nullifies any completely white brightness and will be the base for the other darker colors. With the violet, which has just been used for the background, start to paint the shaded zone above the road. The color is the same as that used previously, but as the painted area is very bright, it does not seem so opaque. On the right-hand margin, orange is painted. This warm tone will be used as the background for the later darker colors.*

Drying of the watercolor can be speeded up with the help of a hand-held hair dryer. Do not place the dryer so close that the drops of color run.

6. *With sienna mixed with umber, the darker contrasts are painted in and the umber tones in the landscapes are increased. When the dark zones are painted, the highlights stand out more, due to the effect of the contrasts. The brush-strokes of the shadows lying underneath have to be wide and uniform. The brush drags the color horizontally. It must take a little bit of color with it every time it passes over this zone so that a gradation is not formed.*

7. *With a very bright orange somewhat tinted with umber, the painting of the top of the tree is continued. The new brush-strokes drag away part of the fomer sienna color and both are mixed on top of the paper. The trunks of the trees on the left are painted with sienna mixed with a little umber. The background should be completely dry so that the colors do not merge into one another. Observe how the color orange stays in the background. On the lower part of the road an ochre tone mixed with orange is painted. The most luminous strip is left unpainted.*

8. *It is necessary to wait for the painting to dry completely before applying the final touches. Once the background color is dry the right-hand side of the mountains are painted red, and on the left in a very dark marine blue. In the foreground* the contrasts of the color of the road are made stronger with a sienna wash. With very dark violet brush-strokes a few lines are added to the base of the shadow of the trees.

SUMMARY

Very **pure cadmium yellow** in the background as the base color to paint the tree.

Superimposition of **red** on the already dry background.

The color green with warm nuances. This color will be the base for later darker colors.

The sky has been painted with a very warm tonality in order to illuminate the whole landscape.

Blue has been used as a complementary color so as to compensate for the excess of warm colors.

A very luminous sienna wash is the brightest part of the road.

Special Techniques

SPECIAL MATERIALS

There are many techniques thant normally can be used to alter the surface of a watercolor. One of the most useful tools in the studio of a watercolorist is the hair dryer. This can speed up the water evaporation from the paper. Another tool that can modify the surface of the paper is sandpaper.

> The watercolor is very sensitive to any alteration that is produced on its surface. This quality is an advantage when the techniques that cause such changes are known. When using watercolors, accidents often happen, like a scratch on the paper, scraping with the brush or many other incidents. This topic will deal with these effects as a part of the normal possibilities for the watercolor technique.

▶ 1. *The dark color is painted in the usual way. In this exercise we are going to do some textures with sandpaper on a painting of rocks. The colors used for the rocks can be very dark.*

▲ 2. *Some techniques are done when the color is completely. To accelerate the drying of the color and to be ab work on the dark mass, the paper is dried w hair dryer. If the paper is too wet it is wise to get very close with the dryer so that does not run or the drying is irregular the surface.*

3. *Rub the surface of the rocks with a medium-grain sandpaper. This action causes the upper layer of the paper to be taken off and the dry color with it. It is not necessary to press too hard. Some areas can be left untouched: just rub where you want to texture the surface.*

▲

4. *You can then repaint on the retextured surface with very transparent washes or with dark colors without completely covering up the resurfaced area.*

▼

▶ **1.** *The effects that can be achieved with watercolor can be realized on a completely dry surface, or on fresh paint. When the paint is wet it is possible to achieve more varied results, since it is not just a question of getting rid of the paint. Depending on the type of paper, the painting can be scored with grooves that do not completely take off the superficial layer. Here the experiment will be done with fresh paint.*

SCRATCH THE PAPER WITH THE TIP OF THE BRUSH

At the opposite end to the hairs, that is to say the tip of the handle, there is another very practical tool which offers many possibilities. Different tasks can be done with the sharp point of the brush, especially when the watercolor is moist. Some brushes have a sharp tip and others have a blunt one. Some watercolor brushes even have a beveled tip, specially designed to scrape the paint.

▶ **2.** *While the painted surface is still moist, start with the tip of the brush. You can see the effect in the photo. Do not press too hard—the smallest indentation is enough to mark the paper. Stroking like this will not achieve pure whites. In the indentation made on the paper, more color is accumulated than on the rest of the surface, unless you persist several times with the brush. In this case pass the brush over each stroke. By doing so, instead of building up more color, part of it is taken away, and this makes the result a clearer and finer tone.*

▶ **3.** *When the tip of the brush is pressed hard over the still moist background, it is possible to open up whites like those among the trees. To make these types of marks not all brushes will do. Some of them have a tip that is too blunt. If it is necessary to make indentations that remove some of the paper a sharp toothpick can be used.*

A KNIFE AND TURPENTINE

A knife or a cutter can scrape the paper with great precision. As these tools are so sharp, they must not be used on wet paper as they could scrape to the point of tearing. The cutter is a more practical tool than the knife since it can be handled with the precision of a pencil. Moreover, another technique that produces interesting effects on the watercolor is the use of turpentine; the mixing on the paper of a brush loaded with turpentine with another loaded with water produces an unusual texture that is worth experimenting with.

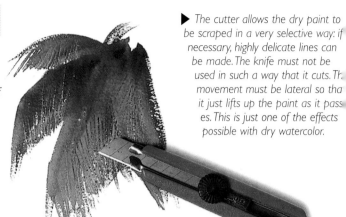

▶ The cutter allows the dry paint to be scraped in a very selective way: if necessary, highly delicate lines can be made. The knife must not be used in such a way that it cuts. The movement must be lateral so that it just lifts up the paint as it passes. This is just one of the effects possible with dry watercolor.

1. This little exercise demonstrates the combination of the technique of watercolor with turpentine and the opening of whites with the cutter. As with all exercises in this book, it is a good idea for the student to put it into practice—it is the only way to understand how the technique works. All work in watercolor is initiated with a drawing. Once the main motif is finished, the paintwork can be started. A brush is dipped into turpentine and some areas of the background are covered. On top of this you paint with a dark color. The turpentine gives the watercolor a very textured appearance.

▲

2. Once the background has been painted, the figure is outlined perfectly. A dark green color is used to paint the leaves of the plant. In some areas quite a lot of turpentine is applied and in others none at all. In the area with turpentine the color penetrates with more intensity.

▲

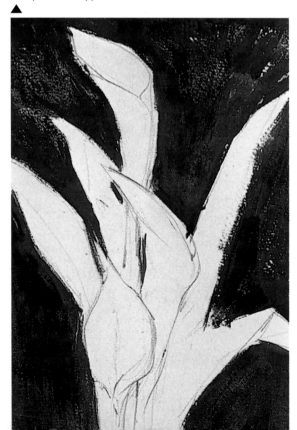

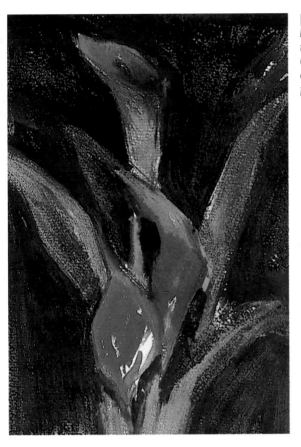

▶ 1. *In spite of using these techniques the watercolorist must always keep in mind the principal techniques: that is to say if you do not want tones or colors to mix you have to wait for the previous layer to dry. Once the green leaves have dried, the red central flowers can be painted. In this area turpentine is not used. However, it is used on the upper flower in which ochre, sienna and red are present.*

COMBINING TECHINQUES

The special techniques do not have to be used constantly in watercolors. In general, it is better to use these effects as very defining notes in any work. All the techniques of watercolor must be combined intelligently so that the painting is not cluttered up with special effects.

3. *Finally, once the necessary scrapes have been done, repaint with darker tones to outline the forms or to include layers through which the background of the paper can be made out.*

▲

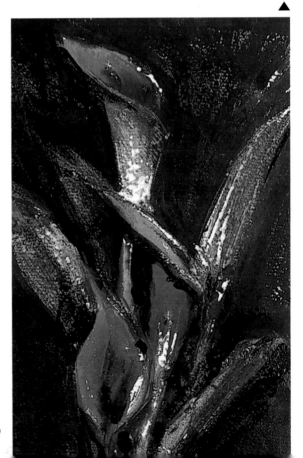

2. ▼*hen all the painting is completely dry, the cutter is used to open up new textures and lift up the white of the paper. The long strokes produce white lines, while, if little scrapes are made close together, very textured white areas are achieved, as can be observed in the upper flower.*

Step-by-Step
A Boat on the Sea

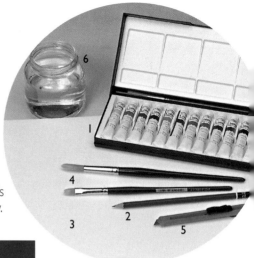

The following exercise deals with a theme that combines the principal techniques of watercolor: the color wash and the brush-stroke superimposed on dried color. In the exercise not too many texture effects are going to be done, only those that are vital, like scraping with the cutter or with the end of the brush. Here the subject is a boat. It is not difficult to do if you pay close attention to the steps detailed below.

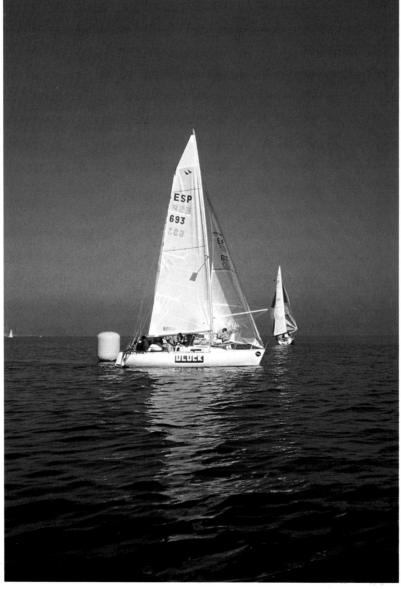

MATERIALS
Watercolors (1), pencil (2), watercolor paper (3), watercolor brushes (4), cutter (5), and jar of water (6).

1. *A subject like this does not require great drawing skills, but it is necessary to know at least how to sketch the form of a boat with the essential lines. After these first lines you can start to paint the first color.*

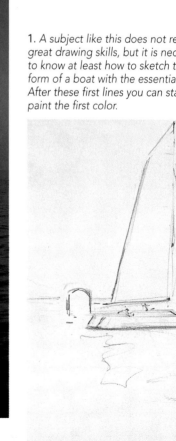

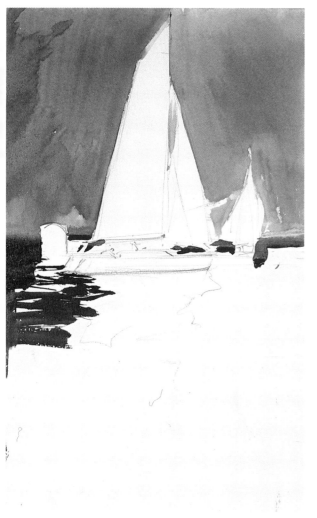

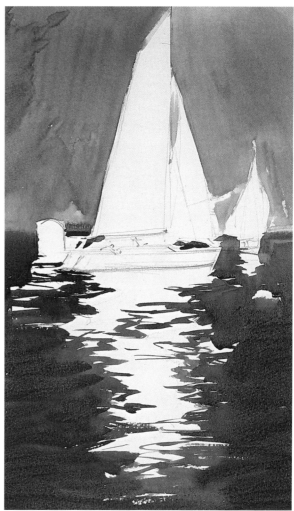

2. A first wash is made over the background with transparent blue, outlining the form of the boat with the brush. It is useful to remember that in watercolor the white is always the white of the paper, so whenever this color is needed, a zone has to be reserved. The color of the sea is begun with dark blue. In the same way that the white of the sail has been reserved so too are the highlights in the sea.

3. In this step the complete outlining of the shape of the boat is finished in the principal tones of blue. Pay attention to how the whites in the water are reserved. The brush is used to draw the dark zones of the reflections with horizontal brush-strokes. In some areas within the reserve these brush-strokes have a very mannered look.

The most luminous areas must always remain white. This means that later gray tones can be added as nuances of the white colors.

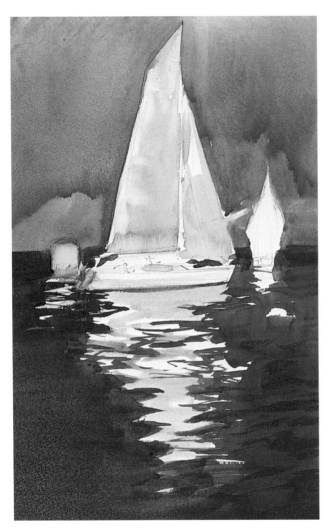

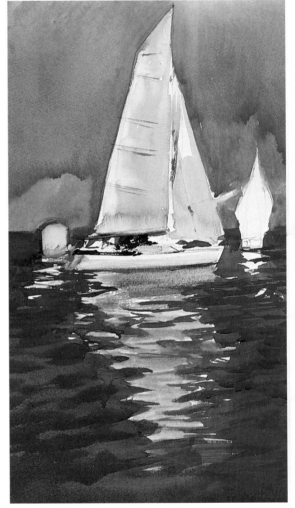

4. The background is made darker by recovering it with a new blue wash; this allows a break to be made with respect to the first layer of color which is already dry. The work on the sea is developed with the same very dark blue with which the area was initiated. As new layers are superimposed on top of previous ones a darker tone is achieved which represents the waves of the sea. Wait until all the color is dry and then paint the sail and the hull of the boat in gray, and the white reflection in the water. The buoy is painted yellow, and a red waterline is added to the boat.

5. Before the gray tone of the sails is completely dry, the back of the brush is used to trace the lines of their structure. The color quickly falls into these little "furrows" and they become saturated. With the same gray color used on the boat the darkest zones of the hull and of the sea reflections are modeled. Now that the sea color is completely dry the shadows can be painted in with irregular horizontal brush-strokes.

6. The cutter is used to begin outlining of the brightness in the sea. It is not necessary to scrape too much; passing over a few times to lift little scrapes will be enough so that the brightness shows up perfectly.

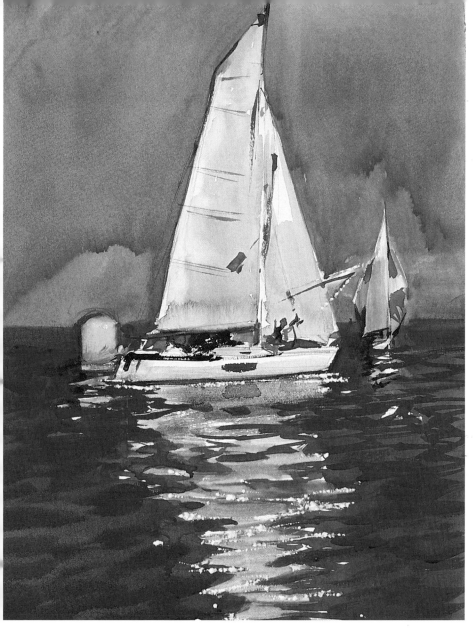

7. *Using the knife finishes off this work which combines different techniques related to the moistness of the color on the paper and the work on the texture, done with the texture, done with the knife or with the almost dry brush. This example shows that the light effects produced by the scrapes on the paper are striking. To maintain interest it is necessary not to overdo the use of this technique.*

It is important to work on heavy grained paper. These effects cannot be done on thin paper.

SUMMARY

The first layers completely outline the form of the boat against the backdrop.

To do the sails the back of the brush is used.

The brightness of the sea is obtained with the trails left by the brush-strokes on the white of the paper.

The textured zone has been opened with a knife, making soft lines.

Value and Modeling

LIGHT AREAS, HIGHLIGHTS

To place the highlights on any object it is important to know the direction from which the principal light comes. Light falls on an object and runs over the shape; depending on its intensity it will provoke shadows or highlights of varying luminosity.

The valuation consists in the correct gradation of the tones to achieve a scaled effect of grays on the surface. A valuation is nothing more than classification of the possible tones that can be obtained from a color. In previous chapters the different techniques of the watercolor have been studied. If in a scale of tones the differences between one tone and another are made finer until a point is reached when it is impossible to appreciate the difference, an effect of modeling is achieved. Starting from the basis of this explanation the volume of an object can be painted according to the light that falls on it. In the exercises that we are going to do in this chapter ideas that we have learned before will be applied. It is fundamental to pay a lot of attention to the images and to the explanation.

▶ 1. *As already stated, the drawing is the basis of all watercolor work. It is crucial not to forget this before starting any work with the paint. The preliminary drawing should always be as clean and neat as possible: the lines must only indicate the fundamental shapes of what is going to be painted. The jug is drawn and the shape of the shadow is also defined. So that the effect of the light can be observed more closely, the background is painted with ochre.*

▶ 2. *Wait until the background is dry. Afterwards, use a blue color mixed with ochre for the shadow zone of the jug. All of the process that is now going to be explained must be carried out in one step, before the color that has been painted onto the paper can dry out.*

3. *The brush is dampened with clean water, it is drained and then it is run along the edge of the still fresh brush-stroke. The wet brush-stroke with the color has to follow the shape of the jug. It is dipped in water, drained, and run along the edge of the gradated area again. In this way you obtain a gradated area which fits the shape perfectly.*

▲

▶ **1.** *Just as in the last exercise, a ceramic jug is taken as the subject. Here the light is frontal and therefore the most luminous point is in front of the viewer. The shape is drawn carefully and any unnecessary lines are rubbed out. The area that surrounds the shape is painted in a yellowish orange so as to emphasize the shape.*

ALWAYS DARK ON LIGHT

The process of watercolor painting has a premise that must always be respected: the lighter colors must always be reserved, the dark colors outline the highlights and light areas cannot be painted over dark tones. That the color white is only contained in the color of the paper and that it is the darker colors which isolate it and make it stand out are important factors to bear in mind. The subject of the color white in watercolors has been dealt with previously. In this simple exercise a valuation is going to be realized using the color sienna. The color white will play a role through the gradation of the tones.

3. *Quickly, without allowing the color to dry, the brush is dipped in clean water and drained off. Several brush-strokes are made following the shape of the jug. The color is gradated and valued toward the center of the figure. The dark color remains on the edge of the shape. When the color is almost dry, make several brush-strokes on the right-hand side of the shadow: the color comes out a little and creates an effect of volume. This technique will be constantly used in all the spherical shapes painted with watercolors.* ▲

▼ **2.** *This time, to do a variation on what we did in the last chapter, the white background of the jug is dampened before applying the darker color. The brush is dipped in sienna and both sides are painted in the same way. The color tends to spread out over the damp zone. On the spout of the jug the shadow is painted with very fine brush-strokes.*

MERGING COLORS AND TONES

To get the volume right it is necessary to control the merging of the tones. The level of moistness of the color will be a deciding factor in controlling the merging of the colors properly. It is necessary to wait for a prudent period of time so that the merging of one color into another can be achieved by gently caressing with the brush. In this exercise the subject is an apple, but the technique is valid for any other object or color.

1. To do these exercises of valuation and modeling, subjects that are straightforward to do have been chosen. In general, it is always easier to paint an object that does not require perfect symmetry, like an apple. After having drawn the fruit, paint all the surface of it with a very luminous yellowish green. As you paint, the most luminous area is left in reserve. As said before, the painting must be done from light tones to dark, that is to say, first a very transparent color, and then the center of the fruit is painted, but in a darker tone.

> To open up highlights any brush can be used, but it is always better if it has many hairs that allow a good tip to be obtained. Sable hairs are the best.

▼ 2. When the first color laid down has dried, all the shadow zone is painted in a dark green. The color does not have to be applied wet because the valuation must not be done by merging with the previous tone, but by gradation of the last color. In the picture, you can appreciate the direction that has been given to the brush-strokes. First, the brush-strokes define the contour of the shadow. These brush-strokes are then stretched to the right with a soft inclination and in a straight line. Lastly, on the right side the cleaned and drained brush is passed over again, following the shape of the apple.

3. While the color is still fresh the paint is brushed to the right of the apple in a soft gradation of the background. If necessary, you can paint a little more of dark green in the central area, but not in the part where the tone is graduated because otherwise you would not be able to do valuation work with the color. To finish the modeling before the color dries completely, stroke the clean and semi-wet brush along the profile of the shadow so as to soften the abrupt edge.

▶ 1. *After drawing the shape of this onion, the color is applied onto the completely dry background so that the principal highlight can be placed at the same time. The brightness is created with long drawn out, supple strokes. The valuation has to be done while the color is still wet. On top of the first very luminous wash, a few small brush-strokes of carmine are made in the lower part. The color quickly merges into the contours but adds a certain volume.*

VOLUME AND FINISH

On the previous page we studied how it is possible to achieve the volume effect due to modeling the valuation. Sometimes, the object depicted requires a better finish than that obtained by values and tones. To obtain this finish it is necessary to combine the techniques studied up until now. First of all, work is done on the values and white reserves and later the texture is added to the dry background.

▶ 2. *The application of color is begun on the right side of the onion, keeping the brightness intact. The background is still wet and the violet sienna color that is painted now must not be too watery so that it can maintain its density. The brush-strokes merge on their own in the curves, while spreading to the limit of the wet background.*

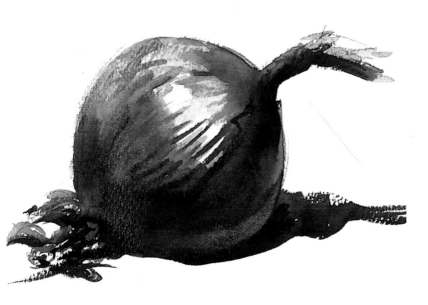

▶ 3. *Until now work has been done on the background; the work of valuation not being very different from that done in the rest of the chapter. To paint on the texture it is necessary to let the background dry. The painting of the texture of the skin is begun with a violet color obtained from sienna, a little carmine and blue. Long and supple brush-strokes are made in the highlights. An area of shadows is also made, merging the colors. Finally, as has been done in previous examples, with a clean, wet brush the highlight on the contour in the shadow zone is opened.*

Step-by-Step
Still Life of Fruits

The color, the brightness, the highlight or the texture can all be varied but essentially the process of valuation and modeling of the shapes is always the same. Getting striking results is a question of study and, above all, a lot of practice. Now we are going to put into practice the notions that have been learned in this lesson. It will be necessary to pay attention to the drying times of each area. Sometimes the work will be done on the wet background, and at other times it will be realized when it is dry. A model with a variety of colors and textures has been sought out so that different solutions to tone valuation questions can be worked on.

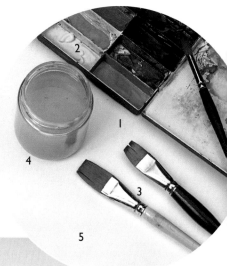

MATERIALS

Watercolor paper (1), wqtercolors and palette (2), watercolor brushes (3), jar of water (4), and support (5).

1. *The work begins with a very plain sketch of the shapes that you want to represent. As can be seen, it is not very complicated but this drawing has to be done neatly and with precision. Do not start painting until it is complete.*

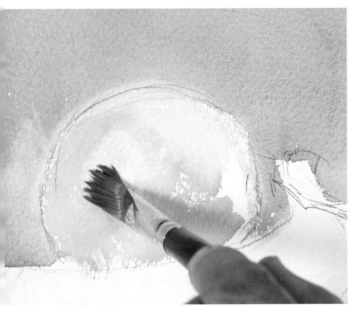

2. *As was done in the first exercises on this subject, isolate the principal elements of the picture by completely painting the background. In this way the shape is outlined and the white of the paper is perfectly marked out. A broken tone of green, sienna and ochre is used to paint the background. To increase the luminosity of the white, the tone that surrounds the shape of the fruit is darker than the rest. Once the background is dry you can start to paint the orange. Pay attention to the highlight: the color tone is densest in the shadow area.*

To correctly model the tones and colors, the work must be done before these are completely dry.

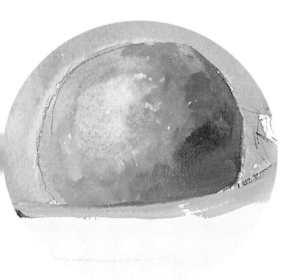

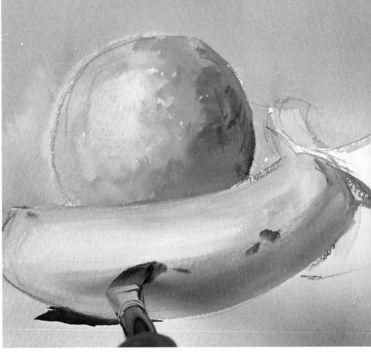

3. *The valuation of the orange is done with progresive tones of the same color, always preserving the same highlight as a reference for the volume. To do the valuation around the shadow, luminous green, orange and some sienna are mixed in the palette. A curvature that follows its shape is painted on orange. Where the highlight meets the shadow, brushstokes tinted with red are made. Once the orange is dry, the painting of the banana is initiated with long brush-strokes in luminous green; follow its shape.*

4. *Be very careful of the valuation of the tones of the banana. Before the green of the first brush-strokes are completely dry, the banana skin is begun with golden yellow. The direction of the brush-strokes has to follow the shape of the banana and pull the green until it is softly merged into its contour. In the lower part the valuation is realized with some sienna and orange. Lastly, in the most luminous part of the banana the clean, wet brush is passed over until some of the color is drawn out.*

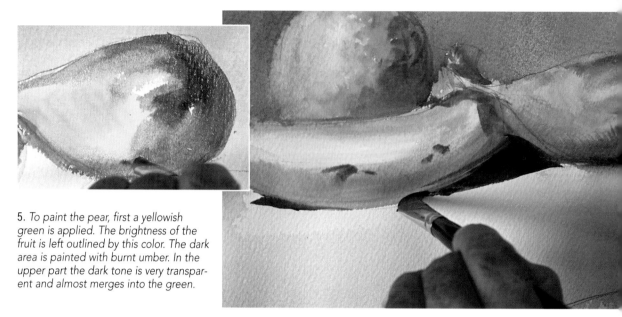

5. *To paint the pear, first a yellowish green is applied. The brightness of the fruit is left outlined by this color. The dark area is painted with burnt umber. In the upper part the dark tone is very transparent and almost merges into the green.*

The color of the paper gives luminosity to the paint. The dark tones do not allow reflections from the paper. These tones must only be used in the darkest area.

6. *A little of dark green is mixed with some water, not too much, to darken the pear. The brush-stroke must follow its shape, pulling and merging with the shadow color. In the lower part of the pear, to increase the modeling effect, the clean, wet brush opens up the typical brightness. Once the pear is dry a final transparent layer of green shadow is painted in the highlight area. On the tablecloth, the shadow is painted in very dark burnt umber.*

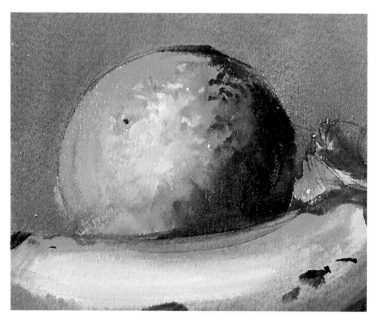

7. *So far we have done the complete modeling of the three pieces of fruit but the contrasts are not accentuated enough. If the contrasts of the shadows are increased, the highlights will stand out more and the volume will be more accentuated. The finish of the orange is begun with a very dense cadmium orange and small brush-strokes to make the texture more noticeable. The upper part of the shadow is painted with a mixture of violet and carmine which as it descends turns into burnt umber.*

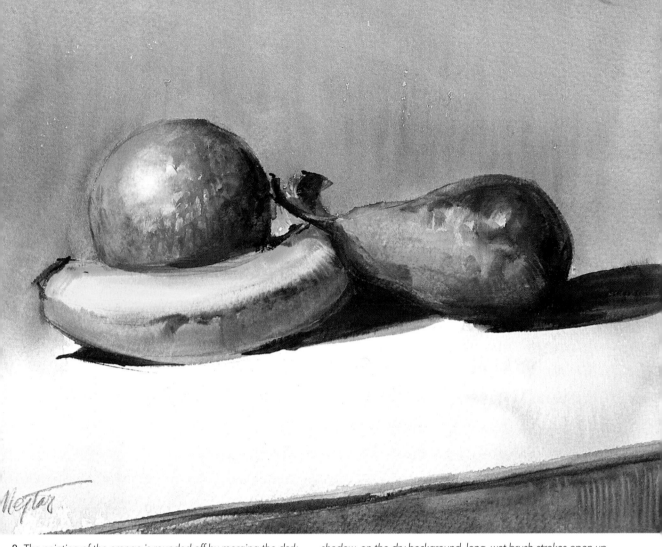

8. *The painting of the orange is rounded off by merging the dark colors that have just been painted into the background with sucessive brush-strokes. On the pear the shadow is painted with burnt umber and soft brush-strokes are made on the limits of the green until the tones are integrated. On the right of the pear shadow, on the dry background, long, wet brush-strokes open up a soft area of light. Lastly, to darken the banana, the lower part is slightly dampened so that the shadow color expands gently. Thus this water color with valuation is finished: the shadows and the white of the paper have played the leading roles.*

SUMMARY

The background is painted first so as to emphasize the shape and light of the fruits.

The brightness of the orange is left reserved from the beginning.

The green color of the banana is softly merged into the yellow tone.

The highlight above the banana is opened with a clean, wet brush.

The contrasts on the orange increase the volume efffect.

The green of the pear is done in two phases: the first to approximate the tone, the second with a darker green, dragging and forming the tone of the shadow.

On the banana the darkest plane is painted once the lower one has dried. Firstly, the zone is dampened so that the shadow color merges in.

Figure

DRAWING AS THE BASE FOR PROPORTION

As we have seen, all the elements of nature can be synthesized from others which are simpler. To illustrate this we are going to look at the construction of a hand. This is one of the most complicated parts of the body to paint; however, as you will be able to see, with a good drawing the proportions and the fundamental anatomical forms can be perfectly shown.

The figure is one of the greatest challenges the watercolorist can take on, not only because of the subject itself, but also for what can be done with the watercolor techniques. With other pictorial themes a watercolor can have some limitations. However, with figure exactly the opposite occurs. This subject requires a lot of attention, starting, of course, with the initial drawing. Although this section is about watercolor, it is important to bear in mind that the outline of the drawing is the base of the color. Therefore, when doing the drawing it is necessary to constantly keep in mind the painting process.

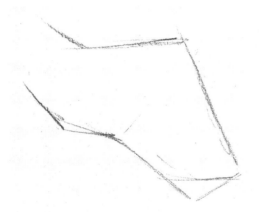

▶ *The initial sketch must lay out the most elementary and simple outlines before you fill them in with color. These outlines have to be expressed in very straightforward lines and at the same time they have to fit. To draw this hand, observe the interior spaces, the inclination of each one of the lines and the distance between them. The advantage of starting with such a simple sketch is that the corrections to the outline are also very easy.*

When the initial sketch is done, the drawing is concluded in an approximate way, but without leaving any line that could produce an error in the painting. Before starting to paint, the drawing, although simple, has to be perfectly finished. In this case the hand is finished in a very elementary but effective way: it is enough to fill in the dark area that surrounds it and then the medium tone that reveals the form of the knuckles. Finally, the fingers are not painted completely: they are just hinted at by their shadows.

THE PLAN OF THE FIGURE

The figure must be planned in detail, but apart from the possibility that these geometric shapes offer, it can be constructed from a well-studied internal structure. In general, the figure moves on several axes which, according to how they move, change the pose of the figure; these axes are shown by the lines of the shoulder, the spinal column and the hips.

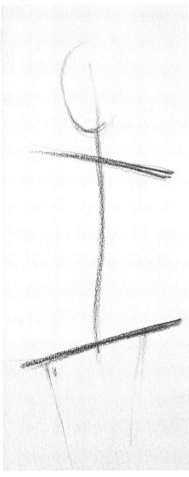

▼ 1. The upper line will be used to show the position of the shoulders. In the central zone the spinal column is represented with a vertical line. The line of the hips, just like the shoulders, will be inclined so that the legs are in a natural pose. Starting from the hip line, the proportions of the legs are sketched with straight lines and the joints are defined.

▼ 2. Building on the previous sketch the drawing of the figure is constructed. As you can appreciate, a lot of practice is needed to construct the figure, but the system of fitting it together using axes allows a well-proportioned development and the security that the drawing is reliable.

▼ To practice the basic scheme of the figure try to find the internal lines of this already finished figure. In the first place, set the axes of the shoulders and of the hip, then the spinal column, and finally, do the sketch of the arms and the legs.

THE VOLUME OF THE FIGURE

When you have learned to construct the figure correctly, the next step is to give shape to the drawing. This is done with color and the various light effects that are carried out on the paper. Just like the other themes that can be painted with watercolor, a certain amount of light is projected onto every figure. This means that some areas can be represented with light and others with shadows. The light areas always have to be those reserved by the darker tones. It is precisely this effect that produces the volume. The parts of the figure most exposed to the light will have to be outlined by the shadow, which will always adapt to the anatomy. Here are two exercises.

1. Once the figure is defined and the drawing is refined, the painting of the volume is started by placing the shadows and the light areas. When starting out with the volume proceed with caution for it must be suggested by the points of maximum luminosity. In this example, the most luminous parts are perfectly marked out by the darker zones. Likewise, in these shadows medium tones are also painted in. It is sufficient to absorb part of the color with a clean, dry brush while it is still moist on the paper. Or, wash the area with a clean, wet brush if the color has dried completely.

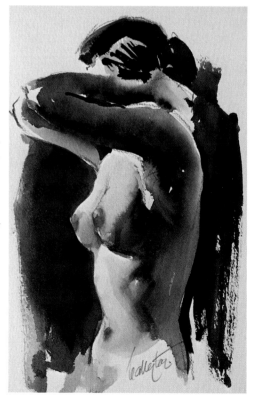

2. The volume is finished off with medium tones that pull some of the darker tones towards the lighter ones, and then they are blended by repeatedly passing the brush over the most luminous parts. To put the final touches on the contrast of the body of the figure, all that has to be done is to paint a dark background. In this way the shadow tones are percieved as having more volume due to the contrast, while the clearer tones gain luminosity.

▼ *First, the drawing must be constructed as correctly as possible. Starting from the dark areas the densest shadow tones are established. These, in turn, are the backdrop to the highlights. Lastly, the background is darkened and the shadows are merged with the most illuminated areas.*

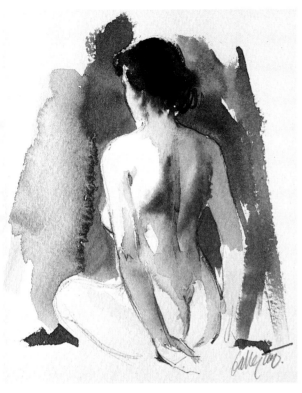

TECHINQUES OF SYNTHESIS

Synthesis should be the principal recourse of the watercolorist. Synthesis means the process by which the representation of the objects is reduced to the most basic elements. In general, when beginners paint there is a tendency to fall into the trap of cluttering with excessive details. As experience is acquired, unnecessary details are eliminated. Here we are going to study the synthesis process in the figure and how economizing on techniques can give much more expression to the overall effect of the picture. To paint well you have to know what is important and what is superfluous.

▶ *Paint this figure following these steps: first sketch the general lines within a triangular form, omitting any detail. Draw the lines that reveal the shoulders and the spinal column. Finish off the drawing of the body with only essential elements. As you can observe, the fingers are not drawn and the legs are hardly outlined. However, the figure is completely defined. With a very quick shading, the forms that make the highlights stand out are finished off.*

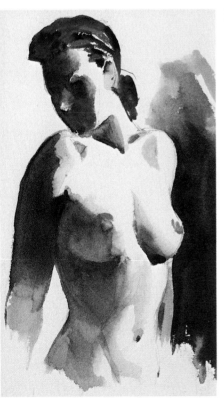

▶ *1. The dark parts of this figure define perfectly the principal points of light and allow the form to be modeled. On one hand they integrate the shadow into the iluminated area, and on the other they open up small highlights in the volume of the breasts. To achieve the maximum contrast, all the side that is in contact with the illuminated zone is darkened.*

◀

2. By being very economical with techniques, it is possible to paint figures of a fairly advanced technical level, despite doing away with unimportant details. Instead, the light points and the modeling of the shadows have given definition and volume to the figure.

Step-by-Step
The Female Back

In this exercise the aim is not to do an excessively complicated painting. If one studies the approach to the principal volumes, starting with their shadows, it will turn out to be very easy.

On top of the picture which will be used as a model, a graph has been superimposed so that it is easier to sketch the principal planes. The lines "a" and "b" correspond respectively to the lines of the shoulders and hips. Starting from these two lines a trapezoid is done on one side, and the other a triangle and square.

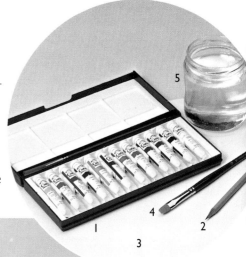

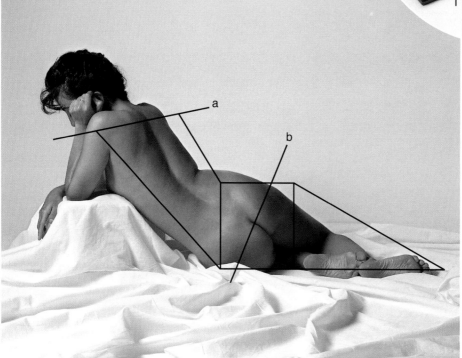

MATERIALS

Tube colors (1), pencil (2), watercolor paper (3), watercolor brush (4), water jar (5).

1. Starting from the simple geometric shapes drawn on the model, outline the figure. The back fits into a trapezoid, the pelvic zone from the waist to the hip fits into a square, and the legs and feet fit into a triangle. From these forms it is easy to define the basic anatomy of the model. The drawing must be perfectly finished before starting to paint. Once it is done, start painting the dark areas with burnt umber.

2. *With wet, clean brush-strokes, color is dragged from the back in a soft gradation, reserving the strip of the spinal column. The process is continued with the shadow of the legs which defines the round shape of the buttocks and frames the shadow of the hip.*

Sometimes it is difficult to imagine the result of one color on another, especially when there are several layers. This is why it is always recommended to have available papers of the same quality as the one being used in the definite work, so that you can do color blending tests and check the final result.

3. *The color of the flesh is obtained with an orange transparent layer. When the paper is wet, the sienna tone that is added to the side of the body blends easily and suggests the volume. A very faint purple tone is added in the armpit zone. The form of the buttocks is modeled with almost dry color: the burnt umber is blended by successive brush-strokes. A very transparent greenish yellow layer is added which mixes with the previous coats of color.*

4. *The contrast of the armpit is increased and the hair is painted with a burnt umber and cobalt blue tone. The color of the skin is obtained from the illumination of the space that surrounds the figure. A transparent wash of burnt umber and blue is prepared with which to paint the background of the picture in a somewhat irregular way. The bluish hue is intensified around the hip.*

5. *When superimposing tones or planes, synthesis should be the main objective of the water-colorist. A lot can be expressed by well-placed shadows and by omitting unnecessary details. Therefore, to paint the hand the fingers are not drawn. This part is resolved with the dark shadows that surround the illuminated area. The back of the hand is contrasted with a slightly bluish burnt umber. The fingers are defined by the hair and by the shadow of the face.*

A general layer can be painted at the end of the session with the dirty water in the jar. This technique is widely used because this water has a highly transparent broken tone. If this layer is painted, the colors underneath must be completely dry, and you must not paint too much so as not to soften them again.

6. *To paint the feet the contrast of the shadow of the legs is intensified and the most luminous areas are defined: the right calf muscle and the soles of the feet. The latter are painted with a very clear burnt umber wash and a dash of blue. The brightest parts are left white. This is the best way to give relief to the highlights of the skin.*

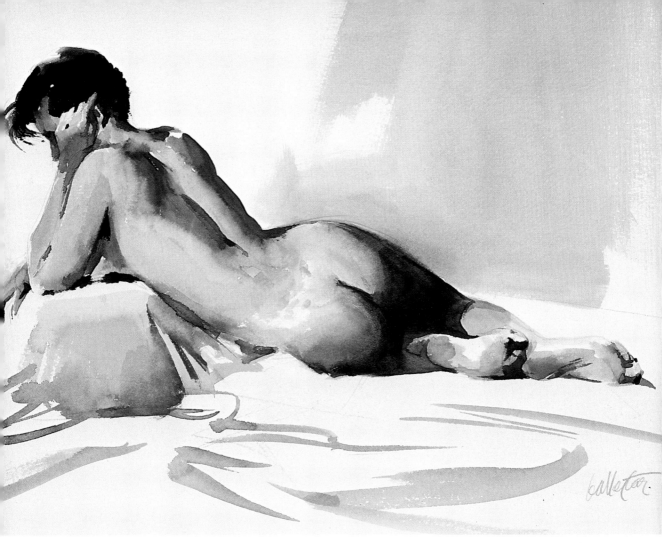

7. *The contrasts of the soles of the feet are intensified with small brush-strokes that outline the highlights of the toes. The tone painted before must be completely dry so that the colors do not mix. The brush is wetted and drained off prior to gently brushing the shadow of the legs so that they have depth.*

Finally, the inside of the leg is contrasted and the buttock is defined. Pay attention to the modeling of the buttocks: the brush-stroke must be curved and must blend the colors without destroying the shadow as it softly superimposes the tones.

SUMMARY

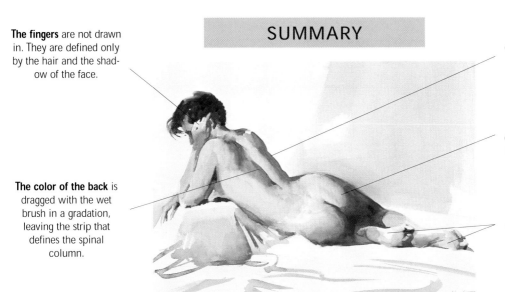

The fingers are not drawn in. They are defined only by the hair and the shadow of the face.

The color of the back is dragged with the wet brush in a gradation, leaving the strip that defines the spinal column.

The figure is outlined by drawing simple geometric shapes into which the model fits.

On the buttocks the brush-strokes must be curved and blend into the colors without destroying the shadows.

The soles of the feet are painted with a very clear wash of burnt umber and blue; the most luminous parts.

6

Texture of the Skin

THE COLOR OF THE SKIN

The color composition of skin is obtained with different colors, tones and reflections. When the skin is young, it reflects the light uniformly and with precise highlights. In contrast, the texture of mature skin no longer reflects light uniformly, but intensifies the texture and shadow cast by the wrinkles over the features of the face.

The painting of skin is an advanced value-related study. Skin-tones are one of the most complicated challenges in watercolor. The examples that are dealt with on these pages are accomplished works. In this topic we will learn the fundamental techniques to solve one of the most common problems related to the figure and portrait: the skin and its texture.

▶ 1. In this illustration, the shadow is only a small tonal difference with respect to the light zones. In contrast, in the light areas sufficient highlights have to be opened up so that the carnation reflects the light. The texture of the skin is begun by painting the carnation but reserving the most luminous area. The tone applied to preserve the brightest areas of the figure is a highly transparent carmine Naples yellow, and a little ochre, although it does not exactly have to be so. What is important is that the carnation has warm and very transparent tones.

2. The very clear tones can be painted by brushing the colors over the dry background, cutting out the highlights. In some areas, a blue layer can be painted to suggest a finer and more transparent skin, or the highlight absorbed with a clean brush. If the paint is dry, repeatedly passing the brush will enable whites or clear spaces to be opened up, perfectly outlined. Here, the texture of the skin has to be done by blending two tones of different colors. The shadow is painted by blending the tones in the areas where it touches the tone below. This blending must be minimal and very controlled.

TEXTURE OF THE SKIN

Besides being able to represent the texture of young skin, it is important to master modeling if one wants to give a correct texture to the skin tones of any figure. In this process we will study in detail each one of the steps that must be followed. This exercise shows one of the many possibilities that can be developed in watercolor.

> Paper is very important in watercolor technique, especially if the work is being constantly corrected.

▶ 1. *The first layer will be the base for the texture of the carnation skin tones. The base color will allow the later applications to act like a filter, modifying the original colors according to the opacity with which they are painted.*

▼ 2. *The background is darkened and the principal shadows are painted. The colors used are the following: sienna on the back and burnt umber on the arm. This step and the next must be realized before the color dries on the paper so that the tones blend. It is important to control the moistness of the paper to avoid unnecessary wetness.*

▼ 3. *Shading is spread with the wet brush, somewhat insistently, to blend it into the background. The areas reserved on the skin are the shiniest areas. This is an important question to bear in mind in all carnation work. The highlights must be reserved from the start so that they do not have to be opened up later. Finally, the shadows are softened by sweeping the wet brush over them. The sharpest contrasts are defined with a soft profile. In this way the figures are outlined and the texture of the skin acquires the brightness and volume necessary.*

FEATURES OF THE FACE

Besides being able to represent the texture of young skin, it is important to master modeling if one wants to give a correct texture to the skin-tone of any figure. We will study in detail each one of the steps that must be followed. This exercise shows one of the many possibilities that can be developed in watercolor.

◀

1. The drawing must be as perfect as possible, correcting any possible errors. Each part of the face is drawn with the maximum precision, bearing in mind the proportion between the features. In this work the planes are very defined. The background is painted in a dark tone to put the face into context. First, an almost transparent layer of sienna is painted over all the face.

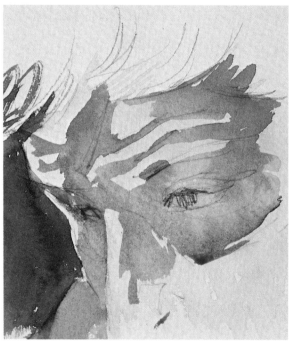

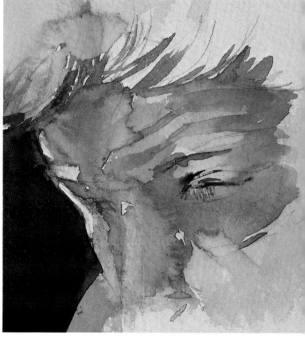

▼ *2. It is necessary to respect the drying times between the layers, both when you want to blend two tones, or when you want to superimpose them. The forehead is painted in orange mixed with a little sienna. The wrinkled area is left blank: to do it, the background has to be dry. As the color descends down the face carmine is added. The reserves of the wrinkles on the forehead are made, painting around them in an orange tone.*

▼ *3. The wrinkles of the forehead and the nasal septum, reserved beforehand, are given a yellowish layer. When the colors underneath are dry, they are retouched with a wet brush to merge the tone of the furrows and to redefine the forms of the shadows. When the brush is passed over the zone to be blended, the fusion of the tone on the background is controlled. Adding new tones could take part of the background away (on the nose). New tones are superimposed on the background to intensify the contrast (on the forehead wrinkles).*

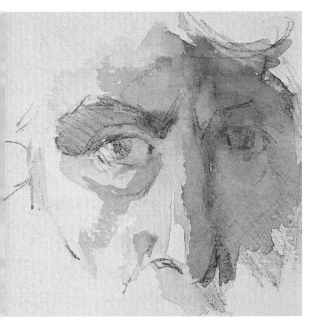

HIGHLIGHTS AND SHADOWS

The highlights on the skin depend on its tension and the amount of light that falls on it. Some areas tend to shine more than others, above all if the skin is smooth or slightly greasy like on the nose and forehead. The highlights of the skin have to be reserved from the start so that the dark areas can be put in once the first layers are dry. With the first color intervention, the light and shadow tones can be established in a luminous way.

▶ 1. *At the beginning the luminous areas of the face are reserved. The background wash is resolved with two different tones to separate the light planes. When the drawing is complete, the light area is painted with a very luminous yellow ochre tone. The maximum highlight area remains reserved. The most intense point of light is on the nose. A dark layer is painted in the shadow zone. In this way, the highlight appears even brighter, making the reserved zone appear much more luminous.*

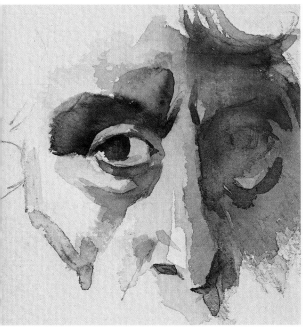

▼ 2. *Increasing the shadows of one area of the face produces a contrast with the adjacent lighter areas. To balance the luminosity of the skin, a strong contrast is painted with sienna in the upper part of the eyebrow. This gives depth to the eye. Watering this color slightly, the shadow of the nose is gently darkened. Its highlights now appear more luminous. On the forehead, a brush-stroke of very transparent red gives a more realistic look to the skin texture.*

▼ 3. *The final contrasts define completely the texture of the skin. These contrasts are obtained with a very pure sienna which is used to profile the darkest zones of the face. As can be seen, the highlights of the skin have not been touched since the start, despite the numerous layers that border on them.*

Step-by-Step
Portrait of an Old Man

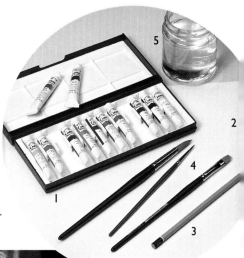

The texture of the skin, its tone, and the reflections of light on the face are learned with continous practice, in which the possibility of copying famous artists should not be ruled out. If, moreover, as in this case, a model is available, and a record of the steps which the artist followed, it is guaranteed that you will learn. The model chosen is an elderly person, portrayed against the light. His face, his features, the skin texture and the way light falls on the model make this a perfect example for this exercise.

MATERIALS

Watercolors (1), stucco watercolor paper (2), pencil (3), watercolor brushes (4), and water jar (5).

1. *The first step requires that the watercolorist make a great effort to do the drawing well. If it is too difficult to do, he or she can resort to tracing. In this exercise a simple outline is not enough: it is advisable to take the drawing further so that when the color comes in, it is integrated into a perfectly defined structure. The features must be sharply defined and the light areas and the most prominent wrinkles schematized with neat lines, without either grays or fuzziness.*

234

2. *Starting from the perfectly constructed drawing of the head, the skin base is painted. The base color is elaborated in the palette with orange, ochre, and sienna. You have to paint over the dry background sufficiently rapidly so that the tones do not seperate when drying. All the face is painted without creating sharp tone changes. The principal highlights are left reserved. The hair is painted with lines of Payne's gray.*

When a portrait is begun, it is necessary that the first rough drawing is sufficiently complete and contains all the elements that precisely define the features of the face, thus allowing easier future development. It is vital that the finished portrait has a good likeness to the model.

3. *Before the base color is completely dry, the first contrasts are painted with burnt sienna. This intensification of the shadow is only done in the darkest areas of the face. The skin base is fundamental to proceed with the successive colors. With the color used to darken the nose, the wrinkle of the eyebrows, the chin and the upper lip are precisely painted. Due to the effect of the simultaneous contrasts, when putting in the dark spots, the highlights gain intensity.*

4. *Allow the background to dry completely. Now you can paint on it without the colors mixing. The right side of the face is darkened with a very luminous gray wash. This phase is extremely delicate: start on the forehead, reserving the highlights. At the same time that the gray area is painted, the lit-up part is profiled, outlining the upper part of the eyebrow and cheekbone. The wrinkles of the forehead are depicted with soft, quick brush-strokes of the same color. The wrinkles of the chin and of the face are painted once the gray background is dry. Hence the colors will not mix.*

STEP-BY-STEP : Portrait of an Old Man

5. The background must be dry before starting the work on the texture of the skin. As we are using heavy paper, it is possible to do mergings and washes on top of previous layers without the quality suffering. The dark shadows of the skin are intensified with burnt sienna, and the profile of the shadow is reinforced around the eyebrow zone, in the eye and on the cheekbone. The shadows that suggest the wrinkles are gone over again until they expand and blend. The shadow of the cheekbone is done in a triangular shape that merges around the mouth.

6. Mix a wash of burnt sienna and umber and use the resulting color to contrast the principal wrinkles of the face, leaving in reserve the brightest parts. The orange color that was used at the start shows through all over the face in the transparencies of the different colors. This base color is covered in some zones by the wash, in others it remains intact. The principal highlights have been reserved since the beginning of the portrait. All the right side of the face and the shadow of the lips are darkened. In this way the volume of the face is accentuated. The wrinkles of the forehead are depicted with fine brush strokes.

7. *The ear is painted, it is defined by its own shadow. The wrinkles of the forehead are darkened, thus increasing their volume. The background color remains as the luminous part of the wrinkles. The right eyebrow is darkened with rapid and spontaneous brush-strokes. Very watery carmine and a little sienna complete the form of the lower lip. All that still has to be done is a very transparent layer over the background, and then this painstaking piece on the texture of the skin is finished. Although it has been a complex work, many concepts have come into play. They will be useful later.*

SUMMARY

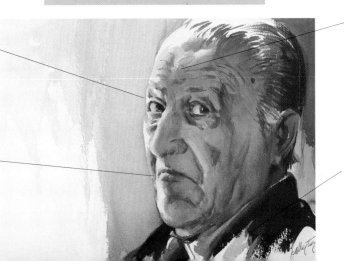

The dark part of the shadow is transparent and outlines the face. On top of the right paper, the tones can be fused over the completely dry background.

The drawing is perfectly defined before the color is approached. The skin does not have a unique color, it depends on the many colors that surround it.

The first color application is an orange wash that is the base of the later colors.

The color of the clothes in the portrait does not have to life. They can be toned according to the needs of the image and to make the face stand out.

The Way They Painted
William Turner
(London 1775–London, 1851)

Saint Mark's Square

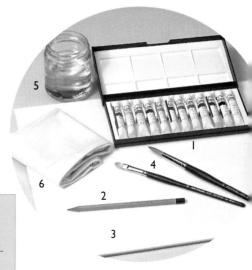

This English painter was famous for his landscapes and sea views. He started painting watercolors and then later he switched to oils. A journey to Italy marked the beginning of a period characterized by luminosity and highly intense and vivid colors. Later, he began to make light itself the center of the paintings, as can be appreciated in his very dreamlike views of Venice. His work, which was very romantic, influenced impressionism.

In recreating this work, the aim of which is not to do an exact copy, we are going to study some of the techniques that Turner used constantly, and which have been explained throughout the previous chapters. The techniques that Turner employed are not complicated. However, they are executed with precision and great care in each of the different parts of the painting. Painting on wet paper gives a characteristic style to the fusion of colors and forms: it is the degree of moistness of the paint on the paper which conditions the blending of the tones. Turner had perfected working with different drying times; this is what is going to be attempted in this exercise. Before starting, look at the subject carefully. Let's see if you can guess the areas that he painted first and how the he did them.

1. *It is important, before doing anything else, to start with a good drawing, for the work that is going to be done later will be based on this. It is not necessary that the drawing be exacatly like the model, but the different elements must be approximately in proportion. In the drawing any possible change in the inclination of the line must be observable. Here, for example, compare the perspective of the upper part of the building on the right of the model. Doesn't the building that has just been painted seem less inclined? These are the type of corrections that must be done.*

2. *If you look closely at the original work you can appreciate the total lack of whites. Instead, the lightest tones are yellow, the product of the initial layer. A very watery yellowish mix is obtained with ochre. It is used to paint all the buildings. However, the sky is left unpainted. How do we know that for the base of the sky Turner did not paint a yellow layer? We know because the blue would have turned greenish and this is not the case.*

You have to be very careful with the chromatic effects that are produced by the superimpositions of color.

3. Paint the area on the right with an orange wash. This color will blend with the just-painted part of the sky; it can be corrected later if necessary. It is certain that this also happened to Turner, if we judge by the earth tone that the sky takes on in certain areas. It can be perceived in the model that the sky was not painted in one period. Rather, it has several layers of color that allow the brush-strokes to show through. A very clear wash of a little umber mixed with dark blue is used to repaint the sky, letting the brush-strokes be very evident. On the left, it can be seen how Turner made a correction. Here, one is made, too, by absorbing the excess of tone with a clean, dry cloth.

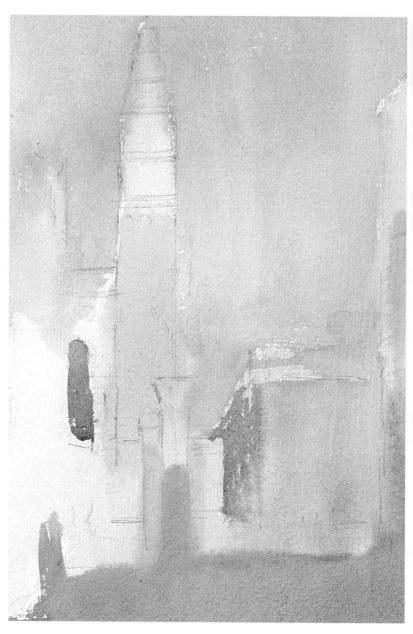

4. Some parts of the buildings, above all on the left and the building in the background, appear merged into or gradated with the blue of the sky. This happened because when the painter was painting the sky these zones were not completely dry and the first color mixed with the new one. In the same way, the color of the buildings is allowed to penetrate into the first layer on the white of the paper. When color is superimposed on top of an already dry one, the tone darkens. In this way dark tones can be achieved that modify the first tones of the upper part of the buildings. Wait until the background is almost dry and repaint it with blue mixed with a little sienna. The dark parts of the buildings are painted in burnt umber.

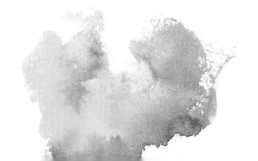

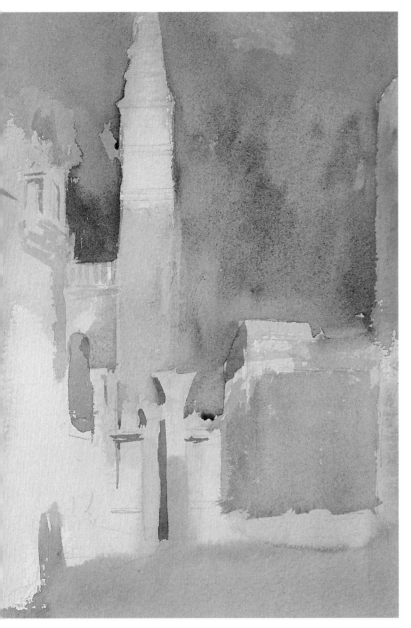

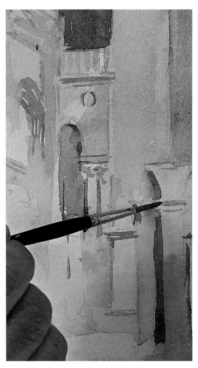

6. *As you can see in the illustration, you have to continue drawing throughout the exercise. A brush is used to paint the lines that define the relief of the buildings, after having painted in the first colors. Paint the decorations on the buildings in the same way. The strokes have to be precise, without either blending or forming flows. Draw the lines with a sufficiently transparent sienna so that although the first color is not totally covered, the drawing of the well-constructed strokes can be seen.*

5. *It is necessary to wait until the background and the later additions of color are completely dry before proceeding. Then, a blue wash with a little sienna is prepared and applied over the background with vertical brush-strokes. This new layer of color is what finishes off the outline of the buildings. Afterwards, with a burnt sienna lightly tinted with blue, but only as a very transparent layer, the shadows of the buildings in the background are painted. The base color changes appreciably the dark tone of this layer.*

The colors that are superimposed produce an overall effect when the bottom layers are dry.

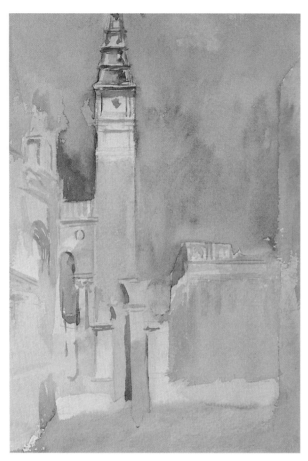

7. The drawing done on top of the first color washes gives a sharp definition, and the cornices, the nuances of the walls and the entrance arch on the left are perfectly traced. It is important that the strokes do not stand out too much. The color must be sufficiently watered down in the palette. Pay attention to the drying process of every tone. When a brush-stroke dries completely, its tone intensity diminishes.

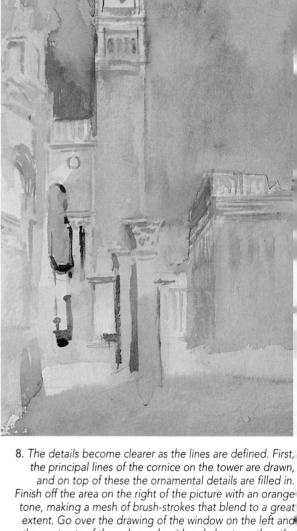

8. The details become clearer as the lines are defined. First, the principal lines of the cornice on the tower are drawn, and on top of these the ornamental details are filled in. Finish off the area on the right of the picture with an orange tone, making a mesh of brush-strokes that blend to a great extent. Go over the drawing of the window on the left and the contrasts of the colonnade with a darker tone than the ones used till now. Some carmine tones are painted on the lower right side. Before they are completely dry you must move on to the next stage.

> The colors superimposed on top of wet colors merge into each other.

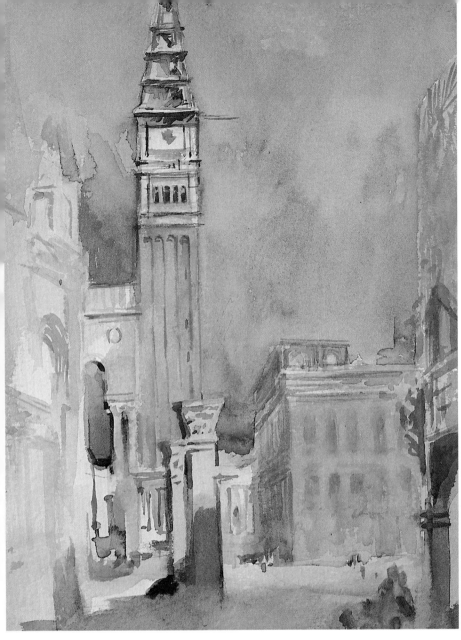

9. Burnt umber is painted around the carmine tones and blends into them. Draw on the tower the vertical strokes that define it and finish off contrasting the entrance of the building on the right. Finally, all that remains to be done is to apply a small touch of color to the lower part of the shadow and add nuances where the contrast can be intensified. The similarity with the original is very close, although rather than do an exact copy, what has been attempted is to experiment with the principal techniques that Turner put into practice. The differences in brush-strokes between the original and the finished work can be explained by the degree of absorption of the paper and the drying times of the wet layers. Moreover, there are more similarities than differences. Of course, the style, the brushwork, and the expression are unique to each artist.

SUMMARY

The sketch is done beforehand in pencil, setting out the forms of all the buildings.

A first, almost transparent, yellow wash covers all the urban landscape and will be a support for the other, darker, colors.

The background color shows through in the upper part of the tower.

The sky is painted with successive layers of blue, every application becoming darker.

The windows of the building in the background are suggested on top of the almost wet background.

The Way They Painted
Henri de Toulouse-Lautrec
(Albi 1864–Malromé 1901)

La Belle Hélène

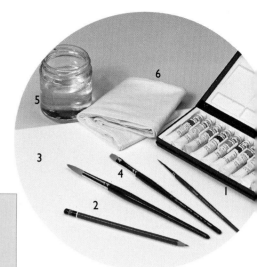

Two accidents suffered in his adolescence left this artist scarred and injured for life. He led a bohemian life in Paris, where he fell under the influence of Bonnat and Degas. He hung out in cafés, theaters, music halls, and brothels, where what he saw and the people he met became an important source of ideas. His works, excellently drawn, are characterized by the spontaneity of the brush-stokes and the expression and freedom of movement.

This watercolor proves that simplicity can be a solid base for a painting. In this exercise the aim is to practice one of the most difficult decisions to make. However, it is also simple: how to know when a painting is finished. Often an inexperienced enthusiast, when practicing, becomes desperate when they see that the work which was progressing well has become so saturated that it is almost completely spoiled. The secret of success in painting, in great part, lies in knowing when to stop: only painting what is necessary. Besides practicing the synthesis of the forms and applying colors, we will also study how the most transparent layers work on the white of the paper and the superimposition of brush-strokes with the background.

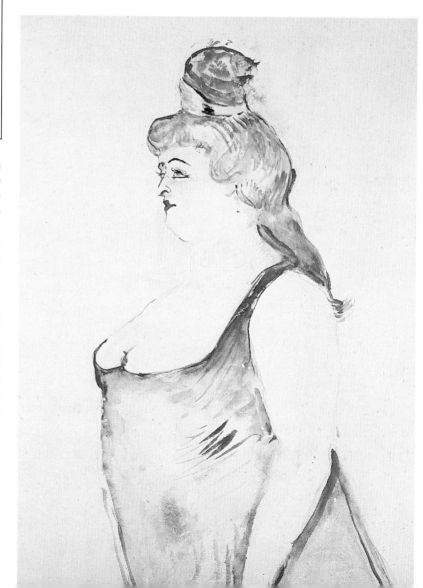

2. Once the drawing is completed, a very transparent layer of color is applied homogenously over all the picture. This color is yellowish, a mixture of ochre and yellow. Despite being highly transparent, this first layer changes the luminosity of the paper. The colors that will be applied afterwards will be affected by this base tone. This layer must be dried before continuing, for any addition on the wet background will make the tones blend. This is not the objective.

1. Although you could start right away with watercolor, as has been done on other occasions, in this case, in which the transparency of the colors is intense, it is wiser not to do so for some zones must be reserved next to others slightly darker. It is important that the drawing is well defined before starting to paint and also that the brush-strokes are extremely clean. This is because, owing to the transparency of the work, any badly placed pencil line can be seen.

In all watercolor work, the initial drawing is a vital guide so that later developments find a good structure into which to fit.

STEP-BY-STEP: *La Belle Hélène*, by Henri de Toulouse-Lautrec

3. *Once the background color has dried, the first base color is painted, which here corresponds to the first layer of the hair. The woman is blond. This hair color uses a luminous yellow as the base, although it is much less transparent than the background. Observe the difference between the painting of a general coat (in the background) and the other more specific layer that is put down now. Not all the hair is painted with the same intensity; the color is applied with different transparencies and qualities, allowing in some zones that the background of the paper shows through completely.*

4. *Paint the upper area of the fringe in cadmium red and add a few brush-strokes of burnt umber to the back of the head. In this zone the background has already dried, and therefore some yellow reserved areas show through. The picture is allowed to dry and another wash is applied around the figure to make the color of the skin stand out from the background. The features of the face are painted with transparent sienna. This work must be carefully done so that the colors do not mix with each other. The dress is painted with a very transparent red wash and the most luminous zone is left unpainted. The following steps must be done quickly so that there is no break in the blending of this area with the background.*

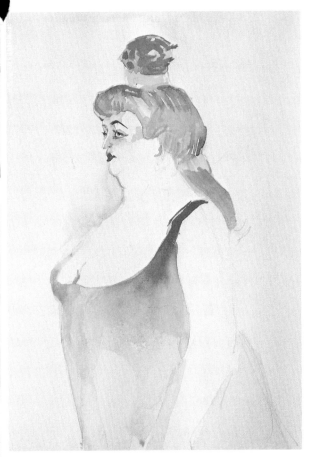

5. *The face and hair are the areas which involve the most complex work, and above all, the white reserves on the face. It is important that the sienna tones and the eyebrow, painted before, are completely dry, otherwise the colors will mix. The shadows of the face are painted with a transparent sienna and the brightest parts are left blank. The eyelashes are painted once this shadow is dry. The hair is enhanced by adding sienna and orange.*

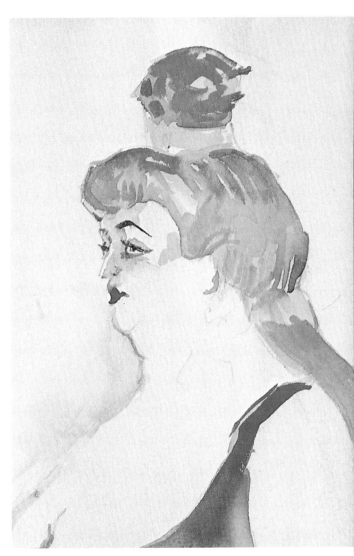

6. *With a slightly wet brush, go over the dress until the bright area starts to blend into the background. As the dress has been dampened, it is possible to introduce a redder and denser tone to the shoulder strap. Start to apply red to the upper part. It will blend due to the moistness of the paper.*

Using high quality paper is very important because with ordinary paper, merging colors is practically impossible once the color has dried.

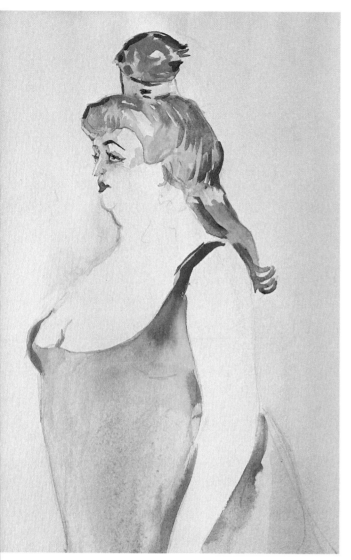

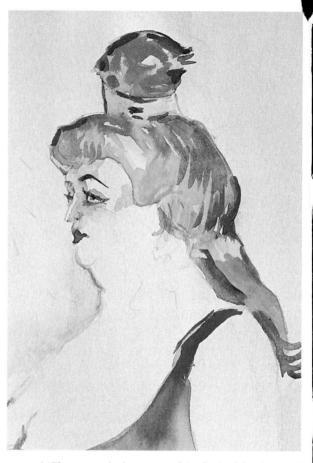

8. The arm and a large part of the flesh of the chest and the face have been reserved since the beginning of the exercise. This color is the first coat on the paper. With red mixed with a little carmine the outline of the dress is reinforced in the area of the breasts. In the part surrounding the form of the arm, paint with a cadmium red wash, without penetrating into the arm, which will now be perfectly outlined. Once again a transparent sienna wash with which to paint the background is prepared. Leave the right side a little darker so that it contrasts with the back of the figure.

7. Focus your attention on the dress while it is still drying. This is especially delicate as the effect that you want to achieve is one of successive layers that are superimposed with free brush-strokes, without the colors blending together, so as to get adequate volume. However, in spite of the work on the hair and the delicacy with which it must be treated, this area is not very difficult, provided that the drying times of the previous layers are respected.

> When putting down layers on the background, it is always prudent to start with the lightest tones and then, afterwards, if necessary, to intensify them progressively with successive layers of color.

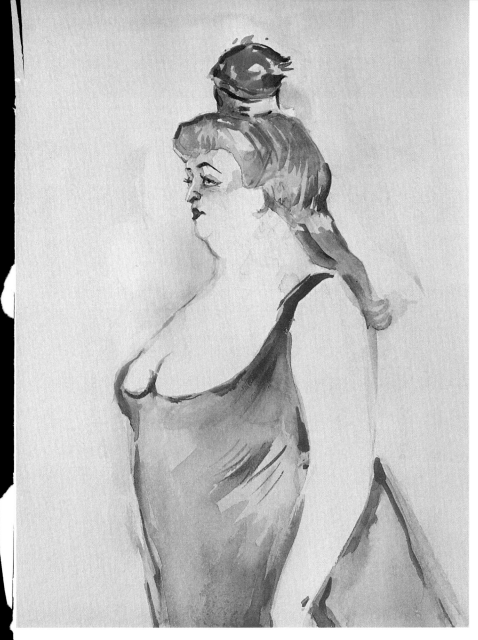

9. *When the background is completely dry the strokes that give texture to the cloth of the dress are painted. This last step requires special mastery of the paint and of the brush as the wet paint must be combined with very defining strokes. The colors that are used on this part of the dress are carmine and cadmium red, always very transparent, respecting the parts that contain the highlights. The creases of the cloth are painted with firm strokes. Now the painting is finished. The similarity with the original is close. It must be emphasized that the object of the exercise is, above all, to interpret the technique of a great painter.*

SUMMARY

The initial drawing must be as clean and as precise as possible as all the color additions that will be done later will be very transparent.

The background is painted with a very transparent yellow tone so as to soften the white of the paper.

The base color of the hair is yellow. On this the darker colors are applied, although in different reserved zones the yellow comes through.

The dress is painted in successive layers of red and carmine, leaving luminous zones as reserves in the lower layers.

The Way They Painted
Emil Nolde
(Nolde 1867-Seebüll 1956)

Flowers

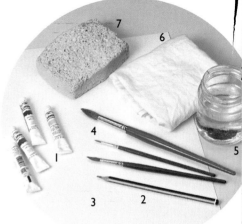

Nolde is the pseudonym of the German painter Emil Hansen. His style recalls that of Van Gogh and Ensor, painters for whom he felt a great admiration. Many of his paintings, full of religious scenes that in their day caused much scandal because of their sensuality, abound in striking colors and expressionist forms.

Flowers are one of the themes that give most play in a watercolor. A simple green shadow is converted almost by magic into a fresh, colorful flower. This allows the development of very gestural pieces, full of vigor and color, as in the present example. This exercise aims at doing rapid, enjoyable work that gives a very effective result.

Once again, it is not a question of copying the model, but rather of trying to understand the technique that the artist used.

MATERIALS

Tube colors (1), pencil (2), watercolor paper (3), watercolor brushes (4), water jar (5), rag (6), and sponge (7).

1. *It is certain that Nolde did not start painting from a pencil sketch, but this is what we opt for here as it will be easier to follow. What must be sought after in the drawing is the proportion between the forms that will become flowers. Although we are not trying to obtain an exact copy of the model, just an interpretation of the artist's painting style, try to be as exact as possible. A subject painted by another artist is as valid as any photo or natural model.*

2. *First, a very transparent violet wash is put down over the background, leaving reserved spaces for the white of the paper or to separate shades that must not be blended. Bearing this in mind, the painting of the violet flower is started. The central part of the flower coincides with an area that is untouched by any wash, thus allowing painting with precision. Just to the right, the blended petal seen in the illustration is painted. The color mixes immediately on top of the wet background. Start painting the yellow flowers in the upper section.*

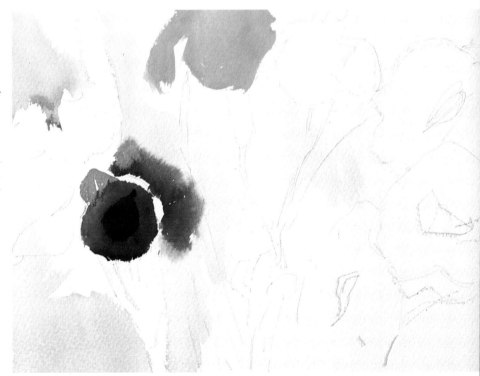

STEP-BY-STEP: *Flowers*, by Emil Nolde

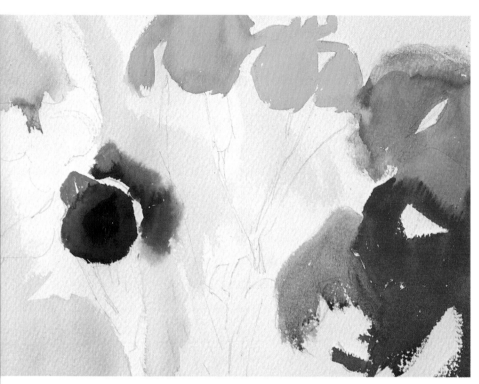

3. *In the center of the flowers a very luminous, almost transparent red tone can be seen. On this color, darker coats can be perceived, as well as much more precise brush-strokes. The red flower in the upper section has the most tones of red. To paint it, it is first necessary to give it a transparent wash and allow it to dry before applying the second layer. The lower flower is painted with a much more opaque red tone. The flowers on the bottom right are painted in shades of violet. In doing this, a part of the color of the red flower is blended in.*

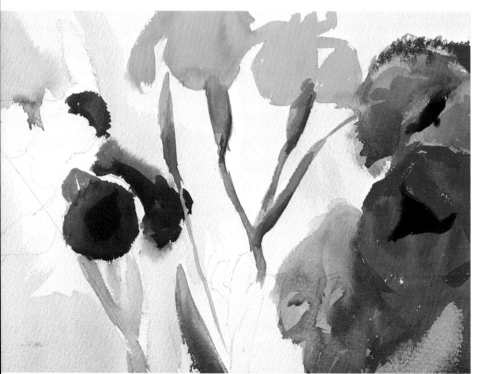

4. *With a somewhat dirty violet tone, this area is completed, allowing the different tones to blend together. Black is used to paint the center part of the poppies on the right, and red tones are superimposed on the already dry first layers. Paint the upper part of the first flower, slightly pressing down with the point of the brush. The same yellow color that was used for the flowers is also used to sketch in the stems. Before these dry, go over them with green brush-strokes and let the color mix in for most of the stroke.*

5. *The principal painting of the picture is complete. Now the first contrasts that separate the flowers can be painted. The background of the flowers must not be completely dry if you want to achieve an effect similar to Nolde's. To create the dark shadows, use a very dense cobalt blue. As for the flowers lower down, just below the poppies, some of the red color is blended in to get a violet tone. Black is used to paint the darkest part of the flowers.*

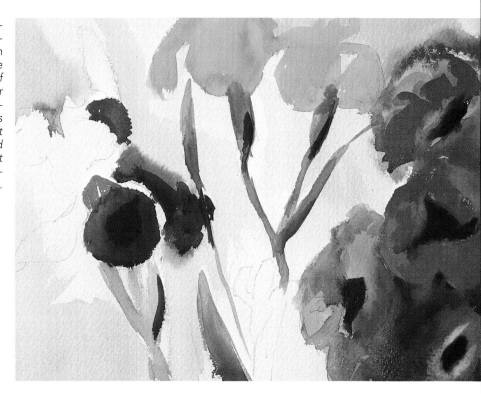

6. *Next to the lilac-colored shadows on the left of the picture, the petals are painted in a strong orange color. But first, make a splash of very dense golden yellow so that the color that is painted on afterwards has a firm base on which to mix. Then, superimpose cadmium red brush-strokes. When they mix, they become a luminous orange. Before the orange tone is dry on the paper, paint the violet again, allowing the color to mix with the lower tones that are still wet.*

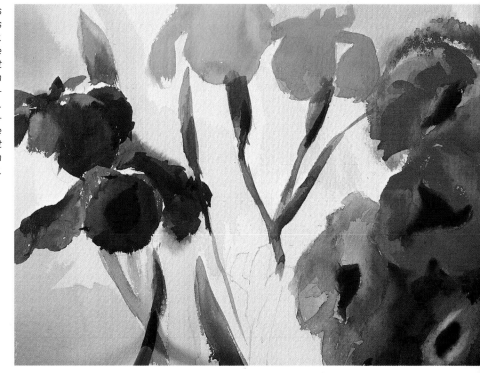

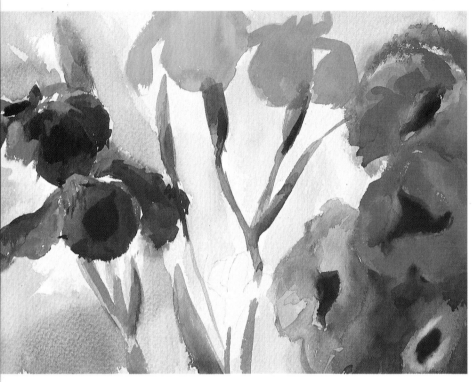

7. *Allow everything to dry before applying layers that darken the background so that these will not alter the colors by blending. When the background is dry, paint it with a violet tone, somewhat stained by sienna to make the tone much warmer. This shade is painted on the layer that was painted in the beginning. It does not encroach on the most luminous colors.*

Yellow is one of the colors that permits the most luminous effects.

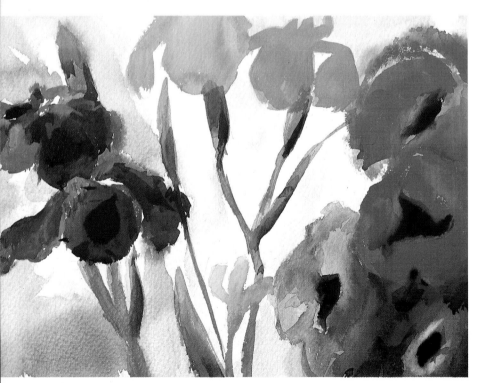

8. *Continue working on the flowers on the left, giving the petals´ form somewhat darker tones, but without contrasting too much with the previous colors. The only remaining flower, which is still outlined in pencil, is painted with the same yellow as was used to paint the flowers in the upper section. As can be seen, the final retouches do not have to be too obvious.*

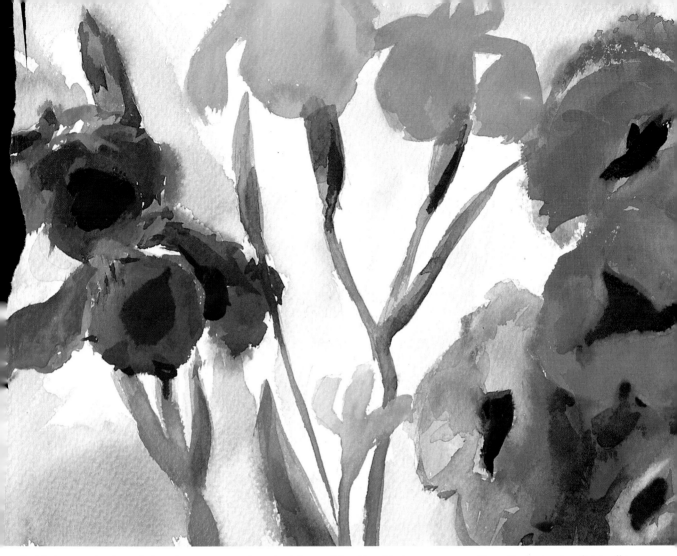

9. *All that remains is to darken the orange petal on the left a little. This contrast is obtained by violet paint that is complemented by the original orange. On top of the violet flower, a new layer of the same color is applied, and it is allowed to* blend in with the green stem. These final retouches finish off this interesting gestural work. Once the piece is finished it is important to reflect on the steps that have been taken and how the work of the artist has been interpreted.

SUMMARY

The first application of color is the violet layer on top of which the violet flowers on the left are painted.

Next to the lilac color on the left, the petals are painted in a strong orange.

The poppies are painted in several phases; first, with a very light wash and then afterwards in denser tones.

The painting of the stems is begun in yellow. Before the zone dries, the brush-strokes are gone over with green.